What the Music Said

What the Music Said

BLACK POPULAR MUSIC
AND BLACK PUBLIC CULTURE

Mark Anthony Neal

Routledge
New York and London

Published in 1999 by
Routledge
29 West 35th Street
New York, NY 10001

Published in Great Britain by
Routledge
11 New Fetter Lane
London EC4P 4EE

Library of Congress Cataloging-in-Publication Data

Neal, Mark Anthony.
What the music said: Black popular music and Black public culture /
Mark Anthony Neal.
p. cm.
Includes bibliographical references and index.
ISBN 0-415-92071-X (hc : alk. paper). —ISBN 0-415-92072-8 (pb : alk.
paper)
1. Afro-Americans—Music—History and criticism. 2. Popular
music—United States—History and criticism. 3. Afro-Americans in
popular culture. I. Title.
 ML3479.N43 1998
781.64'089'96073—DC21 98-3639
 CIP
 MN

TABLE OF CONTENTS

My earliest memories of Jessie Hodges's barbershop, located on 169th Street between Fulton and Franklin Avenues in the Bronx, have nothing to do with haircuts, but instead the discussions. Most casual discussions among black men gravitate toward sports, music, and maybe sex. I grew up in the 1970s, when the National Basketball Association was simply tolerated, not to be talked about until after the baseball season was finished, the Jets and Giants completed another losing season of football and hockey...well, let's just say brothers weren't quite digging New York Ranger goalie Eddie Giocomin. No baseball, in particular New York Mets baseball, is what dominated most summertime conversation in Jessie's barbershop. In my early years I would witness the Miracle Mets win the 1969 World Series and challenge the Mighty Oakland A's for world supremacy in 1973. Despite the team's relative success, conversations in the barbershop rarely addressed the Mets's pennants or star white pitchers like Tom Seaver, Jerry Koosman, and Jon Matlack, but instead its lack of black ballplayers. Sure, John Milner was its imposing, though inconsistent first baseman, and the team brought the great Willie Mays back in 1972 to finish his Hall of Fame career. But this was the same team whose general manager, M. Donald Grant, ran fleet-footed outfielder Cleon Jones out of New York after he was found having sex with a young white woman during spring training in St. Petersburg, Florida. In a sport that was increasingly dominated and redefined by black athletes like Willie Stargell, Reggie Jackson, Joe Morgan, Vida Blue, Lou Brock, and Hank Aaron, the absence of a major black ballplayer in a media capital like New York City was astounding.

Most in the barbershop attributed this situation to racism on the part of the team's ownership and management, charges that were easily supported by the team's shoddy treatment of Jones, who still holds the team record for the highest single season batting average. Such charges were further validated as I learned more about baseball's segregated past and monitored media, fan, and management reaction to Darryl Strawberry and Dwight "Doc" Gooden as they emerged in the mid-1980s as the team's first black superstars and arguably the most talented players ever produced by the organization. Shortly before Hodges's death in 1987, brothers continued to debate about the New York Mets, though as the demographics of my South Bronx neigh-

borhood began to change and the barbershop's clientele became noticeably younger and poorer, many conversations began to center on whether Michael Jordan's presence would render the moves of Magic Johnson antiquated or whether Rakim Allah was "old school," "new school," or a school unto himself.

The conversations were no less entertaining or intense in my aunt's beauty parlor, where as a young boy I spent a significant amount of time being spoiled by black women of all ages, hues, and social status. The daily exchanges between the next-door grocer, Percy, a solid businessman and legendary drunkard, and the numbers runner who made twice daily visits in the afternoon, were just part of the daily interactions of my community. So were the summer evenings on the front stoop, where black folks ranging from two-year-old toddlers to "old Folks" sat on the stoop or on beach chairs listening to the sounds of Graham Central Station or the Three Degrees on somebody's portable eight-track player or the late-night show on WBLS while waiting for husbands, fathers, and children to come home from work. It would be a few years before I would acquire the intellectual language to understand that what I had witnessed all my life in barbershops, beauty parlors, and on stoops were examples of communal critique, governed by the sensibilities of black folks who fought the everyday struggle of survival in which white racism was only one of the more prominent of the many demons. It would be still later that I would understand that these shops, stores, and stoops were part of the formal and informal institutions of the Black Public Sphere.

Despite its title, *What the Music Said: Black Popular Music and Black Public Culture,* is largely about communities, communities under siege and in crisis, but also communities engaged in various modes of resistance, critique, institution building, or simply taking time to get their "swerve on." When I'm pressed for a description, I often refer to it as the "power, politics, and pleasures" of black popular music. The book's major premise is that the black popular music tradition has often contained the core narratives of these efforts to create and maintain concepts of community that embody a wide range of sensibilities, formations, and purposes. Some forms of community are expansive in size and influence while others are often very personal and simply linked to memories and the music that helps to reanimate them. For instance, my most intense childhood memories center on Sunday morning with my father, whose regular Sunday morning ritual included a breakfast of coffee, bacon, buttered toast (toasted by broiler as opposed to a toaster), eggs over easy, and five hours of The Mighty Clouds of Joy, The Highway QCs, the Soul Stirrers, the Swannee Quintet, only to segue way into two hours of B. B. King, and Hammond B-3 specialists Jimmy McGriff and Jimmy Smith. It was only during the beginning stages of this book that I realized that this routine was how my father resisted the impositions that a sixty-

hour, minimum-wage workweek forced upon him, finding pleasure and stability every Sunday as he aurally re-created the Thompson, Georgia community he was born and raised in, temporarily transcending what is often referred to as "northern pain."

Perhaps this project is really about resistance and the various guises of it that James C. Scott theorizes about in his book, *Domination and the Arts of Resistance,* or my man Robin D. G. Kelley presents so eloquently in his work *Race Rebels.* I began this project, in part, to counter assertions by the "hip-hop" generation that hip-hop was the first form of black music to "speak truth to power" or in the language of contemporary black youth, the first form of black music to "keep it real." My own memories of listening to Nikki Giovanni's *Truth is on the Way,* a recording of her poetry intertwined with the gospel singing of the New York Community Choir, suggested otherwise. Thus my intention was to link contemporary hip-hop to the protest tradition of the 1960s, but also to examine the nuances of black communal critique as reflected in the pre–Civil Rights era of the late 1940s and 1950s and the post–Civil Rights/pre-hip-hop era of the 1970s and early 1980s.

Simply put, *What the Music Said* is largely an examination of the black popular music tradition of the past fifty years (bebop to hip-hop). I maintain that the black popular music tradition has served as a primary vehicle for communally derived critiques of the African-American experience, and that the quality and breadth of such critiques are wholly related to the quality of life within the black public sphere. Thus, as the quality of life within the black public sphere has eroded in the past three decades, both the quality and nature of black musical narrative were altered.

To support my thesis, I examine structural changes to and within the black community that affect both the aesthetic and narrative qualities of black popular music, beginning with the bebop era. I suggest that issues as diverse as migration patterns, the dearth or abundance of public venues, national and local political movements, black religious institutions, black youth culture, the corporate annexation of black popular culture, crack cocaine, class stratification within the black community, gender relations, police brutality, and the structural and economic transformation of urban spaces all help shape the nature of black popular music particularly as such issues affect community formation(s) within the African-American diaspora.

The crux of my thesis is, perhaps, best represented in the relationship of the Civil Rights/Black Power movements to the soul music tradition because music is, of course, generally regarded as the soundtrack of African-American demands for racial and social equality during the 1960s and early 1970s. I believe my project can be a welcome addition to African-American arts and letters, because it does attempt to link disparate types of black popular music into a broader common tradition largely rooted in African-American desire to create and maintain community. Despite the chronologi-

cal organization of the book, it is by no means a comprehensive examination of black popular music or the popular history of African-Americans over the past five decades. There are lots of artists whom I wish I could have examined in the context of this work, including some of my favorites like DJ Rogers, the Isley Brothers, Roberta Flack, Nancy Wilson (I own more copies of her recordings than of any other artist), Jimmy Scott, Walter Jackson, Al Green, Jeffrey Osborne, Phyllis Hyman, and Rakim. Rather, the book is a series of forays into the unique relationship between black popular expression and some of its historical determinants of the past half century.

This book was inspired more than thirty years ago in the South Bronx kitchenette apartment that my parents and I called home. It was there that I was introduced to the sounds of Aretha, Bobby "Blue" Bland, and Marvin Gaye. I didn't quite understand the hold that these sounds had on my father, as he sat entranced at the kitchen table, patting his feet, or how important this music was to his survival. Having had thirty years of reflection, I would like to think that this book serves as a tribute to the African-American capacity to survive, particularly the African-American working class of my parent's generation and the dislocated urban masses of our contemporary moment. But I also must acknowledge the intellectual works that my own work stands upon. Amiri Baraka's now-classic *Blues People* and Nelson George's *Death of Rhythm and Blues* were like children's building blocks, indispensable to my search for the history of this music, while Tricia Rose's *Black Noise,* Michael Eric Dyson's *Reflecting Black,* and Paul Gilroy's *The Black Atlantic* introduced me to the critical language necessary to interpret this music in a contemporary context.

I would first like to thank Bill Germano, editorial director at Routledge, for his interest in my project, as well as Gayatri Patnaik, Nick Syrett and production editor Brian Phillips for their timely responses to my many questions, general professional demeanor, and patience with a first-book writer.

Mad love and praises to the folks on the 10th floor of Clemens Hall on the campus of the State University of New York at Buffalo, who constitute the most progressive American Studies department in the country. Thanks especially to the late Larry Chisolm, Charlie Keil, and Francisco Pabon, who read various drafts of this project during the incubation period. Much love, respect, and thanks to Dr./sista/warrior/mentor Masani Alexis DeVeaux for her constant praises, valuable counsel, and refusal to allow me to succumb to lowered expectations both within and beyond the Academy. She is included among a small cadre of committed, determined, and stern black women teachers—the only black teachers I had in more than twenty years of formal schooling, including my grade-school teachers Ms. Goodine, Ms. Riley, Mrs. Armstrong, Mrs. Phipps, and Mrs. Karr—who all inspired me to intellectual and scholarly heights.

A shout out to brother/Rev./Dr./homeboy Michael Eric Dyson for taking an interest in a brother's career and challenging me by setting an incredible example, to take my work to another level. Truly, as so many black minds have been dispersed across the nation at various institutions, I have been tremendously helped by those among the black intellectual elite who shared their insights and experiences with me. First I'd like to thank Tricia Rose, who sat down with a brother at the 1992 MLA convention in New York City and gave me some serious focus. Also, mad thanks and homeboy praises to Robin D. G. Kelley who responded to a few of my letters and agreed to let me interview him for my radio program *Soul Expressions*. Many thanks to Cornel West, Manning Marable, Manthia Diawara, Michelle Wallace, Farah Jasmine Griffith, Jill Nelson, William C. Rhoden, and Greg Tate for their advice and insights at various stages of this project and my career. I also thank Lemuel Berry, president of the National Association of African-American Studies (NAAAS) and the rest of the executive board for providing me a fertile intellectual community to plan and grow. Also props, to my man

Mwalima Shujja, who actively embodies the serious scholar engaged in serious pedagogy and community activism.

Many thanks to those institutions that supported my work these past years, especially the Office of Public Service and Urban Affairs at the State University of New York at Buffalo and the Office of Special Programs at the State University of New York for bestowing upon me the Arthur Alonzo Schomburg Fellowship for graduate study. Special thanks to the University of Pittsburgh at Bradford and my many friends there, whose vision and support allowed me to become the campus's first Predoctoral/Cultural Diversity Fellow. Also thanks to the graduate program at SUNY—Fredonia for its early support of my graduate studies. Many thanks to Linda Phillips of the School of Music for allowing me to share the germs of this project with her students, as well as thanks to Robert Jordan for being the model of professionalism and giving me my first view of a black male academic. Also thanks to the school's director, Peter Schoenbach, for his friendship and advice.

I earned two degrees as well as my first college teaching gig from the English department at SUNY—Fredonia and would like to thank everyone in the whole department for their role in my intellectual, professional, and personal development, especially Minda Rae Amiran for her insights and humor, Steve Warner for his willingness to serve as my sounding board, Pat Courts for his extreme honesty and frankness, and Karen Mills-Courts for her enduring praise and initial faith in my talents as a struggling undergraduate. Also thanks to Ted Steinberg, Andrea Hererra, George Sebouian, and Mac Nelson for their support. Also props to former chairperson Ronald Ambrosetti, who held out higher expectations for me throughout my academic and professional careers. I especially have mad love and respect for my homegirl Janette McVicker, who introduced me to the intellectual terrain I now inhabit and celebrated every one of my successes as if they were her own. No student could expect more from a teacher; no colleague could expect more from a peer. I would also like to recognize Kathleen Bonds and Barbara Yochyum and the rest of the Educational Development Program's family for their support and use of their resources. Also shout outs to Tom Malinoski, Jon Kraus and family, Peter Sinden, Mike Conley, Patricia Feraldi, Colin Plaister and the staff of the Chautauqua day-care center for their friendship and support. Many thanks to the Lababera and Slaton/Torrain families for breaking and sharing bread with a struggling scholar and his young wife. I also have mad, mad love for my big brother Dr. Julius Adams, who allowed me to make so many mistakes without a hint of criticism, but was always the first to congratulate me for the successes. I am very happy that we have been able to share friendship along with our victories.

I would also like to thank the staff and proprietors of the Upper Crust Bakery in Fredonia and the CC Coffee House on Carrolton Avenue in "Nawlins," Louisiana, where I drank more than five hundred cups of coffee and

wrote nearly two-thirds of the first and second drafts of this book on my laptop computer. By the way, major props to Toshiba; it took a licking and kept on clicking. Major props to Dan Bergerren and the staff and board of WCVF-FM, especially my man Perry Albert, for allowing me incredible programming autonomy for my two shows, *Soul Expressions* and the *Sunday Morning Conversation,* both of which were integral to many of the ideas that I examine in this text. I especially want to thank the many folks who agreed to appear on the *Sunday Morning Conversation,* including filmmaker Madison Davis Lacy, the Rev. Calvin Butts, and artist Gino Morrow, but in particular Samuel Floyd of the Center for Research in Black Music in Chicago, music professor Michael Woods of Hamilton College, pianist Onaje Allan Gumbs, Amiri Baraka, and saxophonist Lou Donaldson, for providing me a much deeper understanding of black music in public spaces. Major praise to the "Upstate Flavor" posse of Gary White, Rod Jones, Maurice Gantt and Damil Allah, for making it easier for me to keep a pulse on the hip-hop nation. Peace and love to the past and present members of the Genesis Project who formed my artistic family these past few years, especially Staci Turner, Monika Perry, Andre Chambers, Jay Goff, and Lamont Ford, who reminds me why it was so important for me to become a teacher. I would also like to acknowledge my current colleagues at the State University of New York at Albany, in particular poet and administrator extraodinaire Leonard Slade, Marcia Sutherland, Kwado Sarfoh, Allen Ballard, Carson Carr, secretary supreme Ronnie Saunders, and my graduate assistant Shuray Merriweather. Also I would like to thank my current and former students at the University of Pittsburgh at Bradford and SUNY—Albany and mad love to my former students at Xavier University in New Orleans.

I would like to take this opportunity to thank the Paul family, especially daddy Frank Paul Sr., for introducing to me to the serious jazz that his son didn't want to listen to, to mama Alice Paul for her support, to Sonja for willingly sharing her husband's time with me and her home with my wife and me, Ms. Imani Olivia Paul for the smile that her godfather so appreciates, and the late Violet Paul, who embraced me as one of her own. Mad, mad, mad love and praises to Frank Paul Jr., who is my brother, best friend, confidante. May our game of one-upmanship continue to produce the crazy success it has thus far. Love and kisses to my goddaughters Ms. Iavanna Farrell and Crystal West. Much love and praise to my in-laws Willie B. and Odessa Taylor, for their beautiful daughter, their generous support, and "not asking me 'what do you do for a living?' " Thanks to Wesley Taylor for his friendship and support. Mad, mad love and props to Thomas and Joiel Alexander and family, for their intervention into my life and their continued commitment to young folks like my wife and me. A big up to Gopal Burgher, esq., and Denice Davidson for their love and concern. Peace and love to my sista/warrior/ Dr./New Orleans homie Darnetta Elaine Bell, the diva among divas.

Peace and love to the Lee and Defreitas families and the irrepressible Ms. Linda Ford. Mad love for my "little" brother and one of Mobile, Alabama's finest products, Sebastian Tate, and his wife, Jiann, and son. I also have mad love for my other "little" brother, protégé, and hero, Charles C. Banks, and the lovely Monica Brown for their support, love, and attic space. Also much love to my "aunts" Mariah White and Muriel Bolding, for their undying love, support, and concern. Peace to the Neal, Murray, and Robinson clans in Baltimore, New York City, Danbury, and elsewhere.

Finally I would like to thank my parents, Elsie and Arthur, for wishing a world better than theirs and granting a future that would transcend all of their hopes and prayers. I thank Elsie for holding up tremendous expectations for me and submitting herself to the same academic struggles she inspired me to pursue. I thank Arthur for all those Sunday mornings with the Mighty Clouds of Joy, the New York Mets, and for letting me give meaning to the world he created via music. It goes without saying that my wife, Gloria Taylor-Neal, is my biggest supporter, critic, and counselor. It's a full-time job, and I thank her for her willingness to put up with my mercurial personality, sloppiness, now-legendary snoring habits, and my mistress: my work. Brilliant and talented in her own right, she often prefers hiding in my shadow, though her love and commitment to me and her students shines brighter than any of the bright lights that I crave, and in that I have been blessed.

Mark Anthony Neal
February 1998

Start

Toward A Black Public: Movement, Markets, and Moderns

It has been a long time now, and not many remember how it was in the old days; not really. . . . Neither do those remember who knew Henry Minton, who gave the place his name. Nor those who shared in the noisy lostness of New York the rediscovered community of the feasts, evocative of home, of south, of good times, the best and most unself-conscious of times, created by the generous portions of Negro American cuisine the hash, grits, fried chicken, the ham-seasoned vegetables, the hot biscuits and rolls and the free whiskey. . . . They were gathered here from all parts of America and they broke bread together and there was a sense of good feeling and promise.

—Ralph Ellison

Time. Memory. Movement. Ellison's "Golden Age, Time Past" that, with the glide of his pen, creates a Harlem and a Bebop Revolution scarcely remembered. After nearly three decades of a groundswell of midwestern and southern migration, Harlem—illustrious and ironic icon of the twentieth-century Negro—was coming apart at the seams. More than one million blacks would migrate from the South and the Midwest during the first four decades of the twentieth century, and Harlem was perhaps the most popular destination.[1] Part innovation, part accident, Harlem was the twentieth-century prototype of black public life in the urban North. The Black Public Sphere, with its requisite examples of black church and civic organizations as well as barbershops, beauty parlors, and dance halls, was best realized by Harlem.[2] Many of the institutions that constitute the Black Public Sphere have been invaluable to the transmission of communal values, traditions of resistance, and

"the Black Public Sphere" (BPS)

the Harlem of the early 2000s

aesthetic sensibilities. As Katrina Hazzard-Gordon suggests in her work on black social dance in the urban North, institutions like the jook, the honky-tonk, and the rent party—all integral to the formation of narratives of social and political resistance to the African-American diaspora—were attempts to re-create the covert social spaces of the South,[3] spaces that afforded safety, sustenance, and subversion among the black masses in the Deep South.

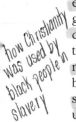

trying to create safe spaces after migration

The initial development and maintenance of covert social or "safe" spaces of the antebellum South are at the core of the black critical tradition in America. Given the oppression and repression of blacks, black critiques of American society can best be understood in the context of what James C. Scott has identified as "hidden transcripts." These transcripts have historically accented an underground resistance in which "signifying" and double entendre played major roles. The most crystalline examples of these underground critiques are seen in African-American spirituals during the era of chattel slavery. Though often interpreted as African-American submission to the God of the dominant culture, these spirituals often functioned as coded messages that called for blatant acts of resistance. In the period of the antebellum South, the hidden transcripts of black culture found expression in the slave quarters, in the church, and most notably and brilliantly in the field under the watchful eye of the overseer. Geneva Smitherman relates in *Talkin and Testifyin,* "The slaves used other-worldly lyrics, yes, but the spirituals had for them this-world meanings. They moaned 'steal away to Jesus' to mean stealing away FROM the plantation TO freedom (That is, 'Jesus'). They sang triumphantly "this train is bound for Glory," but the train they were really talking about was the "freedom train" that ran on the Underground Railroad."[4] Smitherman's comments at once highlight the African slaves' efforts to transcend both space and time—ultimately the primary existential issues facing the African-American modern—through the creation of metaphoric landscapes rooted in literal communal efforts to subvert unacceptable conditions. These modes of expression or hidden transcripts enabled the enslaved Africans to mediate and negotiate their way through hostile linguistic and social terrain. Scott describes the major characteristics of such hidden transcripts in this way:

how Christianity was used by black people in slavery

physical + verbal tools of resistance

First, the hidden transcript is specific to a given social site and to a particular set of actors.... Each hidden transcript, then, is actually elaborated among a restricted "public" that excludes—that is hidden from—certain specific others.... A second and vital aspect of the hidden transcript that has not been sufficiently emphasized is that it does not contain only speech acts but a whole range of practices. Thus, for many peasants, activities such as poaching, pilfering, clandestine tax evasion, and intentionally shabby work for landlords are part and parcel of the hidden transcript.... Finally it is clear that the frontier between the public and the hidden transcripts is a zone of constant struggle between dominant and subordinate—not a solid wall.[5]

"weaponized" "incognito" tence"

As noted above, the mode that black expression takes is often predicated on the proximity of the dominant sphere at any given time and place. Thus those who produced "subversive" transcripts had to be keenly aware of the physical terrain they negotiated. The need to create and maintain covert social spaces as a means of building and maintaining community becomes an enduring force within the African-American diaspora that finds its logical manifestations in the institutional development of the black church and the centrality of the black oral, musical, and literary traditions as natural organs for the transmission and distribution of counterhegemonic narratives. The above factors ultimately ground diasporic efforts to create independent black institutions during the post-Reconstruction period and in part incubate the development of a black nationalist/capitalist ideology well into the twentieth century.

*The Roots and Early Manifestations
of the Black Public Sphere*

The dismantling of chattel slavery created the conditions for the emergence of a black "public." I focus on this newly constituted public not to diminish the significance of the free black "community" that existed before the Emancipation Proclamation or the very real physical and psychic constraints placed on black public life well into the twentieth century, but rather to highlight the relationship between emancipation and the creation of public spaces in the reconstructed South. Despite a viable and somewhat visible free black community—free blacks like Henry Highland Garnet, Sojourner Truth, and in particular Frederick Douglass played invaluable roles in the emancipation of blacks within the realm of public discourse—blacks were largely denied access to American public life, because their legal status, as commodities, denied them citizenship. The subsequent emancipation of blacks gave them a new legal status but did little to lift them from the bottom of America's social hierarchy. *by legal rights, black ppl were now citizens*

The Emancipation Proclamation allowed the conditions for the development of black public life and a philosophy of black public life, which ultimately informs the black political and intellectual traditions of the twentieth century. Crucial to this discourse—and this is particularly evident during Reconstruction—was the notion that blacks had been extended full American citizenship, despite the reality of their social status. The fact that this perceived citizenship is extended, at least in this historical moment, only to black men supports the thesis that many of the early institutions of the traditional Black Public Sphere are constructs of black male discourse. Many of these newly acknowledged institutions would inform the creation of the Black Public Sphere in the urban North during the late nineteenth and twen-

"subversive transcripts"

the connection b/w BPS and emancipation

of course there is still a gender bias

tieth centuries and indeed, as Farah Jasmine Griffin suggests in her work, become safe havens for black male agency.

Despite the visibility of a black public, black mobility, expression, and commerce were still constrained by the dynamics of legal segregation, white supremacy, and threats of physical violence. Such constraints are particularly evident with the collapse of Reconstruction initiatives and the commencement of post-Reconstruction America, events that shaped the spatial and functional logic of the traditional Black Public Sphere as a segregated, thus isolated, province of black interests. In this regard, the creation of covert, yet public, social spaces, became an unvarying desire among black masses during the late nineteenth century. During the post-Reconstruction era, the rudimentary elements of the traditional Black Public Sphere are perhaps most evident in the development of the black church and formal and informal institutions of leisure like the juke joint, or "jook."

The emergence of the black church as one of the most visible and effective distributors of black critical discourse follows the social and cultural logic of pre–Civil War black communities. African-American acceptance or appropriation of Christian ideology allowed the black spiritual tradition to develop with relative autonomy, since Christianity was generally perceived among the white elite as a positive socializing force. The singular presence of the black Christian tradition within the context of plantation life allowed blacks to instill within the tradition and the institutions that promoted the tradition, narratives of resistance and critique, even as such narratives were largely shrouded in African and African-American rhetorical practices. Furthermore, the church pulpit emerged as a natural conduit for black male sensibilities, which were singularly represented in the oratory tradition of the black minister. My intent is not to construct the black church as solely the domain of black male influence or to discount the invaluable presence of black women in the painstaking practice of church building and maintenance,[6] but rather to give insight into the image of the black church, at least within public discourse, as a place where black women were constructed as objects of black male political and spiritual aspirations.

This public image of the black church is one that contradicts the realities of the black Christian tradition; the same could be said of the political nature of the black Christian tradition, vis-á-vis mainstream America's perceptions of black Christian practices. In this regard, the Black Public Sphere is constructed and must be understood as alternative or even counter to the dominant or mainstream American Public Sphere. It is public in that it represents the congregation of numerous blacks at any given time in a communal setting, but still removed by force and ultimately choice from the mainstream public. As W. E. B. Du Bois would say at the beginning of the twentieth century, the traditional Black Public Sphere existed very much as a veil. This, despite the fact that much of the liberal tradition that emerged within the black church and became increasingly the dominant narrative within the

? Ppl wanted the ~~real~~ veil to be lifted? why?

Black Public Sphere during the mid-twentieth century, argued for the dismantling of the formal Black Public Sphere and full integration into mainstream American public life. The Black Public Sphere had been largely predicated on the realities of segregated housing, a reality legalized with the Plessy vs. Ferguson Supreme Court decision of 1896, which parlayed "separate but equal" status as a rubric of racial coexistence.[7]

Evelyn Brooks Higginbotham illustrates both the role of the black church and the larger function of the Black Public Sphere in her examination of the Black Women's Club Movement. Higginbotham writes:

everyone black

to black churches were open to

By law, blacks were denied access to public space, such as parks, libraries, restaurants, meeting halls, and other public accommodations. In time the black church—open to both secular and religious groups in the community—came to signify public space. It housed a diversity of programs including schools, circulating libraries, concerts, restaurants, insurance companies, vocational training, athletic clubs—all catering to a population much broader than the membership of individual churches. The church served as meeting hall for virtually every large gathering. It held political rallies, clubwomen's conferences, and school graduations.... The Church also functioned as a discursive critical arena—a public sphere in which values and issues were aired, debated, and disseminated throughout the larger black community.[8]

the black Church came to signify everything for black communities

Central to the function of the black church as the quintessential institution of the Black Public Sphere, if not a truncated representation of the Black Public Sphere in its own right, was its embodiment of the basic tenets of American democracy. This would only be natural, given that the traditional Black Public Sphere was largely created at a moment when African-American investment in American democracy was most profound, in the aftermath of post–Civil War civil rights legislation. In fact the black church, and by extension the Black Public Sphere of the mid- to late nineteenth century, became the site of a radical democracy that openly critiqued and transformed notions of American democracy.

Though American women were not extended voting rights until the early twentieth century, democracy within the Black Public Sphere was perceived as a broad-based right of all of its constituents. Thus it was not unusual during political meetings at churches for a full contingent of representative views to be expressed, encompassing all gender, class, and age sensibilities.[9] In such a context, black male votes were generally considered communal property. Elsa Barkley Brown writes, "African American women and men understood the vote as a collective, not an individual possession; and furthermore, that African American women, unable to cast a separate vote, viewed African American men's vote as equally theirs."[10] Unlike mainstream concepts of representational voting, African-Americans often viewed the franchise as something that was communally derived. Even with the dismantling of the reconstructed South and the subsequent constraints placed

we know that this prob wasn't true. issue of "one voice for all"

black respect

on African-American expression, critique, and voting rights, for that matter, both externally and internally, the franchise as conceived both within and beyond the Black Public Sphere remained a valued ethic in the black community. As Brown suggests, the franchise, as conceived during the early manifestations of the Black Public Sphere, was defended with the same fervor within black public spaces as Jim Crow laws and antilynching legislation were contested outside of those same spaces.

To a large extent the black church, despite the economic diversity contained within it, privileged the sensibilities of the liberal bourgeois, in that the liberal bourgeois establishment provided the most likely conduit for African-American integration into American public life. It is not my intention to characterize the totality of the black church tradition in this way, but rather to highlight the general privileging among African-Americans of bourgeois models within the black community. The liberal bourgeois model functioned within the Black Public Sphere as a formalized and public expression of African-American political and social sensibilities, that by definition would create alternative and informal spheres of expression and critique. For example, the pursuit of leisure spaces would at once help to incubate traditions of expressive culture, particularly the popular music and dance traditions, and provide cultural spaces for spiritual catharsis and other forms of limited transcendence, that served as alternatives to more bourgeois social spaces.

In the era when leisure time and mass consumer culture were still foreign to the sensibilities of the American working class, the overt and aggressive pursuit of leisure, except during holidays and special occasions, was generally acknowledged as transgressive behavior among blacks. Thus the jook functioned as an institution that was perceived as transgressive in its very nature and the antithesis of the black church when compared to more bourgeois sensibilities. The jook presence, particularly as an incubator and distributor of black expressive culture, would portend the emergence of such institutional icons as the Apollo Theater and the Savoy Ballroom in Harlem in the early twentieth century. Hazzard-Gordon writes of the jook-joint:

> Precisely because gatherings of slaves or free people of African descent were illegal, slavery fostered black social institutions that defied white control, and thus helped create a recurrent pattern of covert social activity. During the post reconstruction era, African-Americans saw a need—and an opportunity—to relocate the clandestine social activities and dances of the plantation days. Their freedom, the reorganized labor system, and their cultural past determined the shape of the first secular cultural institution to emerge after emancipation—the jook. Like the blues, the jook gave rise to and rejuvenated a variety of cultural forms.[11]

Within this context, the jook-joint emerges as a site of resistance not privileged by the discourse of the black church and very much in contest with the

Presents two opposing ideologies

this idea of one or the other emerging again: the church or the jook

black church as a vehicle for black expression. It is important to remember that the jook-joint, beyond its role as a covert social space, also regenerates the tradition of black expressive culture particularly within the domains of popular music and dance. These were of course forms that were intensely constrained during chattel slavery, except for the entertainment and controlling purposes of the ruling elite of the South.[12]

In the post–Civil War era the appearance of the jook, however covert and secretive, highlights developing class schisms within black public spaces. I do not mean to construct the black church and the jook as binary opposites that can be reduced to the sensibilities of the black liberal bourgeois and the black working class respectively, but again to highlight the public construction of these institutions vis-á-vis the dominant culture's perceptions of black public life. Within this construct the black church and, by extension, the black liberal bourgeois served the purpose of defining the scope and limits of black social and political culture. Institutions like the jook openly contested the role and vision of the black church. These conditions produced, like those within the black church, an intensely valued democracy that was largely predicated on the spatial parameters imposed by legal segregation. The tension associated with the contesting of the scope and dynamics of black public life perhaps are most visibly articulated during the Harlem Renaissance and the debates over the content and imagery of black arts production.[13]

repeated phrasing

the church and the juke were not supposed to be binaries

The development of the jook in the early stages of black public life in the urban North is an ideal site to examine the significance of public spaces of leisure within the Black Public Sphere. The Tenderloin district in New York is perhaps most representative of the rudimentary Black Public Sphere in the urban North, while the honky-tonk became the first urban manifestation of the juke joint in the urban North.[14] The early development of these community institutions were predicated on a black presence in New York City as far back as the initial Dutch settlement of New Amsterdam in 1626. Included among this population were eleven African bondsmen, the first blacks to settle in New York City. These eleven African bondsmen would be manumitted in 1644—twenty years before the Dutch would surrender New York City to the English—and thus lay the foundation for a free black society that would coexist with the institution of slavery until gradual emancipation was granted in the state of New York in 1799 and full emancipation in 1827. The presence of a free black society would guarantee more than two hundred years of relative autonomy for some blacks and instill traditions of resistance and dissent within the free black public.[15]

By no means representative of the full range of community institutions that frame the concept of the Black Public Sphere, the black bohemia of New York's Tenderloin district provides an example of the informal spaces that support an illicit underground economy, the incubation of honky-tonk and

ragtime music, and a fleeting catharsis from the demands of an expansive urbanization project. James Weldon Johnson writes of the Tenderloin:

> This black Bohemia had its physical being in a number of clubs—a dozen or more of them well established and well known. There were gambling-clubs, honky-tonks, and professional clubs. The gambling clubs need not be explained. The honky-tonks were places with paid and volunteer entertainers where both sexes met to drink, dance, and have a good time; they were the prototype of the modern night-club. The professional clubs were particularly the rendezvous of the professionals, their satellites and admirers. Several of these clubs were famous in their day and were frequented not only by blacks but also by whites.[16] *intergrated spaces*

The impact and vitality of New York's black bohemia is perhaps best captured through the narrator of Johnson's *Autobiography of an Ex-Colored Man,* a mulatto who resolves the ambiguity of his racial heritage, however briefly, through the sounds of ragtime that he both hears and later plays in clubs like Barron Wilken's Little Savoy. Johnson's narrator states:

> It was a music of a kind I had never heard before. It was music that demanded physical response, patting of the feet, drumming of the fingers, nodding of the head in time with the beat. The barbaric harmonies, the audacious resolutions, often consisting of an abrupt jump from one key to another, the intricate rhythms in which the accents fell in the most unexpected places, but in which the beat was never lost, produced a most curious effect…. This was ragtime music, then a novelty in New York, and just growing to be a rage, which has not yet subsided. It was originated in the questionable resorts about Memphis and St. Louis by Negro players who knew no more of the theory of music than they did the theory of the universe, but were guided by natural musical instinct and talent.[17]

Within this framework, Johnson equates blackness with the rhythms of ragtime music in the urban North, highlighting the seminal role that music plays in the construction of community within the African-American experience. The narrator's acknowledgment in the closing moment of Johnson's novel, having chosen to pass as a white man—"I sometimes open a little box in which I still keep my fast yellowing manuscripts, the only tangible remnants of a vanished dream, a dead ambition, a sacrificed talent, I cannot repress the thought that, after all, I have chosen the lesser parts, that I have sold my birthright for a mess of pottage"[18]—further highlights the centrality of music in the formation and functions of community but also posits the black popular music tradition as a nuanced site for economic and social sustenance within a post-Reconstruction urban landscape.

Despite the impact of music and leisure spaces within late-nineteenth-century urban spaces and the seminal role of the black church in both south-

music was a good way to gain social standing amongst black people

black journalism beginning to flourish

ern and northern manifestations of the early Black Public Sphere, the radical democratic tradition found its most vital presence in the cadre of black journals and newspapers that were allowed to flourish because of the presence of a relatively free and autonomous black public in New York state and elsewhere, prior to emancipation. The appearance of *Freedom's Journal* in 1827 signaled the reality of a structured and organized resistance to slavery in the United States among New York blacks. *Freedom's Journal* was in fact the first black newspaper in the United States; its founder and editor, John B. Russwurm, was the first black to graduate from an American college. Russwurm, along with New York contemporaries Dr. James McCune Smith and the Rev. Henry Highland Garnet ushered in the initial era of the free black press and established the critical and intellectual traditions that Frederick Douglass's *North Star* embraced two decades later and that the *Chicago Defender*, the *Pittsburgh Courier,* and the *Crisis Magazine* represent well into the twentieth century. Though these narratives were distributed to a mostly fractured and isolated black public in the North prior to emancipation, the free black press would be energized by the post–Civil War presence of black public spaces that emerged initially in the South and later in the urban North. Within these parameters, the black press and black popular music surfaced as the primary sites of public expression, in which communal critique played a central if not dominant role.

Post-Reconstruction and Black Public Life

The post-Reconstruction era of the 1880s and 1890s saw the beginning of a process that Gerald Early describes as a battle to locate a "usable American past"—a past in which the civil rights gains of African-Americans would at best be eroded and at worse obliterated.[19] Central to this political landscape were calculated attacks on black public formations and black public rhetoric. At the culmination of the nineteenth century, African-Americans were faced with common threats of physical violence against them; more than 1,600 blacks were lynched in the decade that closed the twentieth century. This new political terrain regarding the "Negro" question in this era would more than explain the resurgence of pre–Civil War white nostalgia in the South and the emergence of Booker T. Washington as the titular leader of the Negro race. In 1895, at the very moment that Booker T. Washington announced his policy of accommodation in regards to the "Negro" question, many whites were re-creating the mythic South, through music and stage shows produced largely by black artists. I maintain the body of black cultural production that appears in the late nineteenth century in the form of musicals like *The Octoroons* and *A Trip to Coon Town* and sheet music like Ernest

wildly racist behavior from white people

T. Hogan's popular "All Coons Look Alike to Me," are no different from the "gangsta rap" narratives that emerge in the late twentieth century in part because of popular culture's presence in black working-class mobility narratives.[20] As late-nineteenth-century America longed for the pre–Civil War era—a nostalgia that blurred the reality of America's past in lieu of an imagined one rife with constructions of an homogeneous citizenry whose fictional presence countered that of immigrants and blacks alike—late-twentieth-century America nostalgically longs for its pre–Civil Rights era. The commodification of black dysfunction, both real and imagined, is a centerpiece in this nostalgia and ultimately aims to freeze African-Americans in a usually precarious moment in their communal history. Because of precarious economic conditions, African-Americans are often forced to be complicit in their own demonization by producing commercially viable caricatures of themselves.

forced to present themselves as the public viewed them

The social and political narratives and counternarratives of blacks in America, best exemplified by the publication of W. E. B. Du Bois's *The Souls of Black Folk* in 1903, were countered by the publication of texts like Thomas Dixon's *The Clansmen* in 1904. Dixon's *Clansmen* represents the quintessential example of the type of popular fiction that attempts to rewrite the history of the American South and freeze the African-American community onto a pre-emancipation landscape. A cinematic treatment of Dixon's novel appears in 1915 in the form of D. W. Griffith's *Birth of a Nation*. In many regards, these tensions were part and parcel of the industrial restructuring of America, a scenario in which the urban North became the dominant site of industrial production within the country, with black flight from the South coinciding with black encroachment of mainstream spaces in urban centers.

in many ways the black community was always politicized

The New York riot of 1900, which ravaged the Tenderloin district, served to politicize the black community within New York's urban spaces in ways that would impact black political and social discourse for three decades. Black New Yorkers of the era could not forget that in the midst of the 1900 riot white lynch mobs made open calls for the heads of hugely popular figures like entertainers Bert Williams and George Walker. The national visibility of the 1900 riot and the continued violence of the South further politicized blacks generally and the black press in particular.

In the aftermath of the riot, New York stalwarts like the Rev. William H. Brooks, businessman James E. Gartor, and newspaper editor T. Thomas Fortune organized the Citizens Protective League. The league served as a precursor to the many civic and political organizations that helped define the scope of the Black Public Sphere in the twentieth century. The league's clarion call for justice and public acknowledgment of the legal rights of blacks as citizens reinvigorated notions of black public life left dormant during the post-Reconstruction era. The publication of Du Bois's *The Souls of Black Folk* and the later development of the NAACP and Urban League were large-

seeking protections for black lives

ly inspired by a new era of black public discourse, largely dedicated rhetorically and institutionally to the protection of public life within the Black Public Sphere. Thus the dismantling of segregated spaces and passage of antilynching legislation were central texts within black public discourse.[21] The integrating of the marketplace also became a basic tenet of the new public discourse of the early twentieth century, though the settling of Harlem in the early twentieth century was largely influenced by "New Negro" notions of black capitalism and nationalist autonomy that were often at odds with public pronunciations championing integration.

Like earlier formations of black public life in South, the burgeoning Black Public Sphere of the urban North, as represented by Harlem, privileged the political and social discourse of black men. In the midst of voracious attacks on black civil rights during the post-Reconstruction era, black women like Anna Julia Cooper, Mary Church Terrell, and Ida B. Wells-Barnett offered trenchant critiques of the African-American condition. These voices are largely supplanted by black male discourse within the newly constructed black public formations of the early twentieth century. Despite this, the hyperdemocratic tendencies of black communal life instigated the formation of vibrant and articulate counterpublics—the National Association of Colored Women (NACW) is a prime example—that are as much a part of the Black Public Sphere of the urban North as the liberal bourgeois model appropriated by the black male elite. The reinvigoration of black public life in the North, in concert with the continued erosion of the quality of black life, public and otherwise, in the American South provoked a steady migration of blacks from the rural South to urban spaces both within the North and border states that would reach its peak in mid-twentieth-century America. This migration would radically change the nature of African-American life in general, and specifically help shape the urban Black Public Sphere as we know it.

increased migration despite the violence

Migration, Industrialization, and The Black Public Sphere

The emergence of W. E. B. Du Bois and the publication of his text *The Souls of Black Folk* in 1903 reflected the growing sentiment of a restless constituency ready to challenge the realities of Jim Crow America. Du Bois's career and training inform the increased influence of the "New Negro," here constructed as a northeastern, urban, middle-class elite, dedicated to creating public spaces in the urban North to affirm black cultural expression, black commerce, and black political aspiration. Underlying the development of the "New Negro" were sharp critiques of the meaning and legacy of the American South. The "New Negro," largely the construct of black male

appropriations of the liberal bourgeois models of public life, was the antithesis of black southern sensibilities, premised on threats of racial violence, political suppression, and sustained misery among the black masses. The public emergence of the "New Negro" championed the promise and possibilities of the urban North, but also the dismantling of the southern foundations of and influences on African-American culture.

Economically, the industrialization and urbanization of northern cities stimulated the development of an urban-based working class. Working-class identity was not only constructed in terms of the spatial sensibilities of the new urban terrain but also by access to mass markets. Thus for a burgeoning American working class, their Americanness—and this was particularly true for many European immigrants—was confirmed by an active engagement with mass consumer culture.[22] Within this context, African-American migration is characterized as an effort to integrate mainstream American public life. Indeed as early as 1914, the *Chicago Defender*, urged blacks to sever their relations with the American South and the soil that so enveloped the African-American condition for more than two hundred years. This latter severance is important in that black identity in the post-Reconstruction South was largely defined by the subtle humiliation of sharecropping and the sheer physical violence associated with the new political terrain of the South. Thus the American North, as constructed by the *Chicago Defender* and the narratives of the "New Negro," represented the possibilities of full citizenship for those who accepted the challenge. Such narratives, along with demands for an inexpensive industrial workforce in the urban North, and natural calamities like the boll weevil would inform the more than one million black migrants who traveled to northern urban centers like New York, Chicago, and Detroit in the first four decades of the twentieth century. Ironically, it would be the assertion of black southern culture in the urban North, what Farah Jasmine Griffin calls "South in the city,"[23] that would largely define the functions and logic of the Black Public Sphere in the urban North.

The Black Public Sphere in the urban North and the mass migration that facilitated its development highlight the diasporic nature of the African-American community. While the term *diaspora* has historically been linked to the disparate relations among global Jews and more recently linked to the global dispersion of African peoples, including the African-American community, I maintain that black migration patterns during the twentieth century represent the development and construction of an African-American diaspora. At the core of this newly defined diasporic construct were challenges to maintain community and distribute communal sensibilities across the chasms of distance and dislocation. Within this context, the concept of "movement" emerges as a primary trope of African-American political and cultural expression in the twentieth century. In his text *Keeping Faith,* Cornel West suggests that the major themes of twentieth century black life are "nei-

(margin annotations: reconstructing black identity away from the South; African-Americans are a diasporic people)

ther integration nor separation but rather migration and emigration."[24] Thus the quest to create safe havens and the geographic movement associated by such quests further problematize the maintenance of communal relations within an increasingly diffused communal base. Within such a context, entities as diverse as the black press, the railroad system and its cadre of black Pullman porters, and the urban blues tradition emerge as primary networks for the distribution of critical expression across the African-American diaspora. *these forms of comerce focus on travel and can be traveled with/on*

In 1910, W. E. B. Du Bois came to New York to begin his stewardship as editor of the NAACP's journal, *The Crisis Magazine. The Crisis,* like many other print organs in the black community, became a primary source of information for the African-American community at large. The quality of northern print organs like the *Chicago Defender* and the *Pittsburgh Courier,* gave these periodicals a clientele that crossed geographic boundaries.[25] With the commencement of the "Great Migration," these organs solidified their singular roles in the network of African-American communal relations. At the height of the Great Migration in the '30s and '40s, writer Roi Ottley could boldly assert that the "Negro press is the most loudly impatient agency for immediate, fundamental change in the status of the race ... it is the Negro's most potent weapon of protest and propaganda."[26] *The Chicago Defender* would go as far as to name May 15, 1917 as the official commencement of the Great Migration. Such an effort simply acknowledged the role that the black press played in stimulating interest in the urban North. *the press was a major source of info regardless of location*

The black press had a rich history of incubating political resistance since the arrival of John B. Russwurm's *Freedom's Journal* in 1827. The centrality of the printed word was largely predicated on the relative lack of communication mechanisms that blacks could access. Radio was still a decade away from being a mainstay of mainstream American life, and television was nearly three decades away. The development of a visible and viable black press at once provided a valuable function within black life, while ideologically supporting the core narratives of the "New Negro" construct.[27] *he press was all ppl had at the time*

The real impact of the black press in the early twentieth century was revealed in the role of the railroad system and the black Pullman porters who served it. During the nineteenth century, the railroad represented the promise of freedom for many enslaved African-Americans. The narratives of Harriet Tubman and her famed "underground" railroad served not only as a tribute to Tubman's unbridled will for freedom but also acknowledged the presence of the steam engine as an instrument for freedom in the modern world—even if such a notion for nineteenth-century blacks remained largely allegorical. As the dominant mode of mass travel and a primary catalyst in the distribution of goods in the urban North, the railroad also represented access to the commercial markets that, in part, had come to define American identity. For the black men who served the railroad system as Pullman *idea of travel and things that can be carried*

the press and the railroad system
working hand-in-hand

porters, their jobs represented perhaps the best possible world for a new and emerging black working class. The railroad would indeed be the "Sweet Chariot" that delivered blacks into the promised land.

The Pullman porters, in concert with the railroad system, fostered an informal web of communication across the African-American diaspora. In an era when the distribution of black goods and services beyond the confines of segregated black locales was at best limited, the Pullman porters used their travels along the railroad system to distribute many goods from one region to another. The black press was one of the principal beneficiaries of this activity. It was not unusual for a Pullman porter to deboard a south-bound train with dozens of *Chicago Defenders* under his arms. This activity, however limited in scope, further enhanced the ability of the black press to facilitate critical exchanges across the diaspora.

While the crisis of African-American life in the South and mythical status of the promised land of the North remain substantial determinants in black migration patterns and the subsequent emergence of a full-scaled public life, several factors, some native to urban life, provide stimulus for Harlem's prototypical development as Black Public Sphere. Within this context, the notion of "South in the city" cannot be underestimated. Griffin states that "South in the city," particularly as reflected in the expressive arts,

> describes the migrants' initial interaction with the urban landscape as well as those remnants of the South which are retained by them. Representations of the former illustrate the artists' emerging concern with the migrant psyche and how it is influenced by changes in the experience of time and space. In this context, the "South in the city" is literally embodied in the migrant. The latter "South in the city" is embodied in spaces, rituals and belief systems which act to nurture or inhibit the urban protagonist.[28]

pitching "North" blacks
and "South" blacks against one
another

Thus the parameters of legal segregation in the urban North and the persistent need to create and maintain covert safe spaces allowed for an abundance of black southern culture in the North. The assertion of a black southern past does not occur, of course, without opposition. The notion of the "New Negro" was premised on the erosion of memory of a southern past. Within the liberal bourgeois model that dominate the discourse of black public life during the first two decades of mass migration, black southern culture and black southern migrants were caricatured, and portrayed as threats to the urbanity of black northern culture and the Black Public Sphere as constructed by the black liberal bourgeois. "South in the city" became one of the many counternarratives within black public life that undergirded the intense democratization of black public life.

The mass migration of the early twentieth century further cultivates the creolization of African-American Culture with the interaction and exchange

refers to the mass migration of Southern blacks to the Urban North

of northern and southern sensibilities. Also exemplified in the concept of "South in the city,"[29] this fusion nurtures the evolution of the urban blues and other forms of popular expression. Furthermore, the spatial logic of the industrial city—a city defined by sharp contours, shadows, crevices, basements, storefronts, rooftops, transformed kitchenette apartments, and so on—nurtured cultural sensibilities that thrive on the creation of covert social spaces and allow for the type of creolization that defines the artistic expression of the era. As the primary musical text of informal public institutions like the jook, rent parties, and after-hours clubs, the urban blues emerges as a secondary site for the dissemination of critical discourse within the African-American diaspora. Again, it is important to characterize these spaces as the site for alternative narratives or counternarratives to the liberal bourgeois narratives of the black church and mainstream black political leadership. Nowhere was this more apparent than the multifaceted functions of the rent party.

as opposed the narratives of the black bourgeois

On the most basic level the rent party addressed the economic disparities associated with segregated housing in urban life in the North. In an Urban League study done in 1927, almost 50 percent of the more than two thousand families surveyed reported spending twice as much of their income on rent in comparison to white families in New York. The Urban League study further illuminated that the average monthly rent in Harlem for a four-room apartment was $55.70 as opposed to $32.43 for the average white family renting the same-size apartment outside of Harlem.[30] This economic discrimination was particularly profound because the average monthly income for those same black families was $270 less than that of the white families. Within such a context, the rent party served a clear economic purpose for families struggling to meet their monthly financial responsibilities.

But the rent party also stimulated aesthetic developments within the African-American diaspora. As a public and participatory cultural space that encouraged artistic innovation, the rent party was an integral part of the creolization project that occurs during the period. The upright piano served as the primary apparatus of musical expression during the rent party. Piano giants like Willie The Lion, James P. Johnson, Fats Waller, and even Duke Ellington would visit and play after their gigs at well-known clubs were done, allowing them access to the emerging styles and tastes within a largely migrant working-class culture.[31] More compellingly, these spaces also allowed younger musicians, who in the spirit of the economic designs of the rent party could be paid a fraction of that paid to established musicians, an opportunity for much needed visibility and a context in which to take the necessary aesthetic risks to develop their own style in the presence of a demanding and discriminating public. Griffin suggests that many of the urban blues texts of the period document the reasons and possibilities of northern migration, while these texts also geographically located performers

and listening audiences attuned to the various regional manifestations of musical styles. Thus, popular performers at rent parties or in other leisure spaces were valued for their ability to conflate various regional styles, in effect creating a sound that would resonate across the diaspora. In this regard, the development of the urban blues contributed to the emergence of the black popular music tradition of the twentieth century.

The urban blues was ultimately important to understanding the scope and limits of the Black Public Sphere of the urban North, particularly given the centrality of black female voices, many of whom counteract the dominance of black male discourse within a black liberal bourgeois model of public life. Griffin writes of the urban blues:

> The blues provides an excellent metaphor for what happens to the migrants when they arrive in the city. In terms of content, blues lyrics focus upon the impact of city on the migrant. However, the form of the blues, the development of urban and city blues (as well as the development of gospel blues), and their subsequent impact on the forms of American music suggest that the migrants impacted upon the city as much as it impacted upon them.[32]

The commercial success of the urban blues has ramifications both within the aesthetic development of black popular music and in the appropriation of black popular music forms by white commercial entities to attract black consumers.

Technology, Mass Markets, and the Black Public Sphere

By the end of three decades of mass migration, many African-American enclaves in the North had been transformed into urban slums. Housing for blacks within the black urban spaces of the North was at a premium, not because of any inherent attractiveness, but rather because of the realities of legal segregation. James Weldon Johnson's assertion that "New York guarantees her Negro citizens the fundamental rights of citizenship and protects them in the exercise of those rights" betrays the reality of black public life in Harlem or any other black urban environment. While such assertions highlight the breadth of opinions maintained within black public life, they also indicate the significant chasms in black working-class and middle-class perspectives. The shape and form of black public exchange from the early to mid-twentieth century is a tribute to the black public's commitment to maintain civil critical discourse within the Black Public Sphere. By the early '30s, several entities would emerge that would forever threaten and ultimately change the realities of black public life in the urban North.

The success of the urban blues helped stimulate the development of the recorded music industry and the increased reliance on radio as the primary medium for the distribution of recorded music. Nelson George maintains in his influential work *The Death of Rhythm and Blues* that the appropriation and commodification of black music accelerated with the advent of the recording industry:

> The record industry began as the stepchild of the sheet-music business, since popular tunes originally were consumed primarily through the sale of sheet music. From World War I through the mid-1920's, advances in the technology permitted an explosion of record sales, causing music industry historians to dub this period the "golden age." Ragtime, highly syncopated piano-based music that sprang from the innovations of black composers such as Scott Joplin, was the most popular "pop" style of the first two decades, and it would be utilized profitably by any number of white composers.[33]

What is crucial to my concerns is that technological advances in the recorded music industry were accompanied by an intense commodification of indigenous African-American music forms.[34] Also, these advancements took place as the leaders of the black liberal bourgeois were consumed by the demise of formal structures of white patronage supporting their agenda and as the quality and leadership of black print organs like *Opportunity* and *Crisis* eroded with the failure of the liberal bourgeois agenda and the Great Depression. Without formal articulations of a black mainstream perspective, many of the counternarratives of black public life emerge as primary conduits of black expression. Black popular music's central presence in the recording industry and later the radio industry allowed for the distribution of black expression, though offerings to the mass public were still severely limited.

During the late '20s, America witnessed the rise of the radio as a major artery for information and entertainment. The appropriation and commodification of black popular music forms were a key ingredient to the early success of radio during the '20s and '30s. Given the severe restrictions on intercultural exchange among blacks and whites, the new technology allowed the space for black popular culture to be caricatured for the purpose of commodification.[35] White businessmen realized the potential of black popular music vis-á-vis their commercial products during the early '30s. In the decade of the '30s "race music" emerged on radio airwaves as a catalyst to advertise and sell to black audiences.[36] While clearly a recognition of a black consumer public, this phenomenon would begin the tumultuous marriage between black cultural production and mass consumerism—one in which black agency is largely subsumed by market interests. Thus black musical artists were not fully integrated into the marketplace, and increasingly white artists appropriated black musical styles, in effect blocking black advancement within mass consumer culture, except in the role of mass consumers.

This interest in blacks as possible consumers is tied to the industrialization of the American economy, the subsequent creation of mass markets, and the phenomenon of mass consumerism. According to Stuart Ewen and Elizabeth Ewen, "On a narrowly economic level, the origin of mass culture can be seen as an extension of the necessity to generate and maintain an industrial labor force and expand markets."[37] Blacks, particularly those who migrated from the Deep South into the urban centers of the North, were also subjected to these mass markets and the ideology of mass consumption. Ewen and Ewen suggest:

> The creation of an industrial labor force and of markets necessitated an abolition of social memories that militated against consumption. A consumptionist ideology required a world-view in which people and nature were not merely separate, but at odds with one another. Consumerism posed *nature* as an inhospitable force, a hopeless anachronism. Industrial production and enterprising imaginations claimed for themselves the rights and powers of creation. Though the question of how such a momentous upheaval in perception could have taken hold cannot be fully answered here, it is clear that, by the early twentieth century, the double prong of "Americanization"—mass production and mass consumption—had dramatically altered the social landscape of American life.[38]

Like many of the ethnic minorities who immigrated to American shores in the late nineteenth and early twentieth centuries, African-Americans were also subjected to this process of "Americanization." If African-Americans were nurtured and expected to become mass consumers—often as an emblem of their perceived Americanness, hence the carnival nature of mid-century black middle-class expression—it would only be natural that the cultural productions of this community would also be subject to mass production and mass consumption. As Ewen and Ewen say of consumer culture, "In its imagery and ideology were powerful appeals from hitherto denied realms of leisure, beauty, and pleasure."[39] Within this context, the African-American price for wanting full citizenship was the relinquishing of their expressive culture to a mass consumer economy that in both form and practice denied agency and dignity to the African-American public.[40]

Moreover, the appeal of recorded music and the acceptance of radio froze the process of intercultural exchange within mass consumer culture. Thus the intercultural exchange that was central to the black liberal bourgeois program of integration is largely conflated within the context of a commodities exchange that is beyond their reach or control. William Barlow is very clear about the implications of the cross-"cultural transactions" that accompanied the rise of the radio in the era:

> The advent of radio broadcasting in the United States coincided with the cultural ferment of the Roaring Twenties, the decade of the fabled Jazz Age. The "flap-

pers" and "flaming youth" of America's white bourgeoisie were in open revolt against the lingering puritanical and Victorian moral codes that were the foundation of their parents' culture. In their efforts to break away from this stifling heritage and its outmoded morality, these cultural rebels turned to African American music and dance.... However, the price paid for this cultural transaction was a misguided and condescending dilution of the original art form, because once they entered into the mainstream of American culture, African song, dance, and humor were appropriated either by white entertainers and/or white businessmen who tailored them to their own liking and reaped the profits from their sale.[41]

With the collapse of formal structures of patronage by whites for the black liberal bourgeois and the Harlem Renaissance, cultural exchange was largely relegated to commodified black cultural products such as swing music. Like the burgeoning film industry in Hollywood, swing music became a viable and ultimately profitable distraction for a country engulfed in both economic and spiritual crisis.

The Black Public at War: Bebop and Executive Order 8802

In social spaces like the segregated Cotton Club, The Savoy, and the Renaissance Ballroom, New Orleans syncopation combined with urban sensibilities and laid the foundations for the black popular music tradition. Black and white Americans over the course of the '20s and '30s would dance to the music of Louis Armstrong, James "Reece" Europe, Fletcher Henderson, Duke Ellington, and Count Basie. Largely informed by the nuances of black vernacular culture, jazz emerged as the first major form of black art, readily accessible and thus commodified and appropriated by a willing and needy white public. Such tensions are evident as early as 1924 in Paul Whiteman's efforts to sanitize jazz in what was called "symphonic jazz"[42] and underlie the emergence of Benny Goodman as the "king of swing" a decade later. Despite its obvious debt to black expressive culture and the significance of black musicians in its production, swing, as it was referred to in the '30s, was largely the domain of mainstream culture. It had a large white audience base and a discriminating "racial-tocracy" that often afforded less talented white musicians access to the better paying venues and the more profitable recording contracts. Some of the more popular swing recordings of the period lacked any indication of significant African-American influence.[43]

Harlem emerged at the beginning of the 1940s ravaged by economic neglect, structural erosion, and the spawning grounds of an angry and frustrated constituency. Many of the first generation born in Harlem after the beginnings of the Great Migration were coming of age and attempting to

redefine their social status, while the trope of the "urban North as promised land" simply represented the defining paradox of their reality. The emergence of a disaffected and increasingly militant youth constituency was the direct product of the changing urban demographics of Depression-era Harlem. In his popular history of Harlem during World War II, Nat Brandt writes:

> When the Depression began, there were more black children in New York than in any other city in the world—more than seventy-five thousand under the age of fifteen, some forty-seven thousand in Manhattan alone. Yet, while the city sought nearly $121 million in federal funds for new school buildings, only $400,000 was earmarked for schools in which blacks made up the majority of students.... The number of black youngsters arraigned in Children's Court, which had nearly tripled in the decade before, more than doubled again afterwards. In 1938, black youngsters represented a fourth of all cases.[44]

These alarming statistics were further compounded by reports that more than 3,200 black youths were arrested during the first five years of the 1930s alone.[45] Many of these children became working age as the '40s and World War II dawned. Part of their lived experiences included, not just the misery of their immediate past, but more contemporary issues like unemployment, police brutality, racism, and poverty—issues that, in the absence of viable progressive leadership within the community, radicalized black youths in ways that were clearly problematic but that denoted modes of political resistance.

Harlem's *Amsterdam-Star News* captured the moment in this way: "Where there was once tolerance and acceptance of a position believed to be gradually changing for the better, now the Negro is showing a 'democratic upsurge of rebellion,' bordering on open hostility."[46] Roi Ottley, in his study of black life in America published shortly before the Harlem riot of 1943, writes, "Listen to the Way Negroes are talking these days! Gone are the Negroes of the old banjo and singin' roun' the cabin doors.... Instead black men have become noisy, aggressive, and sometimes defiant."[47] The new energies associated with black expression at the dawn of United States involvement in World War II, while largely instigated by the burgeoning militancy of black youth, was also buoyed by general optimism among African-Americans regarding their potential service in the war effort, playing roles in both the war industries and the battlefield. These sensibilities are captured in the concept of "Double V"—victory abroad and victory at home, victories that were denied the first generation of northern migrants at the close of World War I. The black public's demands for equality, symbolically represented in the planned 1941 march on Washington organized by A. Philip Randolph, former African Blood Brotherhood member and president of the Brotherhood of Sleeping Car Porters, were realized with Franklin Roosevelt's

signing of Executive Order # 8802, which guaranteed fair hiring practices in both wartime industry and government. The political successes of this effort and the music that served as its background inform the Civil Rights movement of the mid-'50s and '60s.

Culled from the covert spaces of Minton's Playhouse, Monroe's Uptown, and Small's Paradise—spaces that were ultimately efforts to re-create the covert black publics of the American South—bebop, with its requisite examples of jive, zoot suits, and heroin, attempted to musically subvert and thus transcend the impositions of space and time. Eric Lott, in what is arguably the finest cultural critique of bebop writes: "Militancy and music were undergirded by the same social facts; the music attempted to resolve at the level of style what the militancy fought out in the streets. If Be-Bop did not offer a call to arms…it at least acknowledged that the call had been made."[49] Bebop as practice and cultural artifact helped to re-create the vitality of the covert social spaces of both the rural South and the urban North. As Amiri Baraka suggests, bebop may, in fact, be the last form of black musical expression to be wholly derived from the confines of the Black Public Sphere.[50] While black women were largely incidental to this setting—even Ellison's invocation of southern cooking suggests this—these were social spaces that affirmed black masculinity as opposed to the devaluation of black femininity. As Farah Jasmine Griffin suggests in her work on the tropes of black migration, black men and women simply created alternative spheres of affirmation.[51]

While it is debatable whether bebop was inspired by the realities of black urban life in the 1940s or simply appropriated as the soundtrack of a restless, creative, and brash youth, bebop was in fact a music largely developed beyond the grasp of the marketplace. Accordingly, despite the racist implications of the wartime ban on recording, particularly in relation to the ability of black musicians to financially survive, the ban unwittingly allowed the conditions for bebop to develop. In the early 1940s, while the white critical establishment at *Metronome* and *Down Beat* were debating the merits of New Orleans jazz and swing, black musicians retreated to the fertile relations of black clubs and working-class people.[52]

It is only fitting that bebop garnered national attention in the wake of the Harlem riot of 1943. Though the relationship between the riot and bebop is circumstantial at best, both represent rearticulations of black economic interests within mass market culture. Domenic Capeci suggests that the Harlem riot of 1943 was the first clear example of what he calls a commodity riot.[53] The 1943 Harlem riot unlike the Harlem riot of 1935 and the Detroit riot of 1943, was characterized by attacks on police forces and the looting of Harlem businesses. Capeci implies that the act of looting, which became an integral part of urban unrest during the 1960s, is in fact part of a redefinition of property rights. Bebop emerges, partly, as a conscious attempt on the part

of black musicians to remove black musical expression from the clasps of an often indifferent and exploiting marketplace. The complex rhythm and melodic structures of Bebop, with its intricate chord inversions and improvisations, created an aural landscape that privileged community and autonomy within a receptive black male, largely urban constituency.[54]

Many meanings were derived about black youth culture in the aftermath of the Harlem, Detroit, and earlier "zoot suit" riots in Los Angeles. In many regards the period represented a complex historical moment in which the militancy that pervaded much of black life manifested itself in youthful and often illicit resistance, artistic innovation, and challenges to Jim Crow America. But the period also highlighted a clear distance between the sensibilities of black youths and a politically mainstream black middle class. As Ralph Ellison wrote in response to public analyses of the riots, "Much in Negro life remains a mystery; perhaps the Zoot suit conceals profound political meaning; perhaps the symmetrical frenzy of the Lindy Hop conceals clues to great potential power—if only Negro leaders would solve this riddle." Ellison suggests that mainstream leadership was incapable or unwilling to understand or address the increasing stratification within the black community and the reality that this distance would ultimately impede full communal empowerment as black youth would increasingly be politically and socially marginalized within public life.

The recording of bebop, and the subsequent commodification of it, codified the form as the next generation of black expressive arts to be appropriated by an emerging post–World-War II middle class, a group that has historically viewed black expressive culture as a conduit for a more sensual and orgasmic living experience.[55] The popular success of bebop and its subsequent move from the clubs of Harlem to those of Manhattan's 52nd Street would challenge the very intimate relationship between modern jazz and the black working-class communities that it emerged from. As Paul Chevigney surmises in his work on urban jazz:

> Harlem was showing the perennial elements of a strong jazz environment. The clubs not only supported the musicians, but gave them places to hone their skills and learn from one another. The complexity of learning to improvise, to make use of new rhythmic patterns and at the same time play with others, made for a difficult art that, to a large extent, had to be shaped in a group. Hours of playing together made good musicians able to react to nuances of style from others. They communicated excitement to one another, and to an audience, who then communicated a little of it back to them. The relation between the audience and the orchestras at the huge Savoy Ballroom in Harlem was legendary. Performance could create a tremendous sense of common emotional understanding and release.[56]

By the early 1950s, bebop patronage was largely the province of the young white artists and intellectuals of the liberal and radical left. Though 52nd

Street's physical proximity to the still largely black San Juan Hill neighborhood guaranteed a consistent mix of black and white audiences and the music ultimately laid the foundations for the alliance of the white radical left and Black Nationalists in the 1960s, bebop was no longer driven by the nuances and subtleties of the Harlem Jazz scene. Bebop in the late 1940s and early 1950s is characterized by continued debates among a largely white critical establishment that Bernard Gendron describes as the "Moldy Figs" versus the Modernists.[57] Within this context, Gendron argues that bebop became the flagship artifact of mass culture's reevaluation of its relations with modernist high culture. These debates, while wholly related, are far removed from the worldview of a post–World War II black working class.

Legislating Freedom, Commodifying Struggle: Civil Rights, Black Power, and the Struggle for Black Musical Hegemony

The spirituals sounded a call to action—uniting African-American history with a contemporary freedom struggle. The freedom songs galvanized parts of the Black community when other forms of communication failed. Adaptations of earlier spirituals inspired all people, Black and white, female and male, together to fight injustice. Spirituals embodied persuasive ideological elements toward holistic human actualization.

—Cheryl A. Kirk-Duggan *

The time was perhaps right. After five decades of elite leadership—Washington, Du Bois, and Walter White's NAACP—the black working class would emerge from out of the shadows of bourgeois values to directly address its own economic concerns. The process was begun as A. Philip Randolph prepared to march on Washington in 1941, followed by the revolt of black youth in Detroit and New York during the summer of '43, and the second wave of southern migrants, who rejected a history of slavery and sharecropping in the South to pursue economic interest in the industrialized North and West. As the liberal bourgeois leadership of the black community purged itself to protect itself from the wrath of McCarthyism and prepared landmark legal action against legal segregation, the black working class began to rearticulate its relationship to both labor and commodity culture in this country.

Bebop was the first radical sign: the creation of an art form, clearly informed by the sensibilities of a marginalized, male-dominated, urban constituency that needed to reclaim the critical edge of black communal expression from the arms of mass consumer culture and American modernity. Ten years after jazz, in the form of swing, becomes the language of mass consumer culture and an integral part of the cultural buffer that diverts working-class resistance from the realities of Depression-era America, bebop emerges to articulate a distinctly mid-twentieth-century urban blackness. Hard-bop and soul would emerge in the 1950s to emphatically construct an urban working-class blackness that was distinct from the black community's more visible southern-based liberal bourgeois leadership, but a blackness in which the successes of the Civil Rights movement are ultimately premised.

Challenged by a second wave of northern migration, the infrastructure of black urban spaces were under significant stress, though many of these spaces become the aesthetic sanctums for cultural exchanges that undergirded the most profound resistance activities of the period. Ironically, the result of many of these cultural exchanges was the classic and historic conflation of often divergent aesthetic sensibilities, highlighting the profound strengths of communal struggle. In the process, Martin Luther King and the Motown recording label became the dominant icons of black middle-class aspiration. Both would evolve during the 1960s, representing significant structural and economic changes within the African-American diaspora. The failure of the traditional middle-class-driven Civil Rights movement to adequately respond to the realities of black working-class life allowed for the emergence of political alternatives like Malcolm X and the young nationalists within the Student Nonviolent Coordinating Committee (SNCC). The Watts revolts of 1965 bespoke the rage that could no longer remain contained within the black urban neighborhoods. Toward the end of the 1960s, the black popular music tradition would also come to reflect the inner rage of some segments of the African-American diaspora.

The Chitlin' Circuit: Memory, Community, and Migration

In the 1940s radio stations began to use recorded music instead of live music in their programming. As Reebee Garofalo states, "Records emerged as a relatively inexpensive medium.... Records soon became the staple of the music industry, surpassing sheet music as the major source of revenue in 1952. About the same time, radio overtook jukeboxes as the number one hitmaker."[1] As recorded music became the dominant format for American music, the appearance of the transistor radio—a technological advance that allowed for the transformation of radio entertainment from a family-centered activity to a more personal and dispersed listening experience—along with

the expansion of the recording industry during the favorable economic period of postwar America, provided the stimuli for the mass commodification of black popular forms. As Gerald Early writes:

> The effect of the invention of the transistor was similar to the later invention of the microchip: it made electronic appliances smaller and cheaper, particularly radios. And the growth of portable radios had an enormous impact on where music was heard, and on the courting habits of people who used radio for those purposes. In fact, it spurred the growth of portable radios, which had an enormous impact on where music was listened to and on the mating habits of people who used music on the radio for sensual purposes.[2]

Within the context of black popular forms the transistor allowed for a distribution of these texts with a velocity and efficiency that had been previously unrealized within mass consumer culture. Furthermore, the development of transistor radios allowed young whites to access black forms like rhythm and blues by circumventing the parental surveillance that accompanied radio listening in the past. Previously, particularly before the introduction of television into mainstream culture, the old bulky radio console served as centerpiece of intrafamilial relations.

Rhythm and blues became the first form of black popular music to be exposed to the rampant mass consumerism that has defined the post–World War II period. The emergence of rhythm and blues is owed in part to the decentering of big band/swing music and the rise of vocalists in the recording industry. The demise of big band and swing music have both commercial and aesthetic impetuses. In the immediate postwar economy it was impractical and imprudent to support the elaborate needs of a big band; this gave rise to smaller combos. We also witness the rise of bebop and the electrified bass and guitar, significantly enhancing the role of rhythm in the music, hence the term *rhythm and blues*.[3] The dominant artist from this period, Louis Jordan, is recognized as a genius in rhythm and blues because he anticipated the demise of the big band sound and produced black instrumental music that responded to the need for black dance music that would be commercially viable to the recording industry. Many critics consider him the first true black "crossover" artist.[4]

A shortage of shellac limited the number of 78-rpm recordings that were produced immediately after the war, and the major record companies focused on the more popular vocal music as opposed to bebop or instrumental rhythm and blues. This led to the appearance of what Arnold Shaw has called "sepia Sinatras"—named in tribute to the most popular vocalist of the era and the one who arguably benefited most from the new technology—or blues balladeers in the likes of people like Percy Mayfield, Charles Brown, and Dinah Washington. Describing the phenomenon, Shaw writes:

being mindful of black expressive culture

A fusion it was, mixing elements of country blues, boogie woogie and jazz in a cauldron fired by the seductive sales of pop balladry. If the Inkspots were the progenitors, Leroy Carr the father, and Nat Cole an influence, the exponents of the murmuring gentle vibrato ballad style were bluesmen like Charles Brown, Lowell Fulson, Percy Mayfield and Ivory Joe Hunter. They were the black ghetto equivalents of the baritone crooners in pop—in short, they were "sepia Sinatras." [5]

In fact, this phenomenon, as Shaw suggests, explains why Nat King Cole disbanded his highly successful King Cole Trio in favor of a career as pop vocalist.[6] Sinatra of course personifies the technological changes in popular music in that the electric microphone allowed singers who did not possess the chops of blues and gospel singers to be heard above the raucous sounds of swing or rhythm and blues bands.

The music of a group like the Coasters ("Yakety Yak" and "Charlie Brown"), which placed African-American artists in the long-accepted position of jesters, appropriated many of the aesthetics of minstrelsy. Though generally viewed as the domain of white males, James Weldon Johnson writes, "Minstrelsy was, on the whole, a caricature of Negro life, and it fixed a stage tradition which has not yet been entirely broken. It fixed the tradition of the Negro as only an irresponsible, happy-go-lucky, wide-grinning, loud-laughing, shuffling, banjo-playing, singing, dancing sort of being."[7] As Shaw, Garofalo, and George all submit, the music was primarily accepted for its value as dance music. Though many of the lyrics reflected innocuous romantic notions or a popular dance of the time, many of the messages alluded to the very subversive themes advanced during slavery, namely those of community as well as spiritual and physical transcendence. In an examination of the work of Louis Jordan, who on occasion has been charged with advancing clownish black stereotypes, George asserts:

The titles "Beans and Cornbread," "Saturday Night Fishfry," and "Ain't Nobody Here But Us Chickens" suggest country life, yet the subject of each is really a city scene. In "Chickens," for instance, the central image is of chickens in a coop having a party that's keeping the farmer from sleeping. But clearly the bird bash is just a metaphor for a black house party that the farmer—perhaps the landlord, maybe the police—wants to quiet.[8]

The text of this music is of course shaped by what is still a very precarious existence in America for many blacks. The lyrics of rhythm and blues, particularly as a commodified product, could simply not directly address the issues concerning the majority of blacks. As the political terrain for blacks began to change after the Brown vs. the Board of Education of Topeka, Kansas trial in 1954, so did the style and content of the dominant forms of black popular music.

By the end of the 1950s, modern jazz was transformed from an urban dance music and salve of working-class misery into a concert music, appropriated by the mainstream cultural elite and later the Academy. Jazz would, for all intents and purposes, end its organic relationship with black working-class communities and black vernacular culture. I maintain that there has been a continued project among some segments of the black jazz community to reintroduce and reintegrate jazz music into the Black Public Sphere and the black public(s) contained within it. Some black musicians have attempted to conflate modern jazz's aesthetic sensibilities with the rhythms that dominate the Black Public Sphere and in the process create subgenres of jazz that were still honest to the traditions of modern jazz, but accessible and palatable to a larger and often younger black audience. Informed by the black church and the rudimentary elements of a new style of music that was largely derived from the music of the black church, hard-bop emerged in the mid-1950s as a form of modern jazz with roots in black working-class culture.

In some regards the emergence of hard-bop, like that of soul music later, was simply a response by black artists and the black community to the intense commodification and mass consumption of an organic black music form. Paul Gilroy's argument in regards to this best illustrates a structural component of African-American diasporic cultural production since the rise of mass consumerism; namely that the volatility of post–World War II black popular culture is a response to the intense commodification and appropriation of organic cultural forms in the black community. As Gilroy suggests:

> The anticapitalist politics that animate the social movement against racial subordination is not confined to the lyrical content of these musical cultures. The poetics involved recurrently deals with these themes, but the critique of capitalism is simultaneously revealed in the forms this expressive culture takes and in the performance aesthetic that governs them. There is here an immanent challenge to the commodity form to which black expressive culture is reduced in order to be sold. It is a challenge that is practiced rather than simply talked or sung about.[9]

Within the context of Gilroy's thesis, black popular music's ability to create an aesthetic buffer from the travails of mass commodification is contingent on the support of socially taut communities—communities that legal segregation unwittingly helped to maintain.

Hard-bop emerges with and is perhaps also influenced by rhythm and blues music. With the heavy sounding, honking tenor saxophone as its centerpiece and the prominence of an electrified bass, rhythm and blues represented the hard-driving and passionate though predictable life of post–World War II black public(s) in urban spaces. Gone were the aesthetic excesses that defined the bebop moment of the early to mid-1940s; gone were the expectations captured in the concept of "Double V, Double-Time." Rhythm and

blues and hard-bop instead inspired forms of spiritual catharsis as opposed to physical transcendence rooted in political or social resistance. Nevertheless, it was an aesthetic mood that resonated among a black urban public resolved to the realities of "the promised land."

The tenor saxophone was only one of the instruments on which the hard-bop tradition stood. Black jazz musicians would literally pull the dominant musical instrument of the black sacred world out of the church and into the secular world: in 1955, jazz musician Jimmy Smith traded in the sounds of eighty-eight keys for the sound of the Hammond B-3 organ. Though there were examples of the organ's use throughout black popular music, the performances of Wild Bill Davis on the instrument were what persuaded Smith to take up the instrument. The organ perhaps had been introduced into jazz by Fats Waller, an early giant of jazz and son of an assistant minister at Harlem's famed Abyssinian Baptist Church, who began recording on the pipe organ shortly before his death in 1943.

The instrument's use in a jazz context could not have endeared jazz musicians and audiences to the black church, because the organ was in many ways the emblem of gospel music itself. As Rosenthal indicates, the Hammond B-3 found its public voice not in the church, but in the community bar in the form of the very popular organ/tenor combos and organ/guitar trios.[10] These tensions again highlight the continued presence of a hyperdemocracy within black life that valued the various counternarratives to the liberal bourgeois sensibilities of the black church and mainstream political establishment. New York's famed Apollo Theater is perhaps the most visible icon of democracy within black public life, given its seminal role in creating a public space for communal critique of black cultural production. Artists like Brother Jack McDuff, Jimmy McGriff, Big John Patton, Baby Face Wilhitte, and Larry Young made their livings traveling the highly democratic Chitlin' Circuit with these combos and trios. In fact, jazz great John Coltrane, often associated with the highbrow trend that has dominated jazz since the late 1950s, honed his formidable skills as a honker in many of the black bars in Philadelphia in the early 1950s. According to Rosenthal the Hammond B-3 "offered jazz/R&B performers a number of advantages," including a big sound, variety of tones, and a bass line that could replace the need for piano and string bass, which in part reflected the economic and spatial sensibilities of the Chitlin' Circuit.[11]

Removed from the travails of the marketplace and its legions of uninformed consumers, hard-bop retreated to and thus strengthened the quality of Black Public Sphere activities in the form of the so-called Chitlin' Circuit. This loose network of black nightclubs, juke joints, and after-hours clubs was invaluable for the creation of common aesthetic and cultural sensibilities among the African-American diaspora—a noble and significant feat, given the changing demographics of black public life in the midst of post–World

War II migration patterns. In large response to economic transformations in the American South, namely the mechanization of the farming process, more than four million blacks migrated to the urban North and urban South during the postwar period. At its core, the Chitlin' Circuit invoked the reconstruction of community and the recovery of cultural memory for many of these second-wave migrants. Crown jewels of the Chitlin' Circuit, like Chicago's Regal Theater, New York's Apollo Theater, and activities like "Amateur Night at the Apollo," are stark reminders of the African-American diaspora's strident devotion to the democratic tenets of American society. Black popular music in the 1950s and the significance of the Chitlin' Circuit represent a singular moment in the role of the black public(s) in the creation, maintenance, and distribution of black musical expression in the post–World War II era, in that it is a period also marked by the intense commodification of black popular music forms.

Hard-bop's popularity was largely based on its ability to remain malleable to the full range of musical influences and tastes contained within a still largely segregated black public. Thus hard-bop stalwarts like Art Blakey, Horace Silver, and Lee Morgan, as well as fringe jazz artists like hornmen Willis "Gator" Jackson, Jimmy Forrest, and Gene Ammons, had to be well versed in the blues, bebop, and gospel idioms and willing to accept the contemporary influences of rhythm and blues and, later, soul and funk. It is thus no surprise that soul, the next aesthetic movement in black popular music after rhythm and blues and hard-bop, resonates among the total diversity of an increasingly stratified black community. Soul's singular role during the Civil Rights and Black Power movements as a conduit for political expression—a role scarcely repeated among black music forms since—would have been virtually impossible without the solidification of the Chitlin' Circuit in the 1950s. These trends would continue well into the decade of the 1960s, though the black jazz clubs of urban spaces would increasingly represent alternatives to varying class and ideological constructs within the black community, as the Chitlin Circuit represented a distinct link to a worldview predicated on the suppression, exploitation, and disenfranchisement of the black community.

Increasingly a younger generation of black intellectuals, personified by Amiri Baraka (LeRoi Jones), Larry Neal, and the Black Arts movement, began to posit the aesthetic innovations of jazz artists like John Coltrane, Archie Shepp, and Albert Ayler, as emblematic of the postcolonial and black nationalist politics needed to empower the black community. Underlying these notions were powerful desires to sever black expressive culture from the mainstream critical establishment and provide more authentic and informed interpretations of black culture via the Black Arts intelligentsia. Baraka's *Blues People* is perhaps the most profound articulation of this concept.[12] As Lorenzo Thomas suggests in his work on the Black Arts movement,

The militant attitude of writers such as Neal was reflected—and perhaps insti-
gated—by jazz musicians whose playing matched the intensity of an entire gen-
eration of African American intellectuals who were too young to know much
about Jim Crow but old enough to see that integration was, at best, a barely
hatched chicken if not a bird in the bush. One of the most interesting projects of
this group was an attempt to control authorship of jazz criticism and, thereby,
reclaim the music itself as a central cultural expression of the black community.[13]

These ideas anticipate the burgeoning nationalist movement, which would
engulf the black community in the latter part of the 1960s, and the emer-
gence of an organic and largely male critical establishment, initially repre-
sented in Baraka, A. B. Spellman, Stanley Crouch, and a generation later in
Nelson George, Harry Allen, and Greg Tate. These writers helped provide a
context in which to appreciate the artistic innovations of artists like Coltrane,
Ornette Coleman, Marion Brown, the Art Ensemble of Chicago, Henry
Threadgill's Air, and Don Pullen.

Cerebrally challenging to both musicians and audiences, many of these
recordings and performances effectively countered critical renderings which
often reduced jazz as the music of brothels, drug addicts, and a socially
deviant subculture. The desire of black musicians to shatter caricatures of the
smiling entertaining "sambo," and convey a serious musicianship worthy of
high brow considerations—Miles Davis in Hickey Freeman suits is the best
example—was also a part on this design. Unfortunately many of these artists
and critics earned such concessions at the expense of their core black audi-
ences. As Bebop presaged, the heady jazz of the 1960s, often devoid of
swing and an accessible blues center, quite possibly represented the genre's
final break with the black working class, who often valued it, like the blues
and rhythm and blues, for its cathartic powers in the leisure spaces they
inhabited. In this regard, the political agenda of critics and the personal
choices of musicians were at odds with the desire and pursuit of pleasure on
behalf of some black audiences, particularly as pleasure often undermined,
temporally at least, the realities of segregation, Jim Crow politics, and racism.

Davis's last major group of the 1950s serves as a useful metaphor for the
stratification that would appear among black jazz musicians and by exten-
sion the black public at large in the 1960s. In tenor saxophonist John
Coltrane and alto saxophonist Juliann "Cannonball" Adderley, the Miles
Davis sextet contained the opposite poles of jazz sensibilities as they would
appear in the decade of the 1960s and beyond. Coltrane would attain cult
status and his recordings become the measure of jazz's presence as a high-
brow American art form, while Adderley would reach back to his own blues
roots and create a music capable of creating instantaneous catharsis among
his black audiences. Adderley intuitively understood Jazz music's historical
role in the everyday lives of everyday black folks and, as such, fashioned a
jazz style that was both warmly received and culturally useful for the black
community. Baraka writes of Adderley: "Ball's glibness and easy humor cou-

pled with a kind of swinging formalism and miniaturism enabled him to cre-
ate the kind of solos and compositions that would be commercially signifi-
cant.... Cannon's direction is more commercial because it freezes blues as
blues form."[14] Adderley's unprecedented commitment to recording with live
audiences—the aural reproduction of community which I discuss in the next
chapter—underscores his significance in the continued credibility of jazz for
black working-class audiences.

Throughout the '60s, many black jazz musicians, under the banner of
hard-bop and later soul jazz, recorded music that was extremely popular to
a larger black and mainstream audience. This sentiment is perhaps best cap-
tured in the mainstream success of Lee Morgan's *"Sidewinder,"* Adderley's
"Mercy, Mercy, Mercy," and Ramsey Lewis's single *"The In Crowd."* The duo
of Grant Green and Lou Donaldson, who often recorded together in the early
1960s, and Donald Byrd, were most notably attuned to the changes taking
place in black popular music and the black community for that matter. These
artists would infuse jazz with the syncopated rhythms often associated with
the music of James Brown and introduce a new subgenre of jazz, with an
emphasis on catching the attention of a younger, politically motivated, cul-
turally assured audiences raised on the music and production techniques of
the Motown and Stax recording companies.

Largely unknown to casual jazz listeners, the St. Louis born Green was
Blue Note's most recorded artist from the years 1960–1965. According to the
linear notes to Blue Note's *The Best of Grant Green* vol. 1, Green's solo on
Lee Morgan's *Search for the New Land* recording is still used in jazz guitar
classes. (Green, though well regarded among his peers as a session musi-
cian, capable composer, and leader in his own right, often fought with the
demons of drug addiction. Inevitably it curtailed his work during the latter
sixties and led to his early death at the age of forty-nine in 1979.) Green
reemerged in the early 1970s and created a body of work that was wholly in
step with the music associated with some of the dominant social institutions
of the Black Public Sphere. Largely disparaged by critics who longed for the
straight ahead style of Green's earlier recordings, Green's music of this peri-
od was recovered later on both ends of the Atlantic, particularly recordings
like "Cease the Bombing" and his remake of Don Covay's "Sookie, Sookie,"
that anticipate the emergence of jazz-influenced hip-hop on America's East
Coast and acid jazz in Britain, more than twenty-five years after their release.

Lou Donaldson, on the other hand, reemerged several times during his
career. The alto saxophonist began his career largely influenced by saxo-
phonists Earl Bostic, Johnny Hodges, and rhythm and blues artist, Louis
Jordan. He emerged in the 1950s playing straight-ahead hard-bop, the early
sixties playing soul jazz, and finally in the late 1960s and early 1970s with
funk-jazz. Donaldson profoundly understood the power of syncopated
rhythms and the concept of funk within the black community. When queried
about the significance of Funk, Donaldson related:

That's the way Jazz is supposed to be played. People got the wrong concept about what Jazz is. Jazz is not just running through a lot of notes and stuff. That's not Jazz. What they call Funk, that's not Funk, that's Jazz music.... See when I was a kid, all the Jazz bands played for dancing. That's all they played for. When we play that style of music, it's to make people dance.... Put a beat in there to make people get on the floor. Because, you get in these clubs and the cats say, well man if the people don't get on the floor, you fired.[15]

Donaldson's comments highlight the historic role of audiences in keeping musicians accountable to the vernacular traditions and communal desires of the black community. Of course much of this accountability was wholly related to the economy of the Chitlin' Circuit in that the economic livelihood of many black musicians was predicated on the willingness of black working-class audiences to spend their hard-earned money on performances they derived pleasure and sense of community from. While audiences would continue to influence the aesthetic choices of black musicians in the future, particularly as consumers of recordings and live performances, increased corporate intervention in the black music industry and intense market segmenting would limit access of a diverse range of black musical styles to a broad range of black audiences and thus limit their capacity to hold some musicians and artists accountable.

Donaldson's 1967 release *Alligator Boogaloo,* is perhaps the best example of his efforts to remain connected to his core black audiences. The recording which contained Donaldson originals like the title track and organist Dr. Lonnie Smith's "Aw Shucks," featured a rhythm section anchored by a young guitarist named George Benson and the Boogaloo rhythms of New Orleans-bred Idris Muhammad. Muhammad's drumming was the product of the intense polyrhythms that were native to New Orleans. Muhammad, like Meters drummer Joe "Zigaboo" Modelsite, was a student of session drummer Earl Palmer, who Ricky Vincent suggests was the "original funk" drummer.[16] Muhammad's role in Donaldson's band was significant for several reasons. Hard-bop, like Bebop before it, was a product of regional taste. Muhammad's New Orleans-styled rhythms, as well as the playing of New Orleans trumpeter Melvin Lastie, effectively creolized Donaldson's sound making it more attractive to a broader range of black listeners, while mirroring black migration from the South to northern cities. Accordingly *Alligator Boogaloo,* which Donaldson said "brought them back,"[17] meaning the black audience, was one of the Blue Note label's all-time top sellers during the era, along with Lee Morgan's *Sidewinder* and Horace Silver's *Song for My Father.*

But the New Orleans syncopation of *Alligator Boogaloo* also contained elements that were useful to the heightened political sensibilities of the black masses. In some regards Muhammad's playing in Donaldson's band represented the retention of premodern jazz sensibilities. As Vincent relates:

The polyrhythmic emphasis of New Orleans drumming was a specialty of the region—the only region in the United States where black slaves were allowed to play drums from day one. The endless drumming and rhythmic interplay of the slaves at Congo Square is still visible among the storied "second line" of musicians that has followed parades and funeral marches throughout New Orleans for generations.... The very African quality of performing with multiple rhythms playing simultaneously—in a lively syncopation—was retained by the people in the region and has spread through New Orleans Dixieland Jazz, ragtime, rhythm and blues, and, ultimately, The Funk.[18]

These cultural retentions were particularly powerful as African-Americans began to seriously examine their African heritage. New Orleans syncopation was one of the more pronounced remnants of that heritage. Political elements in New Orleans syncopation were also evident in the work of New Orleans natives the Meters, who recorded a spate of popular recordings like "Cissy Strut," "Chicken Strut," and "Sophisticated Cissy" in the late 1960s. The latter recording had its basis in a popular dance from the period known as "the sophisticated sissy." According to dance historian Katrina Hazard-Gordon, the dance called for "black men to step forward as leaders in both their communities and in the black struggle."[19] Such commentary, once again suggest that many Chitlin' Circuit spaces were not only sites of recovery and pleasure, but spaces that afforded some forms of political agency.

Subsequent Donaldson recordings like *Hot Dog* (1969), *Everything I Play is Funky* (1970), and "Pot Belly" with it's use of the Fender Bass—a sound that would come to dominate hip-hop music produced in the Northeast during the late '80s and early '90s—are tributes to the lasting significance of his music. Donaldson's 1970 recording *The Scorpion: Live at the Cadillac Club* (1971) is not only a testament to Donaldson's aesthetic sensibilities, but ultimately according to jazz jock Bob Porter a testament to the Chitlin' Circuit as represented by spaces like the Cadillac Club and Key Club in Newark, New Jersey.[20]

Dr. Donald Byrd, born Donaldson Toussaint L'overture Byrd, like his late contemporary Lee Morgan, was a child prodigy of the hard-bop movement. Possessing a restless intellect, Byrd would spend several years abroad in study and would eventually attain a doctorate in ethnomusicology during the mid-1960s. Byrd's resistance to the commercial affects on the quality of jazz as it related to the black community would become one of his major focuses throughout the decade of the sixties. Byrd devoted significant amounts of his time to the teaching of jazz, but most significantly Byrd would create bodies of work that were indeed reflective of the African-American experience.

In the early 1960s, Byrd introduced gospel chorale groups to jazz and would later recover what Stanley Crouch calls the "gutbucket grandeur" of the blues on recordings like 1967's *Slow Drag*. But no one could have imag-

ined what Byrd would produce when he and a cadre of his Howard University students went into Rudy Van Gelder's New Jersey studios and produced *Black Byrd*. *Black Byrd*, with its production duo of former Motown studio hands Larry and Fonce Mizell, became Blue Note's best-selling recording to date and one of the first Jazz recordings to embrace the recording techniques of popular black music. Ursala Davis writes of this historic album, "Although the public continued to buy his records and the young folks were dancing to them, critics gave Byrd devastating reviews.... Byrd did something that no one realized at the time: he developed a way out of the impasse that had developed in jazz by becoming too experimental and stale."[21] Byrd, sensing the changing dynamics of black music, created a sound that resonated not solely within the Chitlin' Circuit, a concept no longer in vogue among younger audiences and under tremendous attack during the urban upheavals of the 1960s, but within the discotheque, a communal formation that I will examine in later chapters.

Given the near eradication of a visible and viable political left after McCarthyism, the insular dynamics of segregated black urban neighborhoods, and the Chitlin' Circuit, in particular, provided the necessary distance from mainstream surveillance and control. Marable writes that perhaps in response to the encroachments against freedom that the House Un-American Committee (HUAC) represented, "The Silent Generation of the white middle class began moving from urban centers to the suburbs; the populace and politicians alike were occupied with televisions, automobiles and other mass consumer goods."[22] Ironically, the very presence of insular cultural exchanges within a segregated diaspora make the Chitlin' Circuit and its mainstream facsimiles the ideal setting to politicize a generation of young whites who correctly viewed aspects of African-American expression as oppositional to America's ideological devotion to materialism and militarism.

Soul as Struggle: Soul Music, Polytonality, and the Discourse(s) of Black Resistance

In many regards, the successes of Brown vs. the Board of Education and Montgomery's historic bus boycott were driven by the presence and weight of black middle-class influence. While a diversity of class and political perspectives theoretically benefited from both efforts—the working class in Montgomery being an ideal example—the battles provided momentum for a largely southern middle-class social movement against legal segregation and constraints on voting rights and social mobility. For a new generation of northern migrants and second- and third-generation urban dwellers, attacks against Jim Crow were far removed from the issues of economic empowerment, police brutality, and housing discrimination that defined life in the

urban North and Midwest. Despite these significant differences, the rudi-
mentary elements of the traditional Civil Rights movement were critiqued
and distributed across the African-American diaspora, creating a social envi-
ronment of hope and expectation. This was partly achieved because the bur-
geoning Civil Rights movement was initially mediated and distilled by the
most significant institution within the traditional Black Public Sphere, the
black church.

It was only natural that black popular music, like the Civil Rights move-
ment, would also draw from the black church. Its devotion to liberal bour-
geois models of black public life and often puritanical notions of social rela-
tions have helped generate alternative spaces of critique and resistance,
which have often sought to undermine the church's influence and thus
broaden models of black life. Nevertheless, the black church, as both public
space and metaphor, has remained an invaluable artery of African-American
expression. Describing its impact on black life Higginbotham writes:

> For African-Americans, long excluded from political institutions and denied
> presence, even relevance, in the dominant society's myths about its heritage and
> national community, the church itself became the domain for the expression,
> celebration and pursuit of a black collective will and identity. The question is not
> how religious symbols and values were promoted in American politics, but how
> public space, both physical and discursive, was interpolated within black reli-
> gious institutions.[23]

Though various political factions within the black community, dating back to
the era of the Harlem Renaissance, sought to remove critical expression from
the overwhelming influence of the black church and other mainstream insti-
tutions in the Black Public Sphere, the attacks on the left and on black artists
and intellectuals like Langston Hughes and W. E. B. Du Bois created the con-
ditions for the black church's reemergence as dominant institution within
black public life.

The renewed influence of the black church is partially predicated on
aesthetic revisions of black sacred music to make it more palatable to a
broader range of audiences within the black community. Mirroring aesthetic
changes in jazz during the 1950s, black sacred music began to more closely
reflect the growing influences of black secular music like the blues. The cre-
ative energy behind such transformations was a former pianist of the great
blues singer Ma Rainey. Known during the 1920s as "Georgia Tom," Thomas
A. Dorsey is generally recognized as the father of gospel music. Creating a
context that often highlighted and privileged the emotional impact of the
music over traditional religious discourse, Dorsey, with the help of Sallie
Martin, Mahalia Jackson, and others, created an annual gospel convention.
The conventions served as a critical apparatus to develop the tradition, while
providing commercial space for what was becoming a burgeoning sheet

music industry, in which Dorsey compositions like "Precious Lord" and "Peace in the Valley" were top sellers. Dorsey well understood the power of the blues industry and created in gospel an economic vehicle that unlike the urban blues, could be contained within the black community.

Soul music, the popular and secular offspring of Dorsey's innovations, culturally relied upon what Smitherman has called "tonal semantics." As she relates, "To both understand and 'feel' tonal semantics requires the listener to be of a cultural tradition that finds value and meaning in word sound."[24] Influenced by West African tone languages, the practice of tonal semantics allows for different meanings to be derived from the tonal quality of a particular word or phrase. This was of course a powerful tool for blacks in the antebellum South and would become such for the vocalists of black popular forms like soul music. It is within this theoretical context that I want to suggest that the motion and musicality of the African voice, on which tonal semantics are largely premised, are perhaps best understood as the practice of polytonal expression. Denied access to the predominant instrument(s) of rhythmic (human) expression, the vocal quality of the first and second generations of Africans in the United States began to mimic the very diversity of tones and colors that were inherent in the African polyrhythms of the past. The practice of polytonal expression or polytonality, in which complex and varying meanings were conveyed via vocal tones, represents a unique process that is emblematic of the African-American experience.

Ironically, it is through Christian indoctrination and exploitive labor practices, both designed to socialize enslaved blacks to be productive laborers and model citizens within a racially defined economic caste system, that blacks were most able to realize as an option the liberatory meanings of poly-tonality through the practice of song (church and work songs)—songs that were often interpreted by the agrarian aristocracy of the South and their managers as proof that their socialization efforts were having desired effects. Unbeknownst to those outside of the slave community, these songs conveyed rich, textured, and nuanced meanings that were primarily conveyed via tonal qualities as opposed to specific narrative content. Furthermore these songs were impregnated with expressions of pain that related the miserable circumstances of enslaved blacks.

A constant state of terror and fear foregrounded polytonal expression as a set of complex intercultural negotiations that ultimately represented a fuller articulation of black spirituality. Central to this project was the mystification of language in ways that projected communally derived critiques, while simultaneously protecting the organic sites of production and producers of such critiques. Elaine Scarry's work on pain suggests that real biological and psychological needs frame these linguistic and rhetorical negotiations. Scarry identifies eight dimensions of physical pain. For my purposes the fifth dimension is particularly useful in examining the nature of polytonal expression:

A fifth dimension of physical pain is its ability to destroy language, the power of verbal objectification, a major source of our self-extension, a vehicle through which the pain could be lifted out into the world and eliminated. Before destroying language, it first monopolizes language, becomes its only subject: complaint, in many ways the nonpolitical equivalent of confession, becomes the exclusive mode of speech.[25]

In the introduction of her text, Scarry suggest that the transcendence of pain is contingent on naming the sources and implications of pain. Scarry writes:

> Often, a state of consciousness other than pain will, if deprived of its object, begin to approach the neighborhood of physical pain; conversely, when physical pain is transformed into an objectified state, it (or at least some of its aversiveness) is eliminated. A great deal, then is at stake in the attempt to invent linguistic structures that will reach and accommodate this area of experience normally so inaccessible to language.[26]

The public articulation of pain and the ultimate transcendence of pain would provide the foundation of the black modernist project of naming and visibility. Thus tonal semantics can be referenced among efforts on the part of enslaved blacks to give name and, with it, meaning to their oppression and oppressors, as a precursor to emotional and psychic transcendence of their condition—forms of transcendence that themselves foreground efforts of physical transcendence.

Polytonal expression also provides a theoretical framework in which to examine the dominant existential challenges to black life. In many ways the practice of slavery obliterated the distinctions between public and private life, rendering most aspects of black life in the antebellum period open to public domain, as that domain was constructed by the whims and wishes of the planter class, who, ironically, denied blacks the ability to be "public" persons. Thus much of black liberatory expression was initially defined by the desire to create covert spaces that, on the one hand, would provide the physical parameters in which to recover humanity, including the pursuit of pleasure, but also the space to develop more meaningful forms of resistance. While the role of the black church as the seminal institution within the black public sphere, both before and after emancipation, highlights the most visible example of the creation of covert social space, there were clearly other efforts that less effectively or perhaps less visibly constructed covert space. I would suggest that the practice of polytonal expression, particularly when premised by the type of public/social formations that accompanied field work, created the context for the creation of a covert social space in which the parameters were not physical, but aural.

Furthermore, notions of social space imply a framework in which community can be constituted. Though blacks in most cases could convene publicly under the auspices of the agrarian labor system or the mainstream

Christian church, there remained incredible obstacles to the construction and maintenance of black community. The desire to create community and the pursuit of covert social space remained two of the dominant existential tensions within the African-American diaspora well into the twentieth century. I would further suggest that the practice of polytonal expression, particularly within the context of field labor or other social formations in which blacks were communally constructed, represented the reconstitution of community within the parameters of aurally defined social space, that is in and of itself circumscribed by aural expression. It is within this framework that the black musical tradition—in particular the vocal tradition—came to serve as a primary instigator, if not conduit, of black liberatory expression.

In its essence soul music represented the conflation of polytonal vocal expression, over a layered musical landscape of rhythm and blues and gospel. The process of polytonality represents the creolization of various discourses and energies to create a mode of expression that is uniquely African (pretext), uniquely American (context) and capable of liberatory (subtext) interpretations. Thus soul represents a powerful "bricolage" or collage of black public formations, whose presence can be dated to the antebellum South. As polytonal expression constructed aural notions of community and social space, rhythm and blues and gospel music represented music that was distinctly created for transmission within two of the dominant social spaces within the Black Public Sphere of the twentieth century. Soul music represented the construction of "hypercommunity" in that both physical and metaphysical notions of space and community, and all the political and social meanings that underlie such formations, converge within its aesthetic sensibilities. Thus soul music became the ideal artistic medium to foreground the largest mass social movement to emerge from within the African-American experience. As Cornel West writes:

> Soul music is more than either secularized gospel or funkified jazz. Rather, it is a particular Africanization of Afro-American music with intent to appeal to the black masses, especially geared to the black ritual of attending parties and dances. Soul music is the populist application of be-bop's aim: racial self-consciousness among black people in light of their rich musical heritage.[27]

While the blues tradition of the early twentieth century represented a precursor to the purpose that soul would serve after the midcentury, soul singularly emerges in its role because of its conscious deconstruction of black church music, effectively reanimating the most politically benign aspects of the mid-twentieth-century black church, to reconnect the social functions of the black church with the populist demands of the black working class.

Within this historical context, the soul singer emerges as the popular representation of an emerging postcolonial sensibility among the black community, despite the perpetual constraints placed on black public expression

that could be deemed as expressions of resistance. Scarry's work suggests that this phenomenon is directly related to the incidence of pain. In *The Body in Pain* she writes:

> Because the person in pain is ordinarily so bereft of the resources of speech, it is not surprising that the language for pain should sometimes be brought into being by those who are not themselves in pain but who speak on behalf of those who are. Though there are very great impediments to expressing another's sentient distress, so are there also very great reasons why one might want to do so, and thus there come to be avenues by which this most radically private of experiences begins to enter the realm of public discourse.[28]

Emerging at a moment of intense commodification of black musical expression, the soul singer is on a par with the liberal bourgeois leaders of the community as the dominant icons of freedom and liberation.

The forerunner of this cultural development was a very talented blind jazz pianist from Seattle, Ray Charles. Heavily influenced by the instrumental jazz of the King Cole Trio, Charles began to assert his blues and gospel roots during the mid-'50s. With recordings like "I Got a Woman" and "What'd I Say," Charles engendered rage in some audiences because of his use of profane subject matter in what was clearly a sacred musical context. As George suggests, Charles's project served to erode unnecessary boundaries within the black community:

> This sound, not yet called soul, emphasized adult passion.... By breaking down the division between pulpit and bandstand, recharging blues concerns with transcendental fervor, unashamedly linking the spiritual and the sexual, Charles made pleasure (physical satisfaction) and joy (divine enlightenment) seem the same thing. By doing so he brought the realities of the Saturday-night sinner and the Sunday morning worshipper—so often one and the same—into a raucous harmony. It was in this spirit that Charles's children began to multiply, begetting converts and boosting record sales.[29]

One of the most important of these initial converts was a young, Chicago-born son of a Baptist preacher. At the age of nineteen, after a stint with the Highway QCs, Sam Cooke was asked to join the legendary Soul Stirrers, the preeminent gospel quartet of the day. Cooke was an instant success on the gospel circuit because of his good looks and the brooding sensuality he infused into the music. It was only a matter of time before Cooke would permanently alter black popular music and instigate a phenomenon that inspired future generations of black church singers and fueled the burgeoning Civil Rights and Black Power movements of the '60s.

Cooke's transition from gospel to secular music was a significant acknowledgment of the economic opportunities within the black popular

music tradition. Michael Eric Dyson explains the significance of Cooke in a critique of the singer's performance of "Any Day Now":

> Sam Cooke evokes a world teeming with cultural nuances hidden from white society while gesturing to the future of pop music. Though Cooke is singing about going to Heaven, he masks a complaint about earthly restrictions on black life by pining for a day when there's "no sorrow or sadness/Just only complete gladness...." But it's the way Cooke bends the notes, shaping his desire for freedom in effortlessly undulated phrases.[30]

Cooke's use of what Smitherman identifies as "other-worldly" lyrics is firmly rooted in the black spiritual tradition in which such lyrics, when framed by tonal considerations, created rich political narratives. In that soul emphatically represented the secular purposes of the black church tradition, the traditional relationship of God and "man" also had to be redefined within the context of soul music's secular social concerns.

Cooke never repeated the success of his initial secular recording, "You Send Me," which was released in 1957, though he remained a consistent commercial artist until his death in 1964. Toward the end of his short life—Cooke was murdered under questionable circumstances at age thirty-three—Cooke began to refocus his energies on the business aspects of the recording industry. Though he recorded on the RCA-Victor label, Cooke published many of his own compositions through his own publishing company, KAGS, and co-owned the SAR recording label with close friends. SAR recorded several acts during its short time span, including the post–Sam Cooke Soul Stirrers. Based in Los Angeles throughout much of his professional career, Cooke was increasingly influenced by the burgeoning nationalist community in black Los Angeles, whose presence can be dated as early as the 1930s. Cooke was close to Muhammad Ali and knew Nation of Islam spokesman Malcolm X. Cooke's business decisions regarding the production and distribution of his own work would prefigure the nationalist narratives of the late '60s and early '70s.

The Sound of Young America: Motown and the Discourse of Black Middle-Class Mobility

Berry Gordy came of age in midcentury Detroit with ample access to that city's burgeoning hard-bop and rhythm and blues traditions, traditions immersed in unbridled expressions of sensuality and sexuality. A gifted and intuitive promoter, Gordy aborted a career as a professional boxer to write songs for rhythm and blues artists like Jackie Wilson, who recorded two Gordy-penned ballads, "To Be Loved" and "Lonely Teardrops," in 1958. Gordy's successes as a record promoter and songwriter led him to create a

recording label of his own, using his sister's company, Anna Records, as the foundation for his empire. Despite his early immersion in rhythm and blues, Gordy would wisely construct his cadre of youthful artists as the antithesis of classic rhythm-and-blues artists of the era. While sex could sell, Gordy understood that sex, particularly in the years before America's counterculture would assert itself, would never provide an adequate or acceptable context for black music's cross-cultural acceptance. This is, of course, in an era when white middle-class parents in America were alarmed by their young daughters' decision to forgo Frank Sinatra for a new form of music heavily indebted to black expressive culture and whose dominant icon was Elvis Presley.

Gordy was very clear about the role of Motown, ambitiously naming his music the "Sound of Young America." Though the urban blues and swing bands of the 1920s and 1930s, as well as the bebop movement of the late 1940s and 1950s, had successfully captivated a significant amount of young white audiences in their eras—as early as the 1920s, the Columbia label recorded black acts like Bessie Smith, Ethel Waters, and, later, Miles Davis and Johnny Mathis according to their individual popularity as opposed to the musical genres they were most associated with—Gordy astutely understood America's fascination if not obsession with youth, virility, and sensuality. White American fascination with black popular culture throughout the twentieth century is in part predicated in the notion that blacks were in fact the natural conduits for a more sensual, sexual, and orgasmic living experience.

Gordy and his family in part represented the importation of the New Negro onto the cultural landscape of the 1960s. This 1960s construct of the New Negro was based in the urban Midwest, and like the New Negroes of the 1920s, part of a generation of blacks born across an urban landscape far removed from southern experiences. The New Negro of the late '50s and '60s, personified in figures like Sammy Davis Jr., and boxer Floyd Patterson, simply did not aim to be accepted as part of the liberal bourgeois establishment but firmly believed that on the basis of their talent, hardwork, and work ethics, they were already a part of such an establishment, as witnessed by their presence in mainstream culture. Motown's sequined-dressed and shark-skinned-suited artists were the visual representation of these sensibilities. With none of the sexual tensions or politics that have in part defined the black popular tradition, Motown's presumably clean-cut artists simply shimmied the night away in several hundred two-minute, thirty-second segments that would change the landscape of American popular music.

The ascent of the Motown Corporation paralleled the significance of integration for many African-Americans during the early Civil Rights era. In an industry dominated by white corporate interests, the ability of a company owned and run by an African-American to thrive was significant and inspirational for the black community. Despite a lack of formal musical train-

ing, Berry Gordy Jr. was able to rely on his keen instincts and Washingtonian (Booker T.) work ethic to craft a pioneering entity in the popular music industry. Despite being an inspirational icon for the Civil Rights movement, Motown was firmly entrenched in the mechanisms and ideologies of the mass market and on the mass market's terms. Harking back to his own experiences working on the assembly line, Gordy modeled his operation after Detroit's own automobile industry; the quintessential example of mass production in America's market economy and an industry whose marketing strategies are themselves somewhat premised on the youthfulness or sexiness that their products represent for potential consumers. Gerald Early writes:

> His job at the Ford Plant, as Nelson George and other critics have pointed out, made him aware of how production can be efficiently organized and automated for the highest quality. At Motown in the '60s, producers could write songs and songwriters could produce, but artists, both singers and session musicians, were not permitted to do either; and with this type of control Motown put out a highly consistent product...Gordy also became aware that to keep his company going, it was necessary to provide a series of attractive rewards and incentives for hard work, as well as an elaborate system for shaming for laziness.[32]

Gordy's project surmised that the mass consumption of "soul," via an efficient mass-production process, was a natural corollary to broader efforts by blacks to integrate American society in general and corporate boardrooms in particular. As Reebee Garofalo acknowledges in regard to Motown's significantly white consumer base, a fact that would seem to imply or at least foreshadow the successful integration of blacks into mainstream American culture:

> In its early stages, the civil rights movement, as embodied by Dr. Martin Luther King, Jr., had two predominant themes: non-violence and integration. As other, more militant tendencies developed in the black community, such a stance would soon appear to be quite moderate by comparison. At the time, however, it seemed to many that the primary task facing black people was to become integrated into the mainstream of American life. It was in this context that Motown developed and defined itself.... Gordy once commented that any successful Motown hit sold at least 70% to white audiences. Working closely with Smokey Robinson on the label's early releases, he laid rich gospel harmonies over extravagant studio work with strong bass lines and came up with the perfect popular formula for the early civil rights era: upbeat black pop, that was acceptable to a white audience, and irresistibly danceable. This was the "Motown sound."[33]

Despite the generally apolitical lyrics produced by Motown, a song like the Martha and the Vandellas's classic "Dancing in the Streets" metaphorically contained alternative meanings within the context of black urban struggle. Given the political terrain during the early '60s, Gordy's strategy was pru-

dent, as the large white consumption of Motown recordings established Motown as a dominant influence within the popular music industry. Motown became a very visible icon of the economic and social opportunities afforded African-Americans during the early 1960s. Gordy's project legitimately transformed young working-class and working-poor youth—Diana Ross, Eddie Kendricks, and Smokey Robinson all grew up in Detroit's federal housing projects—into social icons that the traditional Civil Rights movement could appropriate in service to its own strategy for racial integration. Conversely, Motown's upward mobility was specifically defined by the sensibilities of mass-market culture, which increasingly used mass-mediated narratives of black middle-class success to counteract legitimate critiques from the traditional Civil Rights leadership.

As Motown continued to dominate mainstream airwaves, subgenres of soul emerged to undermine Motown's hegemony. Though some of these recordings would have mass-market appeal, much of this music would have a grittier and more unrefined sound that reflected a more "authentic" distillation of black musical expression.[34] Appealing to rural blacks in the south and the second wave of southern migrants in the Northeast and West, the music of the Chitlin' Circuit, best represented by recordings produced by the Stax company, offered an alternative to the polished rhythms produced at Motown. Though initially a white owned company—Jim Stewart and his sister Estelle Axton founded the company in Memphis in 1957—the Stax company was a major artery for the consumption of Chitlin' Circuit aesthetics. As Ellis Cashmore asserts, "The Philosophy behind Stax was to record what Stewart called community music: not the type of slick black music that was beginning to emerge from Detroit, nor the blues which was too rambling and untidy.... Stax wanted to build on the production techniques of rock n' roll, yet create something redolent of black authenticity."[35] The significance of this musical experience is witnessed in the subtle differences between northern and southern racism, as the unpolished and grittier nature of the "Memphis sound" represented a response to the more brutal and blatant forms of racism as reflected in the American South. The reality is that Stax's development underscored the economic power that black consumers historically possessed and would further cultivate decades later and the acknowledgment of that power, relative to the power of white consumers, on the part of white business people. The irony of course is that white record label owners, who may or may not have been sympathetic to the crises within the black community, help facilitate black music's role in providing spaces of recovery and political agency because of their economic aspirations.[36] While Motown arguably represented the business of soul, the music of the Stax recording company, Ahmet Ertegun and Jerry Wexler's operation at Atlantic Records, which distributed Stax's recordings until 1967 and others like Chicago's Brunswick, Vee Jay, and the Chess Brothers record companies arguably represented the practice of soul.

Mirroring Stax's own unpolished aesthetics, the working poor of the African-American diaspora very often eschewed the organized efforts of mainstream entities like the NAACP, the Urban League, and the Southern Christian Leadership Conference (SCLC) in lieu of more improvisational and covert responses. In an examination of a riot that developed during the SCLC organizational efforts in Birmingham during the summer of 1964, Robin D. G. Kelley asserts, "The rioters felt their own lives had been in jeopardy far too long. Despite the protestations of black leaders, the people of Birmingham's slums and segregated pool halls resisted injustice and oppression on their own terms, which included attacking police officers and taking advantage of the crisis to appropriate much needed or desired commodities."[37] Increasingly southern soul music became a dominant site of black working-class and working-poor resistance, even if such political resistance remained on the margins of cultural expression and political engagement. Motown's musical hegemony was further challenged as the reserved rage of the black poor in the South migrated to the urban North and West. Motown, like the mainstream Civil Rights leadership, was increasingly criticized for its inability to adequately address the totality of black life. Malcolm X, the Watts riots, and the failure of the SCLC Chicago movement all served as catalysts for a new political landscape within the African-American diaspora.

The Transformation of King: Black Power, the Urban North, and Mass-Market Mediation

In the autumn of 1965, Martin Luther King Jr. and the Southern Christian Leadership Conference announced plans to organize their nonviolent Civil Rights initiative in Chicago. The marches to Selma and Montgomery, Alabama in the summer of 1965 ended an era of black southern protest—an era largely defined by the experiences of blacks in the rural South. Motivated by the urban unrest that decimated the Watts district of Los Angeles during the summer of 1965, King set his sights on the often unacknowledged realities of northern segregation and racial oppression. This period represented a period of radical transformation for King, but in particular for the nature and scope of the African-American protest movement.

The traditional had Civil Rights movement gained significant momentum and support two years earlier with the desegregation gains achieved in Birmingham. SCLC's mass-market-mediated nonviolent demonstrations in May of 1963 garnered significant credibility for King and generated cursory support from mainstream Americans horrified by the violence directed at the demonstrators, particularly black youths. Ironically, many of Birmingham's black poor, who had legitimate concerns beyond the issues of desegregation that captivated the SCLC, were marginalized from efforts ostensibly designed

to improve their quality of life. While the Birmingham movement was a classic example of the failure of black middle-class leadership to adequately acknowledge working-class narratives within the diverse narratives of the traditional Black Public Sphere, the movement also provided a context to further galvanize support for federal legislation to adequately address the issues of Jim Crow accommodations and voting rights. Mass-market culture provided the conduit for the distribution and reproduction of the core narratives of the Civil Rights movement. Through television, mainstream Americans, particularly those in the North, could voice their tacit disapproval of the strategies of southern segregationists, without playing an active role in the most significant black social movement since the mid-nineteenth century.

The successful initiative in Birmingham as well as the late summer march on Washington, in August of 1963, foreshadowed the passing the Civil Rights Act of 1964, which outlawed racial segregation in public accommodations, and the Voting Rights Act of 1965, which protected all citizens' rights in the electoral process. Despite the legitimate impact of these acts, much of the real social movement during the era remained in the shadows of the activities of King and the SCLC. These activities represented the energies of vibrant counterpublic(s) who lacked the organizational skills of the SCLC, but remained a viable force in the movement.[38] Represented in part by both the progressive leadership of the Student Nonviolent Coordinating Committee (SNCC) and random acts of resistance by the working class and working poor of both the South and the urban North, this segment of the movement would be profoundly affected by the bombing of the 16th Street Baptist Church only eighteen days after the nonviolent march on Washington. As Lerone Bennett describes it, "The tempo of the Black Revolution changed now—nobody was playing."[39]

The Mississippi Summer Project, in which both black and white students from the urban North traveled to the Mississippi Delta to organize leadership and register voters, was one of the initial activities to counter the mainstream tactics of SCLC and the NAACP. Though three of these youths—Andrew Goodman, Michael Schwerner, and James Chaney—would lose their lives in a brutal exhibition of southern violence, the summer project served to significantly politicize American youths, by integrating the specific issues of both northern and southern locales. The summer of 1964 would generate a rift in relations between the SCLC and the SNCC that was never adequately repaired.

Vocalist Nina Simone, brought into the movement at the behest of her friend playwright Lorraine Hansberry used her travels on the Chitlin' Circuit to articulate her political commitment. Confronted with racial oppression in the Deep South and appalled by the Birmingham church bombing, Simone recorded "Mississippi Goddamn." Rarely heard on the radio and largely unavailable in the South because of distribution boycotts, the recording

remains one of the most trenchant and timely critiques of the segregationist South. Written shortly after she received word about the 16th Street bombing, Simone states of the recording:

> The idea of fighting for the rights of my people, killing for them if it came to that, didn't disturb me too much—even back then I wasn't convinced that non-violence could get us what we wanted. But Andy [her husband] was right: I knew nothing about killing and I did know about music. I sat down at my piano. An hour later I came out of my apartment with the sheet music for "Mississippi Goddamn" in my hand. It was my first civil rights song, and it erupted out of me quicker than I could write it down. I knew then that I would dedicate myself to the struggle for black justice, freedom, and equality under the law for as long as it took, until all our battles were won.[40]

Despite Simone's self-perceived distance from the movement, many within the movement viewed her music as an aural counterpart to the sit-ins, non-violent demonstrations, and prayer meetings that dominated the movement. Simone went on to record other Civil Rights anthems, including "Young, Gifted and Black" and "I Wish I Knew (What it Means to Be Free)."

Black urban locales in Los Angeles represented another incarnation of the black counterpublics that augmented the activities of the traditional Civil Rights movement. Black Los Angeles represented a rich though dormant legacy to the eradicated political left of the 1930s and 1940s, equally politicized by the trade unions who supported the burgeoning war industries of Los Angeles and the relative autonomy of what Gerald Horne identifies as "hyper-segregated spaces."[41] In the post–World War II period, Los Angeles was the most popular repository for a second wave of black migrants from the South and poorer parts of the Midwest. Like Harlem during the period immediately preceding World War II, the public institutions of the Watts district were overburdened by the increased population.

The events of August 11, 1965 represented the collective rage of a community marred by random police brutality, economic exploitation, and de facto segregation in housing and schooling. Circumventing its largely black middle-class leadership, the black masses of Watts and other sections of Los Angeles used an urban uprising to express their dissatisfaction with the quality of their lives. Premised on the Harlem riot of 1943, the Watts uprising of 1965 aimed to rebalance racial and socioeconomic relations in municipal Los Angeles. Fittingly, the catalyst for the explosion was an instance of police brutality. The Watts riots of 1965 would remain lodged in the national imagination and memory until the community exploded again some twenty-seven years later, again in response to police brutality and quality-of-life issues.

In many regards, Nation of Islam minister Malcolm X personified the bitter antagonisms voiced by the counterpublics of the Civil Rights movement.

National representative for the most visible nationalist organization during the period, Malcolm X was a recovering drug addict and criminal who was reformed by the Elijah Muhammad and the Nation of Islam in the early '50s. Embracing an unorthodox form of Islam, the Nation of Islam exhibited historical links to the brooding economic nationalism of Booker T. Washington and the cultural nationalism of Marcus Garvey. A self-taught organic intellectual and extraordinarily complex individual, Malcolm X eventually jettisoned the Nation of Islam's parochial notions of race and class and embraced mainstream Islam. Despite his broadening political perspectives, Malcolm X maintained his strident critiques of American racism and African-American exploitation. After his death in early 1965, some months before the Watts riots, a martyred Malcolm X becomes the symbolic icon in which many, including SNCC members disenchanted by the traditional Civil Rights movement, would embrace black nationalism. The public narratives of Malcolm X, in concert with the continued severity of the black southern experience and the physical presence of northern organizers in the South, became the galvanizing forces of an embryonic Black Power movement.

Martin Luther King's commitment to organize in Chicago and other urban centers in the North, while largely influenced by public narratives counter to those expressed by SCLC, highlight several changing dynamics for the traditional Civil Rights movement. Black life in the rural South was in part defined by its covert social spaces—spaces that allowed for the production and distribution of narratives highly critical of the limiting parameters of black life. Social spaces like the jook and church were both invaluable to the creation of narratives that undergirded the traditional Civil Rights movement in the South. While black urban life in the North was in part defined by the same overwhelming desire to create covert social spaces like those of the rural South and was in fact reinforced by the spatial logic of the industrial city, the urban unrest of the mid-1960s instigated a plethora of social conditions that undermined institutions within the traditional Black Public Sphere. Also, the social unrest of America's urban spaces, in concert with the high visibility of the Civil Rights movement and the continued influence of television news, exposed black urban life to America's mainstream. Without the formalized social networks that supported his grass-roots efforts in the South, King's organizational efforts in the North were in large part mediated through the prism of mass culture.

King parlayed earlier mass-culture mediation into a large, though fragile base of sympathetic support among mainstream whites. While images of Bull Connor endeared mainstream Americans to the African-American struggle, the fiery imagery of Watts served to demonize urban blacks among the same audience. King's commitment to address what he called the triple evils of "racism, extreme materialism, and militarism" would also help to demonize him among liberal allies and mainstream Americans alike. Challenged by the maturing radicalism of SNCC and rudimentary elements of the Black

Panther Party, King constructed a narrative of black social thought that linked the pervasive militarism of American activities in Vietnam with America's waning commitment to addressing the issues faced by blacks and poor people in urban spaces. In this regard King began to synthesize the most progressive elements of black radical thought with the prophetic and philosophical vision of the African-American church.

King's message represented a new dynamic in African-American resistance because it was accessible to a mass audience not exclusively defined by the parameters of black public life. The mass mediation of King's message, particularly given the increased influence of black nationalist thought, allowed him to reach a broader community of African-American and progressive whites. Such visibility led David Garrow to suggest that King "represented a far greater political threat to the reigning American government" during the last year of his life than at any other time.[42] Thus King's demands for increased levels of civil disobedience, conducted by large masses without violence, were in fact prophesied in his very mass-mediated demands. And so the 1960s progressed, mass consumer culture emerged as an unlikely conduit for black resistance narratives. This is not to suggest that King himself believed that the struggles of blacks and America's poor could be addressed solely through mass-mediated rhetoric, but that the radical narratives of mass social movements, like the Poor People's Campaign, could be effectively distributed across mass consumer culture.

The black popular music tradition remained privy to the changing dynamics of the black protest movement. Nowhere was this reflected more clearly than in the transformation of Aretha Franklin. Literally a child in the black church—her father was renowned minister C. L. Franklin—Aretha's musical development was predicated on the fact that the Sam Cookes, James Clevelands, and Mahalia Jacksons of the world were regularly in her family's living room on Friday or Saturday evenings. She recorded her first gospel album at the age of fourteen, and in 1961, with the blessing of her father, began her secular career with Columbia records. Aretha's Columbia recordings are a confluence of brilliance and failure, often both occurring in a single recording. On the one hand, many of her pop-jazz recordings placed her firmly within the tradition of Nancy Wilson, Billie Holiday, Jimmy Scott, and, most notably, Dinah Washington. But these recordings failed to illuminate her prodigious talents. No one, though, could have foreseen the developments that would occur when Aretha signed with Atlantic Records in 1967.

Accompanied by a group of white bluegrass and black blues and soul musicians, Aretha recorded "I Have Never Loved a Man." In retrospect, the notion of Aretha being the "voice" of the black liberation movement has been overstated. But there is no denying that the appearance of Aretha on the music scene, particularly the singular impact of her 1967 recording "Respect," galvanized many segments of the movement in a language that

was accessible in both working-class and petit bourgeois neighborhoods across the African-American diaspora. Patricia Hill-Collins writes of "Respect," "Even though the lyrics can be sung by anyone, they take on a special meaning when sung by Aretha in the way that she sings them. On one level the song functions as a metaphor for the conditions of African-Americans in a racist society. But Aretha's being a Black woman enables the song to tap a deeper meaning."[43] Writer Sherley Anne Williams adds, "Aretha was right on time, but there was also something about the way Aretha characterized respect as something given with force and great effort and cost. And when she even went as far as to spell out the word 'respect,' we just knew that this sister wasn't playing around about getting Respect and keeping it."[44] The power of Aretha Franklin illuminates the significance of spiritual transcendence, spirit possession, and tonal semantics within the soul tradition. The significance of Aretha, was her ability to articulate the essence of the Chitlin' Circuit aesthetic at a time when black humanity was being severely tested publicly and daily and was often reclaimed in this sphere. The fact that Aretha arrives as a highly public and commodified, though not wholly mediated product, is part and parcel of the discursive ruptures initiated by Malcolm X and the burgeoning Black Power movement. These tensions, which Franklin represented in a politically casual nature and Martin Luther King's assassination deepened, are realized in black popular recordings from the era.

An example of some of the vitriolic narratives of the period can be heard in the recordings of the jazz-poetry group The Last Poets. Predating Gil Scott-Heron's "The Revolution Will Not Be Televised" by three years, the Last Poets, which alternately featured group members Gylan Kain, David Nelson, Felipe Feliciano, Abiodun Obeyole, Umar Bin Hassan, Suliaman El-Hadi, and Alafia Purdin, offered passionate and trenchant critiques of the black community and their conditions within western society. The Last Poets critiqued individuals defined and rooted in archaic definitions of blackness and black professional athletes who allow professional sports to exploit their talents, suggesting these ideas and activities are counter to the revolutionary needs of the larger community. With a limited distribution, The Last Poets's "Niggers are Scared of Revolution" represents significantly different commercial terrain for black artists, though their debut recording, *Right On,* sold more than three-hundred thousand copies and even dented the Billboard album charts. At the same time radical changes occurred regarding acceptable public narratives from African-Americans in a relatively short period. For example, when Sam Cooke's "A Change is Gonna Come" was released posthumously in the spring of 1965, the verse containing the lyrics, "I go to the movies and I go downtown, somebody keeps telling me, don't hang around" was deleted for fear of offending Cooke's white listeners in the South. The recording would not appear in its original context for another

twenty years. Less than five years later, such offenses were not only tolerat-
ed, but were integral to the marketing and distribution of popular black
expression.

The subtle transformation of the music of Curtis Mayfield and the
Impressions is also instructive in this regard. Mayfield, a product of Chicago's
notorious Cabrini-Greene housing project, began his recording career as a
member of the Impressions in 1958 at the age of sixteen. After the band's first
major hit "For Your Precious Love," lead singer Jerry Butler left the group to
begin a solo career of some distinction. Vee-Jay Records, sensing that Butler
was the real talent within the group, dropped the remaining members from
their label in 1959. The group reformed in 1961 to record "Gypsy Woman"
for the ABC-Paramount, following with a string of very popular and well-
received recordings which were often foregrounded by a lilting rhythmic
swing and inspirational though politically innocuous lyrics, firmly rooted in
the black church tradition. Mayfield originals like "People Get Ready," "Keep
on Pushing," and Jester Hairston's "Amen," effectively secularized black spir-
ituals for mainstream audiences, though unlike Ray Charles, the Impressions
did so while maintaining some semblance of religious discourse.

As Robert Pruter discloses in his work *Chicago Soul,* the soft-soul of the
Impressions was precisely the style of black music that ABC-Paramount
thought had the most commercial viability.[45] But as Geneva Smitherman's
work suggests, subversive lyrics were always in the eyes of the "black"
beholder. For example, as theologian William C. Turner, Jr. suggests in his
interpretation of the group's "Keep On Pushin:"

> Pushing out into the larger world from the womb of the black community was
> the mission of the Impressions' generation. With the help of these gentlemen of
> song, "pushing" took place to the tune of music that had long been the proper-
> ty of black people. "Keep on Pushing" was the needed encouragement when
> suddenly we were among the few of our race in the newly integrated schools....
> We were the objects of observation and suspicion. Thus for those who integrat-
> ed dormitories, football squads, glee choirs, and fraternities, it did a world of
> good to hear melodic strains that said, "Keep on pushing." Without pushing we
> would have been bruised and hurt.... Pushing was the posture that produced
> our future.[46]

Turner's comments, which clearly articulate the position of the moderate
segment of the black community, suggest that the music of the Impressions
was appropriated to serve the political sensibilities of a wide range of polit-
ical ideologies incorporated within the rubric of the Civil Rights and Black
Power movements. This again highlights the tremendous currency the soul
genre generated in its ability to articulate the perspectives of a broad range
of African-Americans for mainstream consumption. But as the tenor of the
Black Power movement began to inspire more militant responses among the

black youth masses in particular, even the messages of Curtis Mayfield and the Impressions began to reflect the new political terrain.

The single "We're a Winner" was released December of 1967 and featured a funky drum beat that was clearly influenced by the innovations in syncopated black music that I detailed earlier. Recorded with a live studio audience, the sound of a woman's voice stating "aw sock it to me," is one of the more memorable moments in the recording. But as Pruter suggests, black radio did not respond as effectively to the demands of the Black Power movement, at least in regards to the new terrain for black popular music, and very often chose not to play music that was overtly political. Given the crossover appeal of the Impressions, a recording like "We're a Winner," with its anthemlike theme of self-determination and demands for political expediency, would prove highly problematic for white radio programmers and ABC-Paramount. For example, station WLS, which controlled a significant chunk of the national radio market, refused to play the track. Perhaps in response to or because of Mayfield's new found militancy—At twenty-six, Mayfield was of the same generation that dominated organizations like SNCC and the Black Panthers—Mayfield and ABC-Paramount parted ways in the summer of 1968. For the remainder of the decade, Mayfield and the Impressions would record on Mayfield and Eddie Thomas's independently distributed Curtom label.

The change not only reinvigorated the trio's commercial potential but facilitated their most overtly political recordings like "This is My Country," "Check Out Your Mind," and the now classic "Choice of Colors." Such recordings also formed the springboard for Mayfield's subsequent emergence as a solo artist, where he was able to investigate a full range of black communal issues from a very personal perspective. His soundtrack recording for the Gordon Parks Jr.s film *Superfly* is perhaps most emblematic of his work from that period and clearly represents the praxis of Black Power in both his music and his business dealings, as Mayfield, like Sam Cooke before him, countered the general tendency of black artists to exhibit very little control over their artistry or their products, by applying sound business practices to the nationalist politics that he expounded. Mayfield's and King's transformations mirrored the general aura of change that pervaded the African-American Diaspora, that would force many black artists to reevaluate the significance of their music, including the "crown prince" of Motown, Marvin Gaye.

From Protest to Climax: Black Power, State Repression, and Black Communities of Resistance

Nonviolent protest must now mature to a new level to correspond to heightened black impatience and stiffened white resistance. This higher level is mass civil disobedience. There must be more than a statement to the larger society, there must be a force that interrupts its functioning at some key point. That interruption must not, however, be clandestine or surreptitious. It must be open and, above all, conducted by large masses without violence.

—Martin Luther King Jr. *

There may be no period in twentieth-century America that witnessed more state-sanctioned repression against African-Americans than the period from 1968 to 1972. The election of Richard M. Nixon, in concert with the continued surveillance and destabilization activities of J. Edgar Hoover's Federal Bureau of Investigation (FBI), left lasting impressions on the Civil Rights/Black Power movements, the American Indian movement, and radical elements of the white left. With blatant attacks on the Black Panthers—the December 1969 murders of Mark Clark and Fred Hampton being indicative—the shootings of black students at Jackson State College in Mississippi and Southern University in Louisiana, and assaults on prisoners at Attica state prison in New York, the government made clear that being a dissenter—particularly an African-American dissenter—was very dangerous. In the midst of blatant state repression of black political expression, singer Marvin Gaye would, against Motown's wishes, record and release what has come to be recognized as the quintessential black protest recording.

Released in the spring of 1971, the title track and lead single from *What's Going On* sold more than a million copies. Included in Gaye's musical broadside were overt concerns about inner-city deterioration, drug addiction, child abuse, the crisis in spirituality, the war in Vietnam, political activism, and the deteriorating environment. The influence of Gaye's recording can be seen in the number of artists from diverse spheres who recorded compositions from the recording. Both Gil Scott-Heron and Grover Washington recorded "Inner City Blues," while Donny Hathaway and Rahsaan Roland Kirk used their formidable skills to record versions of "What's Going On." In the ultimate compliment, Aretha Franklin recorded a version of the recording's somewhat obscure "Wholly Holy." Both a tribute to Gaye and his vision, these recordings reflect a broader commitment on the part of black artists to musically augment the black protest tradition of the 1960s and early 1970s.

It is within this context that the musical voices of black women reemerged to deepen the texture and nuances of the black protest movement. Inspired in part by the rapid ascension of Aretha Franklin as a major purveyor of the black popular music tradition, a small cadre of black women song stylists emerged to bring depth and balance to the raw rage that framed the music of many black male artists. Central to the project of black women artists like Esther Phillips and Linda Jones was an unmediated acknowledgment of the pain and experiences of contemporary black women. In this regard, I argue that the music of these artists, like their contemporaries Aretha Franklin and Nina Simone, served as the soundtrack to the explosion of black feminist fiction that emerges during the decade of the 1970s, while also providing fertile creative ground for black male artists like Eddie Kendricks, who recorded his own profeminist recording "Girl, You Need a Change of Mind."

The quality and breadth of black protest art during the late 1960s and early 1970s is perhaps unmatched in any other historical moment. Underlying many of these vibrant expressions of political and cultural resistance were efforts to maintain the very communities of resistance, that produced a black discourse of protest. An early harbinger of the massive erosion of black public life in the 1970s and beyond, black communities of the era were by and large defined by random violence, a heightened military (police and national guard) presence, and a general decline in the safety and stability of their public institutions. With the subsequent demise of accessible social spaces—forums that in many regards help to shape and define the black popular music tradition—many artists attempted to aurally reconstruct these social spaces via "live" recordings. Appropriating the contemporary example of the black church experience and chronicled examples of black communal exchange, these recordings highlight the call and response practices inherent to black expressive culture. In this regard, these recordings

helped to electronically document the black popular music tradition in its natural and intended context, while offering artists opportunities to maintain aesthetic credibility within an increasingly inaccessible public constituency.

Agents of Repression: Hoover, Nixon, and Black Communities of Resistance

The period following the assassination of Martin Luther King Jr. was the most volatile period, domestically, in twentieth-century American life. King represented the last vestige of the traditional southern-based Civil Rights movement that dominated both the popular imagination and discourse of the nation in the early 1960s. The ascendance of both Martin Luther King and John F. Kennedy perhaps represented the apex of liberal bourgeois influence since the post–Civil War/Reconstruction period of the nineteenth century, thus explaining the popular belief that the Civil Rights movement and the legislation that it spurred represented a second "Reconstruction" period.[1] The subsequent assassinations of King, Kennedy, and Robert Kennedy were generally understood as thinly veiled attacks on liberal bourgeois influence within national political and social narratives. Though King's later years mark a break with the traditional liberal bourgeois establishment, King was still largely associated with a more moderate approach to social change, particularly for those who held King as the last symbolic obstacle against America's approaching anarchy. Ironically it was King's willingness to embrace more radically progressive critiques of American morality and militarism that galvanized black communities of resistance, thus bringing America to the brink of either radical social transformation or the total suspension of the general rights and privileges of its most outspoken critics and constituencies.

In an era best defined by the attempts of black communities of resistance to speak "Truth to Power," power responded emphatically with violence and little regard for the legal rights of its critics. By speaking of communities of resistance, I am suggesting that various class, generational, regional, and ideological communities embraced the Civil Rights or Black Power movements as legitimate symbols to organize based on local struggles. COINTELPRO would be the administrative guise for J. Edgar Hoover's counterintelligence initiatives against the most progressive elements of the black protest movement. Developed largely to monitor and contain domestic communism or activities thought to be closely associated with communist sensibilities, COINTELPRO began surveillance of Martin Luther King Jr. during the early 1960s because of purported links with alleged communists Jack O'Dell and Stanley Levinson.[2] Though Levinson's role, often conflated with that of Bayard Rustin, was more in line with that of an executive assistant than that of a communist ideologue, his presence warranted the attention of an FBI

hierarchy less than a decade after the "House Un-American" witch hunts of the 1950s. Hoover, for his part, had been instrumental in the harassment four decades earlier of black political leaders A. Philip Randolph, Chandler Owen, and Marcus Garvey.

Early COINTELPRO efforts against King largely centered on wiretapping for the explicit purpose of gathering information on communist influences on King and the Southern Christian Leadership Conference (SCLC). Surveillance efforts were upgraded during the mid-1960s in an effort to publicly discredit King by distributing evidence of King's purported infidelity for public consumption. In either case, King was the primary target rather than the burgeoning protest movement that King helped to instigate and was attempting to reconstruct and redirect by 1966. With the public split between King's SCLC and the then-nationalist-minded SNCC in 1966, increased attention began to be paid to the young radicals, who could no longer be tamed by King's nonviolent and moderate appeals for racial justice. Marching together one last time, in support of James Meredith's aborted one-man march through Mississippi, the two parts of the famed traditional Civil Rights alliance made a very public split as King and Stokely Carmichael, leader of the SNCC, spiritedly debated the direction of the black protest movement in front of the reporters who covered the march.[3] Though the march ended in violent disarray—a clear sign of the changing dynamics of black protest after the Watts explosion in 1965—it provided the stimulus for the first major public pronunciations of "Black Power." King's subsequent assassination in April of 1968 laid the foundation for one of the most brutally repressive eras in the American twentieth century. The most openly hostile of these repressive attacks were lodged against the most visible and outspoken proponents of Black Power: the Black Panther Party.

Founded in the Oakland/San Francisco Bay Area, the Black Panther Party represented the cutting edge of the new cadre of organizations who offered to revise the dominant model(s) of black protest. With a largely urban working-class and working-poor constituency, weaned on the martyrdom of Malcolm X, the Panthers articulated the rage that King was either incapable or unwilling to expose. Like King and Malcolm X before them, the Panther leadership understood the dynamics of black rage and mass consumer culture. Stylishly dressed in black leather and berets, and carrying semiautomatic rifles, the Panthers presented a commercially accessible revolution, dominating both newspaper headlines and television news stories. In reality, the organization began as a tightly knit, grassroots organization solely dedicated to protecting the rights, legal and otherwise, of its core constituency. With the passing of King and to a certain extent Robert Kennedy, the Panthers represented a new revolutionary vanguard, usurping even SNCC's influence on a protest movement in severe flux.[4]

The brisk growth of the organization—its membership rumored at five thousand at the end of 1968—speaks both to the organizational efforts of the

group, but also the visual appeal of the organization to a constituency accli-
mated to the iconography of the black Christian church and a cautious main-
stream leadership. In an era when black pride abounded, the Black Panther
Party was perhaps the apex of this newly articulated race pride. But the mete-
oritic expansion of the organization ultimately distanced the group from its
core objectives and exposed it to petty tensions. The dissension was
enhanced by the presence of FBI operatives within the national and regional
hierarchy of the organization. One of the lasting legacies of the Black Panther
Party's growth is that it seized Hoover's unyielding attention, making the
organization the first national black organization to be targeted for unprece-
dented surveillance, disruption, suppression, and ultimately destruction.[5]

Against the Panthers, the bureau used eavesdropping, harassment, the
dissemination of misinformation, infiltration, "bad-jacketing," and, in a
worst-case scenario, outright murder. The Panthers were often forced into
unwarranted skirmishes that were instigated, often illegally, by law enforce-
ment agencies and propelled by the need of party members to defend them-
selves and party offices. Given the black protest movement's propensity to
essentialize Black Power and Black Power proponents into rigid racial, ide-
ological, and increasingly gendered constructs, the FBI's practice of bad-
jacketing was particularly effective. Bad-jacketing "refers to the practice of
creating suspicion—through the spreading of rumors, manufacture of evi-
dence, etc.—that bona fide organizational members, usually in key posi-
tions, are FBI/police informers, guilty of such offenses as skimming organi-
zation funds."[6] The practice in most cases isolated key figures from their con-
stituent base and prompted their removal, often at the hands of a fellow
organizational member or rival organization, thus removing the bureau from
any literal association to the deed.[7]

The most blatant example of the FBI's counterintelligence activities was
the pre-dawn raid that caused the death of Chicago party members Mark
Clark and Fred Hampton. In a pattern that was representative of most COIN-
TELPRO efforts against the Panthers, Hampton was identified as a highly
capable agent of black struggle whose increased stature and visibility could
energize the engines of the black protest movement. Hampton would
assume leadership of the Illinois state branch of the Panthers at the age of
twenty in early 1968. Hampton's age and access to the national party hierar-
chy, along with his stunning talents as an organizer and orator, made him a
prime target for Hoover's initiatives—more than four thousand pages docu-
mented Hampton's activities in the two years that he was involved in the
black protest movement.

In late 1968, William O'Neal, a petty car thief, infiltrated the Black
Panther Party leadership on behalf of the Chicago FBI field office.[8] O'Neal
quickly rose through the local hierarchy, becoming the Chicago minister of
defense and Hampton's personal bodyguard. The Chicago FBI field office
made definitive moves against the Black Panther Party in Chicago through-

out 1969, including the trashing of Panther offices.⁹ Hampton was arrested and prosecuted on trumped-up changes of stealing $71 worth of ice cream. The arrest was no doubt the beginnings of a bad-jacket effort against Hampton, particularly since Hampton came to the party at the behest of Carmichael confidante Bob Brown. Hampton in fact assumed leadership of the Illinois Panther Party after bad-jacket efforts against Carmichael instigated a break within the SNCC/Panther alliance. Hampton was able to obtain an appeal bond and continued his organizational efforts, assuming an increasingly visible national profile throughout the late summer and autumn of 1969, which to the FBI meant, "Stronger measures were clearly needed if Hampton's effectiveness and imminent ascendancy to national leadership were to be thwarted."¹⁰

In November of 1969, with O'Neal's assistance, FBI leaders in Chicago began to construct plans for an arms raid—O'Neal successfully influenced the Chicago Panthers to arm themselves and their offices for increased protection—that would serve as a guise for a surprise attack. Using precise floor plans that O'Neal delivered to his FBI superiors, the FBI and the Chicago Police Department began a predawn raid on December 4, that ended in the mortal wounding of Mark Clark and Hampton and the wounding of several other party members.¹¹ Though initially described as justifiable homicides, community pressure and the presence of more objective news media forced a more balanced investigation of the raid. Though the FBI's role in the effort was never publicly acknowledged or questioned, the families of the slain Panthers were eventually awarded damages in the early '80s as a result of a wrongful-death suit filed initially on behalf of Hampton's mother, Iberia, in 1970.

The killing of Hampton and Clark underscored the mounting opposition to radical social movement both within and beyond the black protest movement. Four short days after the Chicago raid, FBI operatives in Los Angeles raided the local Panther offices in a similar fashion. Campus skirmishes at Kent State University in Ohio and Jackson State College in Mississippi resulted in the deaths of college students at the hands of law enforcement and military forces. Within the vortex of mass political rallies staged both within and beyond college campuses, were sharp critiques of America's role as the maintainer of global law and order. As young protesters questioned America's use of force in Southeast Asia, they were introduced to the brunt of such force on the very campuses and streets where they marched. While President Richard Nixon cannot be directly associated with the disruptive activities of Hoover and the FBI, he is culpable for the general aura of political repression which pervades the period directly after the King and Kennedy assassinations. Further, Nixon's election was largely premised on his commitment to bring America back from the brink of anarchy and radical social change under the guise of sustaining "law and order."

The escalation of J. Edgar Hoover's counterintelligence program in concert with Richard Nixon's tacit approval of covert and overt political repression would be the death knell to a definitive moment in the black protest movement. Accordingly, this transformation from protest to silence would reverberate within the black popular music tradition. Understood in full context, the growth of the Black Panther Party and other black nationalist organizations represented the emergence of diverse communities of resistance that were not necessarily formal members of any political organization, but that embraced the codes and symbols of black nationalist rhetoric. Within a social movement increasingly mediated by mass consumer culture, black nationalism could too easily be reduced to cries of "Black Power," "Black Capitalism," and the raising of "Black Power" fists. As an example, the travails of Tommie Smith and John Carlos at the Mexico City Olympics in 1968, as a mass-mediated event, perhaps did more to expose Black Power sensibilities to America's mainstream public.

The absence of a cogent and congruous ideological base, and the increasing constraints of black political expression, reduced the black protest movement to dated and uncritical tropes of black empowerment and masculinity. The movement was increasingly removed from the daily realities of black life and instead defined by mass-market mediation. Thus James Brown's "Say it Loud, I'm Black and I'm Proud," along with the Afro and dashiki, became emblematic of the limits of black political discourse. In the context of post-King black politics, the articulation of black pride replaced the articulation of real political strategies to address the black condition. Much like the rhetoric of the New Negro/Harlem Renaissance period, black political discourse was reduced to issues of black identity and most notably black male and heterosexual identity, with Malcolm X as the martyred icon and the Black Panther Party and SNCC as the most visible purveyors. This is not to say that black popular music simply became an aural conduit for a "feel good" blackness; on the contrary the period of 1968–1972 was probably the most significant period for music devoted to the dominant themes of black struggle and social movement.

"What's Going On": Mass Markets, Social Movements, and the Marvin Gaye Trilogy

As the organized struggles for African-American empowerment intensified and subsequently migrated North to urban centers, the black popular music tradition began to convey the urgency of its historical moment. The Chicago soul of Curtis Mayfield and the Impressions, the southern-inflected New York-produced soul of Detroit's Aretha Franklin, the rudimentary Philly sound of The Intruders, and of course the syncopated political broadsides of

James Brown were early indicators of imminent changes within black popular music, particularly after the emergence of San Francisco's Sly Stone and Motown producer Norman Whitfield. Both Stone and Whitfield helped construct new narrative and aesthetic terrain for the soul music tradition—a genre that by the late 1960s barely reflected the organic elements that Ray Charles advanced in the early to mid-1950s. While much of this is clearly owed to technological advancements in the production and instrumentation of soul—the electric bass guitar figured prominently in the music of Stone and Whitfield—soul also began to reflect the broadly interpreted populist concerns of a largely black, urban-based working class.

Perhaps no one musical artist was as effected by the volatility of African-American life and music during this era than Marvin Gaye. Gaye, whose career was reinvigorated in the late 1960s by Whitfield's production on tracks like "Too Busy Thinking About My Baby" and "I Heard It Through the Grapevine," emerged from a self-imposed professional hiatus and recorded what is generally regarded as the seminal black protest recording. With *What's Going On,* Gaye, with the assistance of modern recording technology and a bevy of cowriters, crafted a musical tome which synthesized the acute issues within black urban life, with the prophetic and existential vision of the African-American church. In doing so, Gaye effectively summarized the hopes and despair of an entire generation of African-American freedom fighters whose primary icons were common, God-fearing, everyday black folks whose primary revolutionary charge was to transcend absurd and bizarre circumstances immediately and often.

Gaye's work after *What's Going On* also reflected a radical transformation, as corollary to the changing dynamics of the black protest movement. The increased militarization of the nation's law enforcement agencies as well as calculated and covert state-sponsored attacks against the black protest movement's most progressive elements, helped transfigure the black protest movement into a social movement of limited potency. I maintain that Gaye's trilogy of early 1970s recordings, namely *What's Going On,* his little-regarded soundtrack recording for the film *Trouble Man,* and the highly erotic and commercially successful *Let's Get It On,* aurally document, with stunning clarity, the demise of the progressive black protest movement. While my thesis is arguably a radical reevaluation of Gaye's body of work, I believe it does help place black social movement and the black popular music tradition in a context that acknowledges the pervasive and expansive influence of mass consumer culture.

The mass commodification of the black protest tradition, as represented in the diverse work of Sly Stone, Nina Simone, Melvin Van Peebles, Amiri Baraka, James Brown, Martin Luther King, the Black Panthers, and even elements of the largely mainstream Motown company, represents an apex in the black protest expression. For instance, the visibility of King's largely

commodified and mass-mediated image helped to popularize the core attributes of the Civil Rights movement. Recordings like Simone's inflammatory broadside "Mississippi Goddamn," the Les McCann/Eddie Harris collaboration "Compared to What," Julian "Cannonball" Adderley's "The Price You Got to Pay to Be Free" which featured lyrics and vocals from fifteen-year-old Nat Adderly Jr., or Eugene McDaniels's esoteric *Headless Heroes of the Apocalypse* were emblematic of black popular music's new aesthetic and narrative license. Even the Motown recording company, which consciously distanced itself from the black protest movement's most radical elements, articulated black protest narratives in the form of Norman Whitfield-produced tracks like the Temptation's "Ball of Confusion" and "Message to the Blackman" and the distribution of King and Stokely Carmichael speeches on the company's *Black Forum* label. It is along this narrative landscape that Marvin Gaye released *What's Going On.*

Released in 1971, *What's Going On* culminated a volatile period in American history and in Marvin Gaye's own personal life. Dealing with the personal demons of drug addiction, depression associated with the death of singing partner Tammi Terrell, and his brother Frankie's service in the Vietnam War, Gaye produced a singular protest statement readily accessible within mass consumer culture.[12] Conflating his personal experiences with those of a broadly defined black public, Gaye's recording was released at a time when the black protest movement and the communities of resistance within it were being altered by forces both internal and external to the African-American experience. In this regard, Gaye's recording climaxed an era of black protest activity as well as synthesized many narratives of protest within the African-American experience.

I maintain that the centrality of Gaye's recording to the black protest tradition and mass-market culture should be interpreted as one incarnation of the nonviolent mass civil disobedience that Martin Luther King demanded shortly before his death. Genuinely interpreted by mass consumers as an overt political statement, *What's Going On,* particularly given its ability to synthesize black progressive thought, represents a clear transgression of historical assumptions about the limits and parameters of black political discourse, particularly in a moment when such discourse is clearly under siege. Gaye was largely able to create this synthesis by aurally re-creating the very communities of resistance that state-sponsored assaults like COINTELPRO targeted.

What's Going On was the first recording that allowed Gaye to technologically layer his three distinct vocal ranges—falsetto, gospel shout, and smooth midrange—for the purpose of creating a Marvin Gaye choir, which metaphorically and aurally reconstructed the various communities of resistance which undergirded black social movement in this era. Stanley Crouch writes of Gaye's work:

His is a talent for which the studio must have been invented. Through over dubbing, Gaye imparted lyric, rhythmic, and emotional counterpoint to his material. The result was a swirling stream-of-consciousness that enabled him to protest, show allegiance, love, hate, dismiss, and desire in one proverbial swoop. In his way, what Gaye did was reiterate electronically the polyrhythmic African underpinnings of black American music and reassess the domestic polyphony which is its linear extension.[13]

The genius of Gaye's work is that by mimicking the diversity of communal voices, he popularized a dominant black social paradigm, precisely at the moment when communal relations within such a paradigm were increasingly fractured and disjointed. Thus Gaye not only synthesized an era of black protest narratives but perhaps documented the era's passing, framing the African-American experience through the very prism of postmodernity that has come to define contemporary American culture and in effect produced an aural and commodified text that could be appropriated by later generations. In this regard Gaye's recording serves as a precursory example of mass consumer culture's ability to commodify and ultimately codify mass social movements. This is not to celebrate the prevalence of mass culture mediated images in our lives, but again to highlight the increased influence of mass consumer culture on the production and distribution of the narratives of progressive mass social movements. The fact that *What's Going On* became the most profound and commercially accessible form of black social critique in the last twenty-five years is a testament to that influence.

The recording's lead and title track, "What's Going On," is a critique of the escalation of the armed conflict in Southeast Asia. The strength of Gaye's critique is manifested in the song's ability to highlight the effect of the conflict on the most basic unit within the American community: the nuclear family. Rather than a collection of politicized rhetorical strategies put to music, Gaye chose to personalize the conflict as he considered his brother's presence in Southeast Asia. Conflating the family unit with the example of a broader national community, Gaye linked the escalating war effort to the role of ruling patriarch of the traditional nuclear family and by extension, the ruling patriarchy of the nation. Gaye's critique is amplified by his well-documented relationship with his own father and the structures of patriarchy and power that his father wielded over Gaye's life. Gaye's critique of patriarchy, or at least the social functions of patriarchy, counters popular expressions of black patriarchy as a vehicle for black empowerment in the post–Civil Rights era and foreshadows the displacement of black men from the lower stratum of the labor force, though it is in the mode of laboring wage earners that black men do in fact invest in patriarchy.[14] The subsequent transformation of the political economy of the black family, in which black women have often become the dominant or only wage earners, has dominated the post–Civil

Rights discourse on the black family. At the heart of these tensions are redefinitions of the roles of black men vis-á-vis the social and political functions of patriarchy in the United States.

Within this context, Gaye also highlighted the demise of civil discourse, as the legal and legitimate protests of America's youth are met with the physical violence and political repression of the nation's ruling patriarchy and its militarized agents. Gaye's solutions to the deterioration of America's social fabric—a solution clearly indicative of King's influence on Gaye's work—was to reevaluate the role of human respect in the maintenance of civil discourse and basic familial relations and to suggest the democratization of traditional familial relations as a precursor to democratizing both national and global relations. Within the full context of the historical period, Gaye's recording is a critique of American imperialism abroad and America's rejection of its own democratic tenets domestically.

The recording's second track, "What's Happening Brother," moves beyond familial relations to address the erosion of communal discourse within the African-American community. Here Gaye's critical eye was focused on the demise of black public life, particularly as black public life was affected by massive unemployment, economic restructuring, and the general dispersion of the African-American community. Within the context of a musical suite consisting of six tracks including the title track, Gaye juxtaposed American imperialism, political repression, and communal erosion against the incidence of drug addiction, environmental exploitation, child neglect, and a crisis in spirituality. The suite as a whole offers a profound critical statement regarding the modern American condition.

Gaye coalesced many of these concerns within the recording's closing track. Perhaps the recording's most significant song, his "Inner City Blues," gives voice to a full range of issues associated with black urban life. "Inner City Blues" at once underscores the centrality of the blues form to black life and the changing demographics of the African-American diaspora. The mass northern migration of the post–World War II period, in which more than four million blacks migrated to northern and western cities, produced a distinct urban constituency. "Inner City Blues" gives presence to the silent masses of black working class and working poor who were displaced and dislocated from community, culture, and social stability—groups historically marginalized from organized and institutionally based struggles for justice and whose only other recourse for resistance, after the death of King, often took the form of improvised and misdirected rage and symbolic nationalist posturing.[15]

Once again the strength of Gaye's narrative was in his ability to link America's external forays into outer space and Southeast Asia with the internal demise of black urban life, a premise which serves as a subtext to the erosion of civility within the broader American community. The general mood of helplessness that pervades Gaye's text finds its resolution in the track's

subtext, "makes me wanna holler," again linking the soul music tradition to the rhetorical and polytonal resistance strategies of blacks in the antebellum period, but also highlighting the lack of an accessible political language to adequately critique the realities of black urban life. Ultimately Gaye offered no solutions, but presented a stunning portrait of urban bleakness. Gaye's commitment to address the issues of black urban life occured ironically at the moment that the Motown recording label, arguably the era's dominant icon of black material possibility, chose to abandon its black urban constituency in Detroit and relocate to Hollywood, after the urban insurrections of 1967 in Detroit, highlighting the larger example of black middle-class migration from America's central cities and into the suburbs. Ironically, it is Gaye's score for a Hollywood film that perhaps best exemplifies his role in documenting the demise of the black protest movement.

Two years after the release of *What's Going On,* Gaye released the commercially successful *Let's Get It On* recording. In the full context of Gaye's historical moment, Gaye's 1973 ode to black sexuality seems a bizarre follow-up to what has generally been regarded as the quintessential black protest recording. I maintain that Gaye's travels from black protest to black climax are the logical manifestations of the effects of pervasive state-sponsored violence aimed, successfully, at destabilizing the most radical elements of the black protest movement. Within this context, the period of 1968–1972 remains a singular moment in the twentieth century regarding black political discourse. With the subsequent corporate annexation of black popular expression—a process largely begun with the release of Sly Stone's *Stand*—the most radical elements of black political thought were again relegated to the covert spaces of the Black Public Sphere. Unfortunately, this occured precisely at the moment that the traditional Black Public Sphere was exhibiting signs of massive erosion—largely effected by black middle-class flight and the emergence of our current service-based, postindustrial economy, which transformed large segments of an urban-based black working class into an urban-based "underclass."[16] Such transformations are in fact intimated in Gaye's "Inner City Blues." Central to understanding Gaye's role in projecting the changing nature of the black protest movement is his little regarded soundtrack for the blaxploitation film *Trouble Man.*

The rather bizarre ending of Gaye's *What's Going On*—in which Gaye repeats the title track's opening couplet, "Mother, Mother, Everybody thinks we're wrong ...," while physically walking away from the very narrative terrain that he exposes throughout the recording—can be better understood after listening to the opening bars of the *Trouble Man* recording. Aside from the recording's title track, which in and of itself is reflective of the continued malaise of black urban life, the recording is a largely instrumental foray into elements of hard-bop and soul jazz. Given hard-bop and soul jazz's roles as soundtracks to black urban life during the 1950s and 1960s, Gaye

aurally reconstructs the black urban landscape, but minus the trenchant narratives that marked *What's Going On*. The narrative silence that pervades Gaye's recording evokes the ghastly silences that accompanied the smoldering ashes of riot-torn Detroit. I maintain that Gaye's decision to create an instrumental recording to address black urban life both on film and reality, is a logical response to state-sponsored attempts to silence such narratives through both covert and overt means, among progressive elements within the black protest movement, and a reflection of the general demise of a communal spirit of resistance. Whether Gaye's conscious attempted to address this issue is speculative at best—he was in fact heavily addicted to cocaine during the period and had always wanted to record a jazz album—one cannot ignore the significance of the Marvin Gaye "trilogy" to the larger issues associated with the demise of the black protest movement.

Issaac Hayes and Curtis Mayfield, both Gaye contemporaries, gave musical life to two separate cinematic treatments of black urban life. *Shaft* and *Superfly,* initiated a genre of black-themed commercial film, augmented with thematically conceived soundtrack recordings from popular black artists. While such films often extended the believable limits of black urban reality and black masculinity—the Robert Hooks's vehicle *Trouble Man* does little to break these conventions—their soundtracks were often designed to take aesthetic risks, not normally associated with more conventional commercial product. Both Hayes's *Shaft* and Mayfield's *Superfly* offered genre-bending fusions of soul, funk, and contemporary jazz, with substantial commercial value.[17] Both recordings and films gave birth to a generation of soundtrack recordings that celebrate the unleashed black *ubermensch* and his highly eroticized urban masculinity. Dominant themes within many of these films were standard tropes of white racist conspiracies, black nationalism, oversexualized constructs of black femininity, and the reconstruction of patriarchal modes of black masculinity. This is not to deny that many of these soundtracks contained relevant social commentary; Mayfield's "Freddie's Dead" remains one of the most stark antidrug messages ever recorded. Hayes, awarded an Academy Award in 1972 for best movie song for the "Theme from Shaft," would assert his own critical view of black urban life on the soundtrack's "Soulsville."

Gaye's *Trouble Man* recording is perhaps less regarded because of his failure to create a soundtrack of ready-made singles.[18] The recording's title track, the only track released as a single, is in fact the only track with any substantial lyrics. Gaye instead coos and hums his way through most of the instrumental tracks, creating an eerie and troublesome aural landscape of black urban life. The recording's memorable title track is perhaps most remembered for the refrain, "There's only three things in life for sure, taxes, death, and trouble," effectively summarizing black urban life for a displaced working class and burgeoning underclass. "Trouble Man" differs from the

more popular "Superfly" and "Theme from *Shaft*" in that it is narrated in the first person, thus again highlighting Gaye's ability to conflate the personal with the communal. In the end, Gaye's opening line from "Trouble Man," "I've come up hard . . ." speaks more of a reality-based urban experience than much of the blaxploitation fare released during the era.

The narrative silence that undergirds Gaye's *Trouble Man,* particularly when contextualized with the narrative themes of *What's Going On* and post-King political repression, represented a conscious retreat from mass-market-mediated social protest. As a commercial product, *Trouble Man,* unlike the more commercially valuable *What's Going On,* could not be reduced or manipulated by mass-market sensibilities. Furthermore, Motown's desire to "cross over" is wholly related to the larger incidence of black middle-class flight from segregated black urban spaces and the black middle class' subsequent retreat from progressive black politics. In an era when progressive black political discourse was characterized as "anti-American" and "anti-law-and-order," the representative constituents of progressive black discourse were also demonized. In this regard, Gaye's subsequent return to the politics of love, sex, and spirituality is better understood, though *Trouble Man* prophetically anticipated the even darker urban terrain that hip-hop artists constructed a decade after the recording's release. *Trouble Man* remains one of the few Marvin Gaye recordings that have been sampled by contemporary hip-hop artists, the most recent of which was Brand Nubian's layering of the oratory of Louis Farrakhan over the recording's main theme.

Ironically, Gaye attempted to revisit the social commentary that propelled *What's Going On* into the national consciousness. Initially conceived as the title track of a larger project, part one of "You're the Man" was released as a single in late 1972 and included on a Marvin Gaye "greatest hits" package in 1973, released prior to *Let's Get it On.* Gaye's narrative is as trenchant, though more direct than any contained on *What's Going On.* Throughout the track, Gaye posits electoral politics as both the hope and bane of African-American empowerment. One of the last tracks recorded by Gaye in Detroit, "You're the Man" once again linked the demise of black urban life to the lack of economic development and employment opportunities. Recorded after the National Black Political Assembly in Gary, Indiana, Gaye's call for black political empowerment transcended specific racial allegiances in lieu of the best strategies for black empowerment. Gaye is ever more direct in the single stanza of part two of "You're the Man," which was not released in its entirety until 1995.[20] Using the proliferation of black elected officials as a backdrop, Gaye also criticized politicians who ask for black support without an active knowledge of their constituent base. Juxtaposing politicians and hypocrites, Gaye then reduced black political empowerment to issues of "peace and freedom" abroad and domestically. Ironically, Gaye recorded the

track a year before Coleman Young was elected to his first term as Detroit's first black mayor. A progressive radical during his formative political years as a labor organizer in the late 1940s and 1950s, Young rejected his core urban constituency throughout his career as Detroit's mayor, a tenure that was emblematic of the general failings and shortcomings of black America's first large generation of elected officials. In this regard, Gaye critiqued the nationalist underpinnings associated with black electoral trends in large urban cities, particularly since investments in a black political elite did little to circumvent the debilitating effects of life within black urban spaces, which began to erode as early as the 1950s.[22] "You're the Man" in this regard, functions as a prophetic warning against the possibility of black political chameleons and the limits of nationalism when symbolically expressed at the voting booth and divorced from the realities of municipal development.

While "You're the Man" both privileges and critiques black patriarchal leadership, it is silent regarding arguably the era's most significant black political story. Shirley Chisholm's ill-fated run for the presidency, partly premised on the failure of the largely male black political establishment to support her efforts, exposed problematic gender relations within the African-American diaspora. Such schisms were blatantly apparent in the tone and vision of a new generation of black popular artists, largely influenced by the strident political tomes of Nina Simone and Aretha Franklin. Defining black struggle on the broader axis of race and gender, black women artists like Roberta Flack, Marlena Shaw, and Valerie Simpson created musical counternarratives to the heroic black male soul singer.

For Gaye's part, *Let's Get It On* marked his return to the sexual and secular terrain, which his gruff vocals had suggested throughout his career. In context, the recording was an obvious retreat from the politicized narratives that the artist had produced during the early 1970s. The music on the recording was more reminiscent of recordings that Gaye wrote and produced for the vocal ensemble The Originals. In fact, many of the early tracks of what was eventually to become Gaye's *What's Going On* project were initially intended for The Originals. Written in three- and four-part harmony, recordings like "Baby I'm for Real" and "The Bells" evoked Gaye's formative years as a doo-wop singer, first as a member of the Marquees and later with the Moonglows—a genre of popular music that predates the political movements that embraced the soul music tradition. Furthermore Gaye constructed himself, via *Let's Get It On,* as the sexual object that his public persona alluded to, but that Gaye often rejected because of his own discomfort with visibility. Though Motown wanted to market Gaye in the vein of former black male sex symbols like Nat King Cole and Sam Cooke—Gaye recorded a tribute to Cole in 1965 and was long rumored to play Cooke in a proposed film of the late singer's life—he performed with several high-profile female vocalists to deflect attention away from him. Despite surface interpretations

of the recording's core themes, namely sex and lust, *Let's Get It On* can be interpreted within the context of the same political terrain that Gaye explored on earlier recordings.

Recorded during the height of the blaxploitation movement, *Let's Get It On* represents Gaye's willingness to reconstruct himself within the vein of the blaxploitation era's dominant icon, the black superstud. Though the absurd imagery of *Shaft, Superfly,* and *The Mack* would replace the real-life news footage of black social movement with exaggerated and superfluous expressions of black masculinity, sexuality, and patriarchy, critic Paul Gilroy suggests that there are political components to such expression. Gilroy writes:

> Gender is the modality in which race is lived. An amplified and exaggerated masculinity has become the boastful centerpiece of a culture of compensation that self-consciously salves the misery of the disempowered and subordinated. This masculinity and its relational feminine counterpart become special symbols of the difference that race makes. They are lived and naturalised in the distinct patterns of family life on which the reproduction of the racial identities supposedly relies.[23]

Thus Gaye's ode to black sexuality can be examined beyond the specific context of blaxploitation film, America's own heightened awareness of its sexuality (as expressed in literature like Erica Jong's *Fear of Flying*), or even the idea that sexual relations had become the acceptable terrain to explore African-American existence in post–Civil Rights America. Thus lyrics from the recording's "Please Don't Stay (Once You Go Away)," when interpreted within the broader historical context of the post–Civil Rights movement and the state's antiresistance measures against the Black Panthers and other radical organizations, suggest a deeper meaning. Take, for example, the refrain of "If I Should Die Tonight" from *Let's Get It On.* The stanza "If I should die tonight/Tho' it'd be far before my time/I won't die blue, Sugar/Cause I've known you,"[24] is invested with powerful oppositional meanings when considered within the context the early-morning massacres of Fred Hampton and Mark Clark in December of 1969, especially that of Hampton, who was killed in his sleep while lying next to his pregnant girlfriend. In this regard, Gaye's beautiful and haunting lullaby transcends simple interpretations, in that it highlights a very human relationship between Hampton and his partner, but also humanizes the increasing effects of repression on these relationships, particularly when one considers the urgency and passion of Gaye's vocals.

Such an interpretation of Gaye's work gains further credence based on Gaye's quoting of T. S. Eliot's unfinished poem "Sweeney Agonistes" in the recording's liner notes. Eliot's reduction of life to "Birth and copulation and death" is strikingly similar to Gaye's own summation of "taxes, death and

trouble" from "Trouble Man" and clearly a reference point for Gaye.[25] The poem examines an exchange between Doris the missionary and Sweeney the cannibal, a context which clearly suggest the process(es) of colonization and the struggle(s) against it. Both the war in Vietnam and African-American struggles for political and economic empowerment in urban spaces, the dominant themes of Gaye's social criticism, were postcolonial struggles that differed little from previous struggles against colonization.[26] Within the context of Eliot's poem, Sweeney's statement is invested with a profound sense of futility. Gaye's referencing of the poem clearly suggests the futility of his struggles in the face of a militarized and capitalistic patriarchy. Gaye's response was to reconstruct himself as a sexualized patriarch in the guise of the black superstud, a character that gained mythical status in the black community as an agent of empowerment in black celluloid fantasies like *Truck Turner, Shaft in Africa,* and *Superfly.*

Gaye never returned to the overt and covert political themes that marked his artistry in the early 1970s. His subsequent recordings after *Let's Get It On,* including the duet album with Diana Ross, *Diana and Marvin* (1973), *Marvin Gaye Live* (1974), *I Want You* (1976), and *Live at the London Palladium* (1977) lacked the social impact and aesthetic consistency of the early '70s recordings. Gaye's final two offerings for Motown, *Here My Dear* (1978) and *In Our Lifetime* (1981) both highlight troubles within Gaye's own life including drug addiction, infidelity, and divorce. The latter recording finds Gaye confronting the core tensions of many of his original compositions, that of the spirit and the flesh. These tensions are symbolically reflected in the cover art of *In Our Lifetime,* which finds Gaye dually represented as God and the Devil across a black-and-white-checkered tablecloth, while death and destruction loom beneath the two figures on Earth. Motown's release of the recording without Gaye's approval effectively ended his two-decade-old relationship with the label.

Gaye's political concerns were largely expressed in his conscious refusal to pay income tax throughout much of the period. It was this failure to pay his income taxes that forced Gaye into exile, first in Britain and later in Ostend, Belgium, where he collaborated with author David Ritz and Odell Brown on "Sexual Healing," the recording that would instigate Gaye's return to the states and a final moment of mass public acceptance. As an African-American expatriate, Gaye, like expatriates Richard Wright, James Baldwin, Chester Himes, and Josephine Baker, rejuvenated his creative energies. Gaye's only two Grammy Awards were earned for the recording, which was included on Gaye's first Columbia recording *Midnight Love* (1983). This new-found popularity framed, what was arguably Gaye's last political testament.

In February 1983, Gaye was asked to perform the National Anthem at the National Basketball Association's annual all-star game in the Pontiac Silverdome—a symbol of the region's economic and political resuscitation

after years of deterioration and neglect. The National Basketball Association was itself experiencing a resuscitation of fan interest after a decade of widespread drug and gambling scandals in professional and collegiate basketball. Berry Gordy's decision to relocate Motown to Los Angeles in the late 1960s was largely premised on the demise of civic life in Detroit, thus Motown's symbolic and ironic return during the city's rebirth, in the form of Gaye's performance carried significant meaning, particularly as Motown celebrated its twenty-fifth anniversary. The symbolic connection between the two corporate entities was further enhanced that Motown, like the National Basketball Association, was an emblem of black material possibilities in the post-Civil Rights era, as the demise of the automobile industry in postindustrial Detroit concurrently mirrored the erosion of a stable black working class in the region. It is within this context that Gaye chose his last foray into American political discourse.

Using a syncopated hip-hop-inflected Reggae back-beat, Gaye presented a highly personalized and deconstructed version of the "Star-Spangled Banner." Often referred to as a sacred text, Francis Scott Key's composition—afforded national anthem status in 1931 as vehicle to accompany America's drive toward empire and to nationalize European immigrants—is rarely performed beyond the parameters intended by its composer and in such cases when performed beyond these sensibilities, the performances have often been controversial. Such was the case when guitarist Jose Feliciano gave the composition a distinct Chicano inflection during the 1968 World Series. Performed during the height of anti-Vietnam and Black Power demonstrations, Feliciano's efforts were invested with a clear reference to the political discourse(s) of the era. Gaye clearly understood the context of his own performance of the composition and used the vehicle of televised sports, to once again politicize the presence of African-Americans in this country. Furthermore, Gaye's performance suggested that African-Americans had a right to "African-Americanize" the composition, because of the price they paid for American democracy, while highlighting African-American music's hegemony within American popular music and perhaps American popular culture, logically during an event which showcased African-American hegemony within at least one professional sport. Lastly, Gaye's musical text constructs a landscape which considers contemporary black urban culture—are not hip-hip culture and professional basketball two of the primary tropes of contemporary black urban culture—while also including a diasporatic construction of black urban life which considers the continued influx of Caribbean blacks on the black urban landscape.

Gaye was murdered by his father on April 2, 1984. The details of Gaye's death center on the late soul singer resisting the patriarchal impositions of his father on his ailing mother. Like much of Gaye's mature work suggests, such an attempt at resistance proved futile.

How Can I Ease the Pain: Black Popular Music and the Black Feminist Movement

In 1968, Shirley Chisholm became the first black woman elected to Congress. In the spring of 1972, she began a symbolic, but sincere pursuit of the Democratic Party's nomination for president. The broad alliances that under-girded the progressive political movements of the 1960s created an environment ideal for Chisholm's political aspirations. Eldridge Cleaver had gar-nered almost two hundred thousand votes in the 1968 presidential election in a campaign every bit as symbolic as Chisholm's but supported by a broad alliance of black nationalists and white progressive radicals.[27] Martin Luther King gave serious consideration to such a symbolic presidential campaign during the final months of his life. Given these prototypical considerations, Chisholm's candidacy, buoyed by the increased presence of African-American and progressive white liberals in electoral politics, should have been the focal point of efforts to institutionalize the protest agenda of the late 1960s. As the attacks on the black protest movement escalated, much of the fractured movement coalesced around the reconstruction and maintenance of a largely middle-class, patriarchal leadership. Chisholm's unwavering sup-port for fellow feminist and progressive radical Angela Davis, as well as her support for the efforts of the National Organization for Women (NOW), alienated her from the vanguard of black mainstream leadership.[28]

Ultimately Chisholm's candidacy was relegated to the margins of pro-gressive political strategy by racism on the part of white feminists and, more profoundly, sexism on the part of the ruling patriarchy of the black commu-nity. Within the parameters of black public life, Chisholm's efforts, like the efforts of her political foremothers in the National Association of Colored Women (NACW), were simply the counternarratives to a black political vision largely defined and maintained by a middle-class Christian patriarchy. Throughout the era of the traditional Civil Rights movement and more visi-bly during the Black Power era, much criticism was lodged at the tacit priv-ileging of patriarchal aspirations within the larger networks of the black protest movement.[29] The mass-market mediation of the black protest move-ment served to publicly expose these counternarratives of black struggle, though largely in the service of mass-market interests as opposed to any redress to the concerns articulated within such counternarratives.

The high visibility of black feminist/womanist discourse in the late 1960s and early 1970s would, perhaps, present the first major challenge to the abil-ity of the African-American diaspora's mainstream patriarchal leadership to control the public distribution and consumption of the various counternar-ratives within the Black Public Sphere. The emergence of more progressive political elements within the black community during King's final years ren-dered the traditional, mainstream, and patriarchal leadership of the NAACP

and Urban League irrelevant to the concerns of the black working class and poor. Attacks on the patriarchal nature of leadership within the black protest movement were clearly an escalation of this process. This latter fissure, as represented in the emergence of black feminist discourse, differed from the former in that the legitimate narratives of the black feminist/womanist movement became a province of mass consumer culture, creating a burgeoning industry of black feminist expression in the arts and letters. This phenomenon anticipated the increasing role that mass consumer markets would play in the creation and distribution of the counternarratives of the Black Public Sphere within the public consciousness of the broader American community. In this regard, the mass-market visibility that the New Negro movement craved in the 1920s as a vehicle of integration was poised to undermine patriarchal influence within the new black middle class, which represented the New Negro movement's logical offspring.

Buoyed by the emergence of feminist fiction, nonfiction, and poetry by the likes of Toni Cade Bambara, Alice Walker, and Nikki Giovanni, black popular music increasingly captured the tenor of the period regarding the centrality of gender concerns within the tradition. In truth, both Aretha Franklin and Nina Simone represented singular voices on the axis gender and race, as both were represented within the black popular music tradition of the 1960s. Both artists consciously appropriated the sensibilities of a lineage of black women blues singers, ranging from Ma Rainey and Bessie Smith to more contemporary artists like Dinah Washington and Billie Holiday. The highly visible presence of Simone and Franklin, both within and beyond the black protest tradition, created the aesthetic and commercial space for a new generation of womanist voices within the black popular music tradition. The significance of Franklin and Simone as creative icons are in part captured in Nikki Giovanni's "Poem for Aretha." Giovanni's work places Aretha and her work in the broader contexts of the lived reality of black women as well as the black musical tradition that she upholds. More notably, Giovanni clearly interprets Aretha's musical career within the parameters of a exploiting and dehumanizing recording industry, while recognizing that her presence within mass consumer culture helps reintroduce earlier styles of black popular singing and politicizes much of the music of her contemporaries.

Among a mainstream and white consumer public, Franklin was arguably the most popular black woman artist since Bessie Smith and Billie Holiday and was clearly more accessible to these audiences than Smith or Holiday were at any point during their careers. Like Smith and Holiday, Franklin infused public narratives of black rage and militancy, with nuanced demands for human respect and human decency. Historically, black women's willingness to articulate the rich diversity of human emotions within black popular culture, particularly given the lack of accessible language to articulate such

emotions, has served to broaden the limits of black popular expression. Billie Holiday's musical reading of Lewis Allan's antilynching narrative "Strange Fruit" infused the text with an emotional depth that transcended ordinary public denunciations of the practice. As powerful as Allan's original text was, the historic legacy of the narrative has been maintained via Holiday's singular interpretation of it.

In the waning moments of the black protest movement of the 1960s and early 1970s, many black female artists responded to the public silence accorded many of their defining issues. Within the context of the male-dominated protest movement, black women began to articulate their singular experiences with the external forces of racism, sexism, and exploitation, as well as the internal forces of sexism, exploitation, and condescension. Perhaps no artists better articulated the specific atrocities faced by black urban women in black popular music than Linda Jones and Esther Phillips. Their compelling voices broadened accepted examples of racial- and gender-based suffering, while both acknowledging and indeed celebrating the ability of black woman to transcend multiple oppressions.

Jones was born in Newark, New Jersey in 1944 and was reared, as were most black singers from her generation, in the black church. Beset with a particularly debilitating case of diabetes throughout her childhood and most of her adulthood, Jones died at the age of twenty-eight in March of 1972 after a series of performances at New York's famed Apollo Theater. What was perhaps most striking about Jones's artistry was her ability to use her singing ability to, as Bruce Huston suggests, reflect her "desperate determination to triumph over pain and loneliness."[30] Marked by what could only be described as fits of melisma, Jones's vocal style epitomized the definition of soul music, particularly on tracks like "Hypnotized," her most well-known recording and arguably one of the finest performances in the soul tradition, and in many of her later recordings like "Stay with Me," George Kerr's "I'll Be Sweeter Tomorrow," and Jones's own self-styled rendition of "For Your Precious Love." As *Rolling Stone* critic Russell Gersten would remark about Jones's last recordings, she sounded like "someone down on her knees pounding the floor, suddenly jumping up to screech something, struggling to make sense of a desperately unhappy life."[31]

Born in Galveston, Texas in 1935, Esther Phillips was performing professionally by her fourteenth birthday. Promoted as "Little Esther" throughout much of her career, Phillips achieved national popularity as a vocalist in a Johnny Otis-led band, based in Los Angeles. Her early exposure to the rigors of the Chitlin' Circuit—one-night stands, bus travel, segregated hotels, and fast food—primed her for the drug and alcohol addiction that curtailed her recording career and caused her death at age forty-nine in 1984. In 1966 Phillips made her most recognized recording, the country-western ballad "Release Me." *From a Whisper to a Scream,* released in 1972 on Creed

Taylor's CTI label, represented a second reemergence of the vocalist and initiated the most consistent recording period of her career.

Representative of Phillips's personal maturation process, *From a Whisper to a Scream* unabashedly embraced the blues idiom, at a moment when the form was losing both visibility and credibility among black audiences. An ideal form from which a new generation of black female vocalists could assert themselves, the blues was a tradition that played a special role among black women. Patricia Hill-Collins states:

> The music of the classic blues singers of the 1920s—almost exclusively women—marks the early written record of this dimension of Afrocentric oral culture. The songs themselves were originally sung in small communities, where boundaries distinguishing singer from audience, call from response, and thought from action were fluid and permeable.... Because literacy was not possible for large numbers of Black women, these recordings represented the first permanent documents expressing a Black women's standpoint accessible to Black women in diverse communities.[32]

From a Whisper to a Scream succeeds precisely because it harnesses Phillips's personal experiences, expressed through the prism of recorded music, for the purpose of illuminating the broader experiences of African-American women. Phillips's reading of Gil Scott-Heron's "Home Is Where the Hatred Is," nuances the state of drug addiction as broadly experienced by black women and particularly experienced by Phillips in her life and in the lives of her primary influences, Holiday and Washington. In this regard, Phillips transforms Scott-Heron's antidrug message into a narrative of personal and communal transcendence. In a moment of rare artistic admiration, Aretha Franklin gave her 1973 Grammy Award to Esther Phillips, who had been nominated for her performances on *From a Whisper to a Scream.*

Phillips's willingness, like that of Linda Jones, to use her personal demons and triumphs as a vehicle to communicate the experiences of black women is emblematic of the artistic projects of many black women during this era. Central to this project was a willingness to move beyond rage and anger, to acknowledge both fear and pain within the lives of African-Americans. The literary works produced by Toni Cade Bambara, Toni Morrison, and Alice Walker would be the natural manifestation of the mass-mediated narratives of black women that appeared via the music of Phillips, Jones, and others like Mavis Staples, Roberta Flack, Valerie Simpson, and Marlena Shaw, whose "Street Walkin' Woman" from *Who is This Bitch, Anyway* (1975) and "Woman of the Ghetto" from *Live at Montreux* (1973) were definitive declarations of black womanist thought.

Unfortunately, many of the musical narratives of the era, given the tremendous commodification of black popular music during the 1970s, were constrained by market limitations that often betrayed black women's agency

in their own work. The subtle changes in the marketing of Aretha Franklin is instructive in this regard. Dressed in African garb on the album covers of *Young, Gifted and Black* and *Amazing Grace,* both released in 1972, Franklin instilled pride and respect in the narratives of African-American women and the larger black protest movement. Subsequent recordings, most notably *Let Me in Your Life* and *With Everything I Feel in Me,* both released in 1974, find Franklin's image increasingly sexualized. Both cover photos feature a supposedly nude and noticeably trimmer Franklin, covered with only a fur coat. The cover to *With Everything I Feel in Me* exposes notable cleavage and a thigh. While the choice to portray her as such may have ultimately been Franklin's own decision, the reduction of her image from matriarch of the black protest movement to common sex prop speaks volumes about the limitations placed on black female expression, despite the proliferation of narratives by black women. Such a trend reached its logical conclusion during the disco age of the late 1970s, an era in which black women were the central objects of a popular movement that embraced gratuitous sex and drug consumption as its primary texts.

(margin note: black female agency)

(margin note: matriarch to "sex prop")

In Search of Community: Country Preacher, *"The Ghetto," and* Amazing Grace

Live recordings, premised as a response to the deterioration of black public life, and particularly to the ability to present black popular music in an organic context, became popular with many artists. Gilroy describes the process as "a relationship of identity ... enacted in the way that the performer dissolves into the crowd. Together, they collaborate in a creative process governed by formal and informal, democratic rules."[33] This relationship is best embodied in the role of the Chitlin' Circuit, which served as an incubator of new forms of popular music like rhythm and blues and soul and helped revitalize and maintain older forms like jazz and the blues. With the increased corporate annexation of black popular music and the continued deterioration of black public life, organic processes of black popular music production and critique were circumvented. The generation of live recordings that appear in this era document the last vestiges of the very intimate relationship between black musical artists and their black constituents, forever changing the nature and quality of the popular tradition.

Proliferating during the Civil Rights and Black Power eras, many of these live recordings also distributed political narratives in a context that often integrated musicianship with oratory. Perhaps no artist better achieved this combination than alto saxophonist Julian "Cannonball" Adderley, whose live monologues were legendary. Adderley's "Mercy, Mercy, Mercy," a huge crossover hit from 1966, perhaps best documents his understanding of the

active interplay of black music and communal struggle. Recorded at The Club in Philadelphia, Adderley begins the track with the following spoken introduction:

> *You know, sometimes we're not prepared for adversity.*
> *When it happens sometimes we're caught short,*
> *we don't know exactly how to handle it when it comes up.*
> *Sometimes we don't know just what to do when adversity takes over*
> *and I have advice for all of us,*
> *I got it from my pianist Joe Zawinul,*
> *who wrote this tune and it sounds*
> *and it sounds like what you're supposed to say when you have that*
> *kind of problem.*
> *It's called "mercy mercy mercy."* [34]

Adderley intuitively links the reality of black urban suffering with the cathartic power of the black musical tradition. Though Zawinul was Austrian-born, his compositions and presence within Adderley's largely black band bespeak the pianist's immersion in the cultural traditions of African-Americans. Zawinul's credibility among Adderley's largely black audiences can be documented in the lone voice that rises above the cacophony of music, clattering glasses, and casual banter to state, "Go on Joe, speak to me," again transforming the song into a aural salve to help transcend black misery.

Adderley even more effectively welds his political beliefs with his aesthetic sensibilities on the recording *Country Preacher,* perhaps his most popular tune. Recorded live at Operation Breadbasket in Chicago in October of 1969, the recording is the manifestation of an ongoing relationship between Adderley's band and the organization's director, the Reverend Jesse Jackson. Originally conceived as the economic arm to Martin Luther King's Chicago-based organizational efforts, Jackson assumed leadership of the organization shortly before King's death. Explaining the motivation behind the recording, Adderley states:

> When Dr. Martin Luther King appointed Reverend Jesse Jackson ... I am sure that he expected profound dynamic leadership.... The mother chapter in Chicago is supported by a variety of people from the broad social spectrum of the community—black, white, rich, poor—and has begun to revolutionize economic relationships in the black community. Certainly a great part of this success is due to the moral validity of the cause, but the leadership of the young Reverend Jackson is probably most responsible.[35]

Jackson for his part, begins the recording by delivering one of the most stirring introductions ever to a recording of black music. Using Zawinul's composition "Walk Tall" as his narrative inspiration, Jackson states:

We're getting ready to have a live session
now, what we were trying to say, just before we got started a while ago
that we getting ready to do a little walking
and when you have real change, everybody's thing begin to change
teacher begins to teach a new lesson, preacher begins to preach a new
* sermon*
and the musician also tries to capture the new thing
so that we might have melody, and have rhythm as we do our thing
we say every Saturday that the most important thing of all is that
no matter how dreary the situations is, and how difficult it may be
that the storm really doesn't matter until the storm begins to get you
* down*
so our advice to you, message that the Cannonball Adderley Quintet
* brings to us*
is that it's rough and tough in this ghetto, a lot of funny stuff going
* down,*
but you got to walk tall, walk tall, walk tall... 36

Jackson's introduction accentuates the powerful relationship between the popular black music tradition and the black protest movement as it was understood by individuals within the movement. Within Jackson's narrative, black music's role in communal catharsis and pride is reemphasized, as is black music's capacity as a vehicle for progressive change. In this regard, *Country Preacher* posits the Cannonball Adderley Quintet as the quintessential musical agent for change, a notion that Adderley both embraced and furthered until his death in 1975.

The album's title track, "Country Preacher," features a moving and evocative introduction by Adderley to explain the mission and the vision of the recording. Composed by pianist Zawinul, the track evokes the classic spirit of the Christian-based Civil Rights movement of the early 1960s, though it is dedicated to a political figure definitively shaped by the urban protest movement of the North. Zawinul's composition builds an aural bridge to two distinct protest traditions, both grounded in the prophetic tradition of the contemporary black Christian church. Bluesey in feel, the track also welds together several distinct genres of black popular music, which like the Chitlin' Circuit of an earlier era creates a broader community of protest and resistance, as witnessed in Adderley's introduction:

Yes, brothers and sisters
you know our leader has been a strong influence on his friends
who happen to be members of our group
we been going around preaching the good word of
Operation Breadbasket and the country preacher
who is your leader, our leader, and so forth, all over

in fact we use your music, we talk about your band and your choir
and brother Ben Branch, and everybody all over the country
we been preaching about black music and how it's all the same thing
we got the word from the country preacher, he told us, and we been
 talking about it.
so you'll hear a little culmination of how brother Joe Zawinul
is so impressed with Breadbasket and Reverend Jackson
and his concept of what the Country Preacher feels like to him.[37]

Adderley's text counters efforts to essentialize the black protest movement under specific ideological and political discourses, and it presents a strategy against pervasive attacks on the movement by refusing to allow any community of resistance to be isolated from the larger protest community. Contrary to the efforts of black nationalists to essentialize community, *Country Preacher* reinforces the seminal role of black public life and invests in the notion of broad-based communal resistance against political and structural oppression. Evocative of the church congregations that sustained previous black social movements, the recording creates a secular and politicized congregation grounded in the spiritual vision of the black church—a notion of congregation described by Robin Kelley as that which "enables black communities to construct and enact sense of solidarity; to fight with each other; to maintain and struggle over a collective memory of oppression and pleasure, degradation and dignity."[38] Such efforts to broaden definitions of community are also represented in the recording's last track, entitled "Afro-Spanish Omlet" which alludes to the increased intersecting of African-American and Latino/Latina interests, while acknowledging the historical musical links to both traditions.

Adderley and Jackson's willing conflation of often oppositional discourses of black life, namely the secular jazz and blues traditions and the sacred gospel traditions create an enhanced, though arguably utopian vision of a black community under siege. Moreover, despite the real visionary work of Jackson's Operation Breadbasket, it was a community aurally maintained and distributed via mass consumer markets. Ultimately the success of the recording, which served as a prototype for the Jackson-inspired WattStax concerts of the early 1970s, must be defined within the full context of a black protest movement mediated by mass-market culture and the willingness of the African-American diaspora to invest in mass consumer culture as a valid conduit for community. Increasingly, as Adderley and others understood, there were fewer means to adequately maintain such communities, particularly the role of such communities in the sustenance of the black popular music tradition.

Adderley's efforts to construct an aural community of resistance, best representative of the democratic processes of black public life, inspired sim-

ilar efforts to reconstruct the organic site of black popular music production. Born and raised in St. Louis, Missouri, Donny Hathaway garnered a significant amount of attention for his first two Atlantic releases, *Everything Is Everything* and *Donny Hathaway,* in 1969 and 1970 respectively. Embracing the blues, soul, gospel, and jazz idioms with a seamless ease, the pianist also possessed a subtle though passionate tenor singing voice. Hathaway's body of recordings synthesized an entire generation of black popular music and remain the definitive examples of progressive soul music. In addition to his fine musicianship, Hathaway was an innovative arranger, whose arrangements of Errol Garner's "Misty" and Nina Simone's "Young, Gifted and Black" invested both compositions with an urgency and vibrancy representative of the diminishing opportunities afforded the black protest movement.

Nowhere were Hathaway's broad talents more apparent than on his own composition, cowritten with Leroy Hutson, "The Ghetto." Released as the first single from his debut recording *Everything Is Everything,* a twelve-minute rendition of "The Ghetto" was also contained on Hathaway's live recording, *Donny Hathaway Live* at the Troubadour Lounge, released in 1972. Containing few lyrics but the repetition of the phrase "the ghetto," the live recording covers a wide range of black popular forms including traditional African drumming. Like Gaye's *Trouble Man* recording, "The Ghetto" creates an aural landscape of black urban space; unlike Gaye's project, though, it celebrates the ghetto as a site of community and cultural resistance. In this regard, it is instructive to consider Hathaway's core audience. In an interview with Nelson George regarding *Donny Hathaway Live,* Hathaway producer Arif Mardin states:

> When I arrived at the Troubadour where he was rehearsing for the show that night, I found a line of well dressed, middle class looking black people three times around the block with tickets waiting to enter three hours before the show. Donny wasn't famous then, you know. "The Ghetto" had been memorable, but by no means had he sold a lot of records. I called the office. "Something's going on here," I said. "The electricity was unbelievable." Then during the live performances at the Troubadour, they knew every song. He opened his mouth and the audience went berserk. It was like Name that Tune. On the live recording, we kept the audience exuberance up loud because it was so much a part of the show. He was a star waiting to sell records. Sure enough, it was his first gold record.[39]

Representative of a younger, newer middle-class formation, Hathaway's core supporters were the beneficiaries of the limited economic and social gains afforded to college-educated blacks during the 1960s. The first real generation of blacks to be educated in predominantly white colleges and universities, many within this nouveau black middle class struggled to maintain communal ties with the institutions and constituency of the Black Public Sphere,

an undertaking that became more difficult as this segment of the African-American diaspora was able to move into neighborhoods opened to them by fair-housing laws. Hathaway's mixture of diverse musical styles and non-controversial racial pride created a space for a nostalgic referencing of black urban life. More to the point, it was a relationship premised on the ability of such narratives to be accessed via mass-market culture. Thus for a new generation of blacks both physically and emotionally removed from the realities of black urban life, consumption of mass-market products constituted a limited engagement with black urban life.

Aretha Franklin's *Amazing Grace* recording stirs no less nostalgia than *Donny Hathaway Live,* though its nostalgia is premised on the passing of an era of black public life. Recorded over a two-day period in 1972 at the New Temple Missionary Baptist Church in Los Angeles, the live recording marks Franklin's return to the gospel music of her youth. Pairing Franklin with her childhood mentor, the Reverend James Cleveland, the recording offers a stunning tribute to the scope and influence of the black Christian tradition on black public life and the black popular music tradition. Dressed in traditional African garb on the recording's cover photo, the recording, like others from this specific era, reaffirmed Franklin's commitment to the black protest tradition—a tradition to which she is invariably linked, though her music has never overtly asserted such a relationship.

In the period from 1967 to 1971, aside from artists of the Motown label, Franklin was the most celebrated black commercial artists of the era, if not her generation. Beginning with the recording of *Spirit in the Dark* in 1970, Aretha began to take more individual control of her career and recording material. In early 1971, Franklin headed out to promoter Bill Graham's famed Fillmore West club in San Francisco and recorded a live album, which confirmed her maturation as an artist and her value as a commodity for corporate interest. The highlight of the recording is the seamless transition she makes from "Dr. Feelgood" to "Spirit in the Dark" fully embracing the "holy ghost" or spirit possession inherent to the black church experience and culminating with the appearance of Ray Charles. In some regards things came full circle.

Aretha's recordings after the Fillmore experience all reflect an enhanced level of crafts(woman)ship with the gospel tradition firmly at the center of these projects. *Live at Fillmore West, Young, Gifted and Black,* and *Amazing Grace* represent the apex of her career as a musician and commercial artist. Firmly entrenched in mass-market culture, Franklin used her popularity and credibility as a conduit for a more balanced and progressive mode of self-expression. Her reading of Simone's "Young, Gifted and Black" represented Franklin's most overtly political musical statement, a statement that carefully constructed blackness as a medium for the black church tradition, and vice versa, though none of the tracks on *Amazing Grace* is as overtly political as

"Young, Gifted, and Black," the recording was the manifestation of Franklin's willingness to acknowledge the influence of the seminal institution of black public life on her own maturation process.

Including a logical mix of new and old gospel classics, the recording also features several secular compositions like Carole King's "You've Got a Friend" and Rodgers and Hammerstein's "You'll Never Walk Alone," allowing Franklin to highlight her willingness to tackle mainstream material, but to also showcase her abilities to interpret such compositions within the context of the gospel idiom. As Franklin's career gives homage to her ability to secularize her gospel training, *Amazing Grace* emphatically suggests that it is an exchange that travels both ways and reflects the broad and diverse sensibilities of the African-American diaspora. "You've Got a Friend," for instance, was performed as a suite with Thomas A. Dorsey's "Precious Lord, Take My Hand." No doubt performed as a tribute to Dorsey's seminal role in the rise of gospel music, the juxtaposition of Dorsey's composition with King's hugely popular tune implies that Dorsey's marginalized talents are worthy of the same critical attention afforded King, who was arguably the most celebrated popular songwriter of her era.[40] More significantly, Franklin's popularity and high visibility affords her the opportunity to privilege Dorsey's work in such a way, particularly given the mainstream critical establishment's inability or unwillingness to adequately consider Dorsey's influence on popular music.[41]

Most notably, *Amazing Grace* documents the passing of an organic communal process within black public life. Franklin's tribute to the black church, in an era when its influence was diminishing, celebrated its extraordinary role in building communities of cultural and political resistance and recovery. As historian Robin D. G. Kelley suggests in his work on black community:

> The Church was more than an institution. In addition to providing fellowship, laying the foundation for a sense of community, and offering help to those in need, churches were first and foremost places of reflection and spiritual empowerment. By spiritual empowerment, I do not simply mean a potential site for political organizing. Rather, the sacred, the spirit world, was often understood and invoked by some African Americans as veritable weapons to protect themselves or to attack others.[42]

I am by no means suggesting that the black church no longer wields significant influence on the African-American diaspora, but that *Amazing Grace* documents the end of perhaps its most influential period, a period defined by its willing partnership with the black protest movement.

Taken as a whole, the live recordings of Franklin, Hathaway, and Adderley, aim to maintain and renew public spaces of communal sharing

and struggle that were being significantly altered by structural and political influences. Such efforts are emblematic of the African-American diaspora's existential quest for community, even as such communities were increasingly to be found in the aural traditions of the diaspora and determined and delimited by mass-market interests. The live recordings of these artists serve as a precursor to later community constructs determined by eroding public institutions, the pervasiveness of mass-market culture, and radical transformations in the geographical and labor demographics of the African-American diaspora.

Soul for Sale: The Marketing of Black Musical Expression

Black political agency seems embedded in cultural performance with the performing revolutionary. The selling of black political culture suggests a race discourse abstracted from material struggles and radical agency. . . . Where performance reigns, vacuous renditions of black revolutionary struggles take center stage. Performing blackness reworks the history of radicalism to market "Black power" as a commodity.

—Joy James *

Forever emblematic of stark class divisions within the African-American diaspora, the Stax/Volt and Motown recording companies began the 1970s with equally divergent notions of progress. Despite its multiracial ownership, the Stax/Volt recording company had always maintained a privileged relationship with its black constituency, particularly those still based in the American South. Motown on the other hand made no secret about its investment in the mainstream consumer public as a vehicle for black middle-class mobility—a mobility that would remain largely symbolic for Motown's core black constituency. As Stax/Volt set its corporate vision inward to the complexities of black urban life, Motown set its visions upward into the higher realms of corporate diversity and development. In the aftermath of these developments, Stax/Volt faced bankruptcy as Motown fell prey to the very marketing and production strategies it helped to develop, as soul, both the music and its cultural icons, became mass-market fodder for corporate America's entertainment and marketing devices.

The corporate ideologies of Stax/Volt and Motown were parlayed through their investment in two singular cultural and social events in 1972. Although WattStax, an all-day outdoor concert featuring the Stax/Volt roster

of artists, and the Motown-produced cinematic biography of Billie Holiday were both worthwhile social and cultural endeavors, both revealed a lack of attention to the quality music production that had grounded each company's success. Major corporate entities, perhaps sensing a major ideological shift on the part of black music producers and distributors, began to appropriate the music and the iconography of soul for use in the highly combative arena of cultural commodities. Within such a context, the black popular music tradition would be divorced from many of its organic sources, sources that often sought to invest the tradition with a highly politicized and critical consciousness. By the mid-1970s both Motown and Stax/Volt would be largely marginalized from the dominant positions in black popular music production, though for entirely different reasons, while the last great artist produced under the tutelage of Berry Gordy, Michael Jackson, would be poised to become the most popular recording artist ever, albeit while under contract with a major entertainment conglomerate.

Soul in the Hood: WattStax and Black Corporate Responsibility

Buoyed by their abruptly severed distribution deal with Gulf and Western and the popular and widely circulated expressions of black capitalism, personified in part by Jesse Jackson, his Operation Push organization, and the National Black Political Assembly, Stax/Volt began the 1970s captivated by notions of black corporate responsibility. In March 1972, the largest black political caucus in United States history was held in Gary, Indiana. The Gary convention stood on the two major pillars of black capitalism and black political empowerment. As Manning Marable explains:

> The National Black Political Assembly was a marriage of convenience between the aspiring and somewhat radicalized black petty bourgeoisie and the black nationalist movement.... The collective vision of the convention represented a desire to seize electoral control of America's major cities, to move the black masses from the politics of desegregation to the politics of real Empowerment, ultimately to create their own independent black political party.[1]

The National Black Political Assembly represented the pinnacle of the grassroots and national political movements of the 1960s and early 1970s. The assembly remained a dominant influence on post–Civil Rights black political thought throughout the decade of the 1970s, particularly among those shaped by the modern black nationalist tradition. The Stax/Volt corporation was, perhaps, also impacted by these narratives of black empowerment, as witnessed by the many changes the company underwent in the early 1970s.

The immediate impetus for change was the emergence of Al Bell as the label's sole proprietor, in effect turning a highly successful integrated recording label into a highly visible black-owned one. Jim Stewart's exit from Stax/Volt coincided with the company's efforts to end its distribution deal with the Gulf and Western conglomerate.[2] In some ways these events underscore Stax/Volt's fixation with the overwhelming shadow cast by the larger and more visible Motown recording company, particularly in the eyes of a core audience base who took pride in Motown's "black-owned" status. Stax/Volt could, of course, boast that its new "black-owned" status was not earned by cultivating a mainstream audience at the expense of the core constituency both companies claimed to represent. In an era when visions of black corporate development abounded, Al Bell's Stax/Volt cast itself as the more responsible corporate "big brother." The full weight of such responsibility would be realized with the ambitious WattStax project of 1972.

The Watts district of Los Angeles had been etched in the minds of the mainstream American public since violent upheavals in the summer of 1965. Those riots, along with similar exhibitions of urban unrest in Newark and Detroit, were emblematic, at least among mainstream white sensibilities, of the deteriorating conditions of urban life. In this regard the racial component of many of the urban riots of the 1960s were further examples of the black urban "horde" which threatened to undermine the sophistication of American urban life. Many critics identify these urban upheavals as a primary impetus for the white middle-class flight from urban centers during the 1960s that stimulated the deterioration of American urban life in the 1970s.[3] Stax/Volt's relationship with the neighborhood underscored the need for responsible corporate intervention within inner cities, even if such support was limited to underwriting summer festivals.

Implicit to the notion of responsible corporate intervention are examples of savvy business acumen. Stax/Volt's core consumer constituency of southern blacks, had begun to migrate from the American South into industrial Los Angeles during the post–World War II period as part of the second phase of black mass migration from the South. Since the end of Word War II the black population in Los Angeles had grown by 400 percent by the end of the 1960s.[4] Given the potential consumer constituency that Stax/Volt could cultivate through a relationship with the community, social responsibility could easily be equated with quality business decisions. With the exception of some support from the Schlitz beer company, the WattStax effort was entirely underwritten by Stax/Volt. The moment still remains an apex in black corporate community relations and probably informed the civic responsibility expressed by contemporary "gangsta rap" entrepreneurs like Suge Knight and Dr. Dre.[5]

The WattStax recordings (a second festival was recorded in 1973 under the banner of WattStax II) at once highlight the possibilities of corporate-

based community activism and the significance of communities of listeners that black popular music had begun to distance itself from. In an era when popular music concerts were increasingly held in large municipal stadiums, Stax/Volt dared present such a concert as a gift to urban black America. *Essence* magazine staff writer Vernon Gibbs wrote of WattStax II:

> The concert, which was the climactic event in the Seventh Annual Watts Summer Festival, was sponsored by Stax records and featured members of the Stax line-up exclusively.... In a very handy way, all good interests were served as we see a clear example of Black helping Black. If there is a nation united by something like a common ideology, these are the kinds of channels that constructive effort must take.[6]

Like the live recordings of Julian "Cannonball" Adderley and Donny Hathaway, the WattStax recordings presented black popular music in an organic context that highlighted massive audience interaction with the music. Such efforts by Stax/Volt were laudable given the physical demise—a trend that portended a national trend in black urban spaces during the 1970s—of valuable institutions within the Watts community. The singular presence of the Rev. Jesse Jackson, again harking to Adderley and in particular the *Country Preacher* recording session at Jackson's Operation Breadbasket, suggested that the triad of black corporate responsibility, political activism, and quality aesthetics could serve as a paradigm for African-American empowerment beyond the limitations of grassroots and organic movements. The ultimate failure of this paradigm in any sustained or significant manner underscores not only the limited vision of many black corporate entities, but, more notably, the overwhelming presence of mainstream corporate interests in the production of black popular music.

Motown Goes Hollywood: Diana Ross and Black Middle-Class Desire

Unlike his contemporary Al Bell, Berry Gordy saw black progress in terms of the integration of mainstream and elite American institutions by blacks with highly textured middle-class sensibilities. As Al Bell followed his black working-class constituency to Los Angeles, Gordy consciously abandoned his working-class constituency in Detroit in favor of the fast-paced and highly competitive culture industry of Los Angeles. While Gordy's decisions during this era spoke to a legitimate need to diversify the corporate interests of Motown, the company's relocation to Los Angeles and subsequent dislocation from black urban life served as an ironic and prophetic symbol of black middle-class development. If Motown was founded firmly on black middle-

class aspiration, the post–Civil Rights Motown was premised on black middle-class mobility.

Given Motown's investment in mainstream middle-class interests, the the urban riots of 1967 in Detroit made moving to the West Coast a logical transition. In this regard Motown's move mirrored mainstream middle-class movement, while portending black middle-class movement during the 1970s. Never driven by the communal responsibility that undergirded the Civil Rights movement or the later Gary convention, Gordy's abandonment of Motown's working-class constituency in Detroit did not seem problematic, particularly given the view that the company did represent a valuable symbol for black communal aspiration. Unfortunately, during the 1970s Motown would come to better represent the rather tenuous status of the black middle class, particularly in relation to sustained economic power.

Gordy's corporate desires manifest themselves under various guises, not the least of which was in the area of songwriting and production credit. Embroiled in a bitter legal battle with former Motown songwriters and producers Lamont Dozier, Eddie Holland, and Brian Holland (H-D-H), Gordy would recruit a second trio of staff writers and producers to usher Motown's sound into the 1970s. While the names Holland, Dozier, and Holland were nationally renowned, most would know the trio of Deke Richards, Fonso Mizell, and Freddie Perren only as "The Corporation."[7] The "Corporation" was named as such to circumvent the type of popularity and ultimately power within the Motown Corporation that Holland, Dozier, and Holland held during their prime as definitive Motown staff writers and producers. Clearly an effort on Gordy's part to maintain the strict hierarchy at Motown, the name also underscored Gordy's quest for corporate maturity, as no "real" corporation should be beholden to the individual whims of its employees.[8]

The subtle elevation of Diana Ross within the Motown hierarchy personified Gordy's own quest for corporate/social mobility. Ross's calculated break with the Supremes to pursue a solo career was wholly supported if not inspired by Gordy. Diana Ross served as the commercial icon who would deliver Motown into the next phase of its development. By chance, Ross's emergence as solo artist coincided with the development of the first major body of black feminist work. Devoid of any particular political or racial agenda, Ross nevertheless came to represent the full articulation of black "divahood" for a generation of young divas in the making. Motown's development of a cinematic treatment of Billie Holiday's life would serve as the vehicle for Ross's superstardom and Gordy's middle-class aspirations. According to Nelson George, the screenplay for *Lady Sings the Blues,* partially written and fictionalized by Motown executives Suzanne DePasse and Christine Clark, "transformed Holiday's story into a parable of Motown's rise: a strong black man, played charmingly by Billy Dee Williams...battles to harness a female singer's headstrong energy and ambition."[9]

A critical and commercial success, *Lady Sings the Blues* helped Ross earn a best acting Oscar nomination. Given the paucity of balanced portrayals of black women within the film industry—an industry notorious for positing Aunt Jemima-like figures Hattie McDaniel and Butterfly McQueen as dominant black female icons—Ross's Oscar nomination was well received within an African-American diaspora starved for positive representations. In this context, Ross's success at once highlighted a black woman's independence and mainstream acceptance for a black CEO from Detroit. Commenting on the film, Gerald Early writes:

> When Gordy financed the film … he insisted on so distorting the life of the famed jazz singer Billie Holiday, upon whose autobiography the film is supposedly based, that in effect he simply swallows the life of Holiday into an ocean of pop-culture kitsch for the benefit of Ross.… What interested Gordy most about the life of Holiday as a vehicle for Ross was precisely what interested Ross herself: that Holiday was the only sufficiently gigantic bitch-goddess of popular culture whose art could legitimate Ross's own standing as the reigning black bitch-goddess of her own day.[10]

Gordy always believed that black women were the logical channel for a sustained mainstream commercial acceptance, in part, according to Early, because Gordy felt that "black women were less threatening and, in some ways, more comforting to the white public than a black man would be, especially with the intense sexuality and sensuality that the 'new' popular music of Rhythm and Blues and Rock and Roll suggested."[11]

Despite Ross's high visibility, her success, like the commercial success of *Lady Sings the Blues,* betrayed many of the sentiments expressed by a burgeoning black feminist movement, premised in part on the idea that black women would be the dominant agents within their lives and experiences. Ultimately, Gordy's calculated control over Ross for much of her career represented little change from the standard uses of black women within popular culture. Ross's image as an independent black woman was as saccharine as her singing voice, while Gordy parlayed this imagery into a limited victory for black capitalist patriarchy. Gordy's distortion of Holiday's life is even more disturbing in that it mirrors mass consumer culture's proclivity to divorce African-American expressive culture from its political and social roots, solely for the purpose of mass-market acceptance. In this regard, Gordy became the very corporate animal he aspired to become.

Ross and Gordy revisited their contradictory narratives of middle-class mobility and pseudoblack feminist imagery with the production of *Mahogany* in 1974. A commercial and critical failure, the film represented the problematic aspirations of Gordy and Ross. Within the context of *Mahogany,* the classic theme of "poor girl gets lucky, makes it big, and must

choose between the big lights and her high school boyfriend" is weaved along the sensibilities of a burgeoning black middle class, lacking both identity and a sense of rootedness. Early writes of *Mahogany:*

> A brilliant film, mythifying, in concise symbolic terms, the middle-brow black struggle for identity. Ross, whose acting is much better here because the role is much closer to her own experience, plays a ghetto-dwelling, struggling, department-store clerk who wishes to be a high fashion designer.... In the meanwhile, she is torn between her love for Billy Dee William's character, a committed activist in the ghetto running for public office, and her love of success and the artsy European life which she has grown accustomed to. Gordy here has superbly conflated the old Hollywood formula of a woman torn between her career and her man with the identity struggle of the successful middle class black.[12]

Within this context Gordy cast his lot with the well-intentioned activities of William's character, who is constructed in the vain of a "blaxploitation" staple: the committed, though inadequately empowered "brotherman." Within this narrative, the quest for black love is firmly set against the overwhelming "whiteness" of mainstream success. This narrative is perhaps buoyed by Gordy's tacit acknowledgment that Motown was outclassed and outfinanced by the larger corporate entities in the entertainment industry; a notion further enhanced by the fact that Gordy himself took over main directorial duties midway through the film.

Unfortunately Ross, who clearly must be seen as a metaphor for the black popular music tradition, is caught between the patriarchal struggles of two opposing corporate entities: the diversified corporate conglomerate and the independently owned black business. The periods in which *Mahogany* and *Lady Sings the Blues* were produced were in fact dismal for Ross's promising solo recording career, in that much of the sass and energy that her image suggested were stifled by Gordy's crossover fixation. Ross's solo career really did not reach its potential until the late 1970s and early 1980s, with recordings fittingly entitled "It's My House" and "I'm Coming Out." Ross left the company during the early 1980s.

Ironically a non-Motown-produced film mined the Motown catalogue—often brilliantly—to give rootedness and substance to the music's role in the lives of the black urban poor and working class of the Midwest. Directed by black director Michael Schultz and based on an autobiographical script by Eric Monte, *Cooley High* is the definitive cinematic portrait of black urban life during the 1960s. Released in 1975, the film documents the middle-class aspirations of a cadre of black males living on the boundaries of poverty in Chicago. Within this context, the music of Motown is woven in and out of the daily experiences of the film's protagonists, suggesting the

pervasiveness of the Motown sound to the lives of the black masses. Further irony is realized in the fact that the main protagonist, played by Glynn Turman, aspired to become a Hollywood screenwriter.[13]

Ultimately, Gordy's quest for massive crossover appeal occurred not with a woman, but with a little black boy from the same Gary, Indiana which housed the 1972 National Black Political Assembly. The sudden emergence of Michael Jackson and The Jackson Five underscored several trends in the development of Motown and the marketing and distribution of black musical expression.

Soul for Sale: Blackness, Blaxploitation, and the Commodification of Soul

The Jackson Five was the last major act produced by Motown prior to its relocation to Los Angeles and, arguably, the most popular ever produced by the company. Had Gordy completed his move before the end of the decade of the 1960s, the group might never have signed with the label; Gary, Indiana was part of the midwestern scene that Gordy felt so compelled to leave. To a certain extent, the Jacksons would never know the familial atmosphere of Motown/Detroit—they were the last act on the label who could bear witness to Gordy's guiding hand—and so Motown/Los Angeles held no special place for them. Critic David Ritz writes:

> A transitional group merging with a transitional company, moving from factories to dreamland, from working class dreams to Hollywood reality, the J5 and their mentor discovered themselves at the start of a new cycle fueled by old drives and well worn patterns.... Gordy worked the boys harder than these hard-working children had ever been worked before. In contrast to Gary, LA looked like paradise, but the assembly-line sensibility of Detroit prevailed.[14]

While The Jackson Five was groomed exclusively in the early years by Motown staffer Bobby Taylor, Gordy made the conscious decision to base the group in Los Angeles, recording more than seventy tunes with the quintet during their first year on the West Coast. With Taylor's subsequent dismissal—representative of Gordy's own post-Detroit worldview, Taylor was accused of saddling The Jackson Five with an outdated sound—the group was firmly in the hands of "The Corporation."[15]

Aside from the group's first three releases, Gordy's fascination with Diana Ross and producing films increasingly kept him out of the very artistic loop that helped distinguished Motown's sound from other companies during the 1960s. As evidenced in Gordy's own belief that The Jackson Five was little more than a novelty act, the group's record sales dropped with their growing maturity. But their earlier success sent ripples through the

recording industry, spawning a whole generation of copycat artists and producers trying to reproduce the doo-wop sound that foregrounded The Jackson Five sound. According to Nelson George, one Motown staffer and "Corporation" member was wooed away from Motown explicitly to re-create The Jackson Five sound in other groups, most notably The Sylvers family group. [16]

While the popular success of Michael Jackson can arguably be construed as a novelty or fad, the group represented a market segment that had never been exclusively targeted by black popular music producers, namely those in their early teens and younger. Michael Jackson's stature as a popular icon during the early 1970s was contingent on commercial support from those ages eight to fifteen. When Michael Jackson reemerged in the late 1970s and the early 1980s as the dominant popular music artist of his generation, he did so at the instigation of the Epic/Columbia recording company. The often surreal marketing of Michael Jackson is forgrounded on corporate America's appropriation and improvement upon the very strategies that Gordy developed during the 1960s. What is significant here is that the corporate annexation of black popular music began precisely at the moment that Motown was witnessing its greatest success marketing and selling black popular music in the form of Michael Jackson and The Jackson Five. It was only natural for corporate entities to attempt to reproduce the most successful of these strategies, and in this case that strategy produced a black popular music industry almost distinctly directed toward American youth culture. Regarding the value of youth culture to mass-market producers, Stuart Ewen and Elizabeth Ewen write:

> Youth, embroiled in the "free market" courting practices of modernity, was perceived as a market whose most absorbing problem is that of personal adornment.... Such a definition of "youth" cast the young as ideal consumers, unconcerned with questions of profligacy or waste; committed to an understanding of needs that placed them within the confines of a continually changing marketplace.[17]

Thus the musical taste of American youth culture, mecurical in its own right, was partly driven by the very volatility that Paul Gilroy argues is a structural component of black popular music because of the tradition's own attempts to resist intense commodification. This factor would hurt the quality of music, because of its inability to successfully develop lasting traditions both within and beyond the market place and the need on the part of corporate entities to divorce black popular music from its organic meanings.

Ironically, it would be The Jackson Five and Michael Jackson in particular who would attain the mainstream acceptance that Berry Gordy craved. After The Jackson Five, Motown never, with the exception of Lionel Ritchie, produced artists of the caliber of those who represented the company dur-

ing the 1960s. In addition, Motown lost many of its artists and producers, including Marvin Gaye, Diana Ross, The Jackson Five, The Spinners, Ashford and Simpson, and Gladys Knight and the Pips, to corporate entities. In the case of the Spinners, Ashford and Simpson, and Gladys Knight and the Pips, this occurred before they reached their artistic and commercial maturity. While the subsequent demise of Motown as a major player could be blamed on Berry Gordy's decreasing involvement in the aesthetic process at Motown, the fact remains that with corporate entities increasingly dominating the production and marketing of black popular music, neither Motown nor any other independent black label would ever again be the singular conduit for new black talent.

The cornerstones of corporate America's annexation of the black popular music tradition were the implementation of strategies developed by Berry Gordy himself; namely to market soul music, if not blackness itself, to a young mainstream consumer base and as a purveyor of youthful sensibilities for older audiences, but also as a measurement of racial and social difference that could be construed as enticing, appealing, or wholly repugnant, as market taste demanded, particularly when mediated through that various prisms of race, class, age, geographical location, and sexual preference. Furthermore, many corporate marketing strategies aimed to exploit post–Civil Rights movement narratives that often implied the inclusion of African-Americans and African-American culture into the mainstream American life by, ironically, embracing modes of black nationalist discourse, but in reality rarely offered African-Americans significant autonomy and agency in their commercial products.

In an influential essay initially published in *Esquire* magazine, author Claude Brown writes, "The language of Soul—or, as it might be called, "Spoken Soul" or "colored English"—is simply an honest portrayal of black America. The roots of it are more than one hundred years old."[18] Brown's commentary bespeaks the larger social and cultural connotations of the word soul. Generally associated with the genre of music that bore its name, throughout the 1960s soul became primarily linked to evocations of black communal pride. In this regard, soul came to represent an authentic, though obviously essentialized blackness that undergirded the Black Power and Civil Rights movements that soul music has come to be associated with.

With the subsequent annexation of black popular music, in which the soul genre was then the dominant popular form, the larger meanings of soul were also deconstructed for use within mass culture. Divorced from its politicized and organic connotations, "soul" became a malleable market resource merchandised to black and white consumers alike in the form of music, television shows, and hair-care products. This process underscores a major facet of contemporary mass consumer culture, which has often sought to separate the iconography of political struggle from the organic sources and purposes of such struggles. William L. Van Deburg writes:

"Soul" was closely related to black America's need for individual and group self-definition.... In this sometimes crazy quilt world of the cool, the hip, and the hustle, stylized forms of personal expression were developed which not only conveyed necessary social information, but also could be utilized to promote a revitalized sense of self. At its most fundamental, soul style was a type of in-group cultural cachet whose creators utilized clothing design, popular hair treatments, and even body language (stance, gait, method of greeting) as preferred mechanisms of authentication.[19]

The commodification of "soul" had a particularly compelling impact on African-American popular expression, in that political resistance was often parlayed as an element of style. This is not to suggest that the Afro hairdo or the dashiki were as politically meaningful as sit-ins or mass rallies, but that many of the icons of black social movement were invested with some vestige of oppositional expression. Nevertheless the mass commodification of soul reduces blackness to a commodity that could be bought and sold—and this is important—without the cultural and social markers that have defined blackness.

For instance, within the maelstrom of commodities exchange, the cultural meaning of the Afro hairstyle could be reduced to mass-market products that supposedly enhance the ability to grow or buy an Afro. Most importantly, these products could be accessed by a mainstream consumer public simply as an element of contemporary style, which in the case of Afro wigs could be easily removed when they proved socially problematic. Once emblematic of the increased militancy of the youth wings of the Civil Rights and Black Power movements, the Afro simply represented a stylistic choice, though as the decade wore on the Afro again became demonized, along with a black youth underclass, as an element of a deviant criminal subculture of African-American men, personified in the form of hip-hop music and culture. Nevertheless, these earlier developments had particular implications for black social life because blackness, loosely defined as a broad-based and diverse black identity, largely grounded in the black communal experience, was also displaced from its organic sources. Paul Gilroy writes that black identity

is not simply a social and political category to be used or abandoned according to the extent to which the rhetoric that supports and legitimizes it is persuasive or institutionally powerful.... It is lived as a coherent (if not always stable) experiential sense of self. Though it is often felt to be natural and spontaneous, it remains the outcome of practical activity: language, gesture, bodily significations, desires.[20]

Thus as the 1970s progressed and black public life began to exhibit signs of deterioration predicated on black middle-class flight, the demise of central cities, and the destruction of community institutions dating before the riots,

black identity—in other words blackness—was largely mediated and thus determined by the mechanisms of mass consumer culture. Yes, Berry Gordy's attempts at Hollywood filmmaking were efforts to broaden the scope and visibility of blackness, particularly as such efforts were related to black middle-class concerns about self-identity, but Motown was incapable of competing with the larger, more established corporations, who unfortunately often viewed black identity and the notions of blackness so integral to it as a medium to expand their market shares.

During the 1970s Sherman Hemsley's *George Jefferson,* Esther Rolle's *Florida Evans,* Ron O'Neal's *Superfly,* Pam Grier's *Foxy Brown,* and Antonio Fargas's *Huggy Bear* emerged as the dominant representations of blackness on the television and movie screens, in effect erasing political icons like Malcolm X, Fannie Lou Hamer, Eldridge Cleaver, and Angela Davis. Though images of the black buffoon, black maid, black superstud, oversexed black woman, and black pimp broke no new ground in black stereotypes among white Americans—the major political and cultural icons of the 1960s made distinct efforts to revise such stereotypes—these images represent the first that would be wholly consumed by African-American audiences as emblematic of black identity.

The desire for identity that foregrounds much of black expressive culture forced corporate entertainment industries to walk a fine line between diversifying their market activities while also acknowledging a black middle-class and working-class buying public. In their efforts to sell "soul to the masses," the short-lived but prolific era of blaxploitation, corporate America's uncompromising exploitation and revisioning of the meanings and icons of blackness introduced both cartoonish and surreal constructions of blackness to a mass buying public. Steven Haymes writes that these processes transform black culture "into signifiers, absent of historical references to black life and absent of signification other than making luxury consumer goods pleasurable to middle-class whites. This stripping of history and signification from black culture has reduced it to a simulacrum."[21] The prevalence of absurd imagery like that of *Shaft* and *The Mack* suggested that the social crises of the 1960s and early 1970s could be solved by Hollywood during the course of ninety-minute voyages into hyperblack fantasies that often featured groundbreaking and award-winning musical soundtracks by soul performers like Isaac Hayes, Donny Hathaway, Marvin Gaye, and Curtis Mayfield; recordings that satiated both mainstream curiosities about blackness and African-American desire to consume their own images. Hayes's *Shaft* soundtrack and Curtis Mayfield's *Superfly* soundtrack were not only among the first generation of blaxploitation soundtracks, but were definitive examples of soul music in the era, if not in the careers of Hayes and Mayfield themselves. The conflation of black musical expression with black imagery

in the form of blaxploitation cinema and network television afforded main-stream consumers unprecedented access to black popular expression.

Just as Hollywood and the Ziegfield Follies quelled the resistance of America's poor and working class in the 1930s, so mass consumer culture in the 1970s offered narratives of blaxploitation to the restless and unsatisfied masses of the African-American "nation." Furthermore, this strategy was aimed at the most uncritical segment of the black community, namely black urban youth, who did not have the benefit of the presence of a black middle class capable of presenting counternarratives of black struggle. Perhaps even more useful to this example is an examination of how commodified soul translated blackness, in audience-friendly ways, to a mainstream and bur-geoning television-viewing public that was in part African-American. Two fairly popular, though short-lived television shows from the mid-1970s illus-trate both the problems and possibilities of soul's commercial uses.

That's My Mama debuted in the fall of 1974. The sitcom was largely a vehicle for actor Clifton Davis; it also featured Theresa Merritt, in the role of Mama, and Ted Lange, better known to television viewers as bartender Isaac from *The Love Boat* series. Introduced the same year as Norman Lear's more successful *Good Times*, *That's My Mama* was perhaps the first television sit-com to use expressions of soul as a primary thematic device. The show was a caricature of itself, boldly pronouncing its pastiched blackness, especially in Lange's character, who served as a sounding board and prop for overly animated and decontextualized examples of black dress, black speech, and black style. The centrality of Merritt's 300-pound character to the story line validated it to its mainstream audience by reconstructing and conflating cen-turies-old caricatures of black women with contemporary black iconogra-phy. Primarily set in the barbershop owned by Davis's character, the sitcom missed a valuable opportunity to capture the multidiscursive and highly crit-ical exchanges that have marked such spaces within the traditional Black Public Sphere. The barbershop exchanges, like the soul aesthetic that the show attempted to parlay, were often reduced to banal clichés of the black experience; clichés that were ultimately rejected by the show's primarily black audience.

Using many of the same clichés as *That's My Mama*, including a 300-pound Mabel King as the contentious mother figure, *What's Happening* was introduced to television viewers in the autumn of 1976. The sitcom proved more popular than its predecessor, in part because of its conscious playing to teenage sensibilities via its largely teenaged cast. The half-hour show scarcely missed an opportunity to validate mainstream America's percep-tions of single-parent households, frivolous black youth, and the overstated tensions associated with black male-female relations. More important than what it confirmed to mainstream audiences are the issues that *What's*

Happening failed to address, issues integrally linked to mass culture's proclivity to deemphasize black reality.

The show, set in the Watts district a decade after the riots of 1965, offered an ample opportunity for mainstream America to glimpse the everyday conditions of perhaps this country's most visible icon of racial tension. While the show succeeded, however humorously, in capturing the depressed economic state of Watts, it also offered a glimpse of a highly depoliticized Watts. This is ironic given the show's link to Watts's radical political past. The show's title was borrowed from the name of a real coffeeshop that served as a focal point for the district's burgeoning activist class. The Watts Happening Coffee House, which was emblematic of both the formal and informal spaces of the Black Public Sphere in Los Angeles, was a meeting place for the Black Panthers, Maulama Karenga's United Slaves organization, and other local writers and activists. *What's Happening,* which was largely set in "Rob's Coffee Shop," appropriated in name one of the more renowned social spaces of the Watts community yet totally ignored the vibrant political culture that was central to its namesake's legacy.[22]

Nevertheless *What's Happening* and *That's My Mama* remain two of the few examples of television programming that at least attempted to capture the realities of black public spaces however truncated. Ironically, such television programming occurred at the same time real institutions within the Black Public Sphere were under siege. Nowhere is this more evident than in the demise of affordable public venues for live music within the Black Public Sphere. In the early 1970s, Don Cornelius introduced a television concept that helped address the problems of affordable performances and in the process created one of the great commercial institutions within the African-American diaspora.

Soul Train was one of the more successful venues to access black popular music. It was also one of the only venues available to black urban centers, which with specific exceptions—cities like Atlanta, New Orleans, and Memphis—had lost the very commercial venues in the black community that were integral to the Chitlin' Circuit dynamics that dominated the production, reproduction, and distribution of black popular expression before the Civil Rights era. The longest-running black television show in television history, *Soul Train* was born in 1971 and partly influenced by Dick Clark's successful *American Bandstand.* Cornelius attempted to use television as an apparatus to promote and distribute black popular music. Amazingly in tune with organic developments in the black community, the show's success was partly generated from the immediate exposure afforded to many of the newer dance styles within the black community. Sensitive to the various regional articulations of soul, the show in effect gave national exposure to the "local" within the African-American diaspora. Given the role of dance within traditional black social experiences *Soul Train* was a visual affirmation of the

black communal ethic. In this regard—and ultimately the thing that separates *Soul Train* from *American Bandstand*—*Soul Train* served as an electronically derived audiovisual extension of the Chitlin' Circuit, privileging organic developments within black expressive culture.

Produced explicitly for syndication and remaining relatively untouched by a disinterested white corporate structure, the program gained a national following among segments of the African-American diaspora and mainstream consumers. Though the show did nothing to familiarize its young audiences with jazz and blues—*Soul Train* never broadened its scope beyond soul music—the program nevertheless remains one of the great examples of a black presence within the post–Civil Rights mass consumer marketplace. The success of *Soul Train* would presage the emergence a full decade later, of venerable black and urban institutions like Black Entertainment Television and Video Music Box, particularly as a inexpensive and accessible conduit for audiovisual representations of African-American music.

The developments of the early 1970s had radical implications for the nature, production, distribution, and meanings of black expressive culture in the postsoul era. Several genres and entities emerged as the decade progressed that addressed both the realities of African-American communal life and the mass commodification of black popular expression; others, however, affirmed and validated the new spatial and commercial terrain of black popular expression.

Soul for Real:
Authentic Black Voices
in an Age of Deterioration

The general interpretation of the period was, at least for the black elite, one of tremendous optimism. There was no longer a need to march in the streets against the policies of big city mayors, because blacks were now in virtually every municipal administration across the nation.... Certainly, it was said, the Second Reconstruction was on the verge of success. Black Freedom would become a reality through gradual yet meaningful reforms within the existing system.

*—Manning Marable**

Released in 1974, "Be Thankful for What You Got," William DeVaughn's critique of rampant materialism and mass consumerism attempted to reinvest, within the black community, a sense of identity that existed beyond the province of corporate marketing schemes aimed at equating self-worth with purchasing power. The construction of post–Civil Rights black identities, via mass culture, often rendered the social status of many blacks, including a burgeoning black middle class, unchanged within America's "racial-tocracy." Issues of individual self-worth and political self-determination, intertwined with tensions over community development and communal autonomy, buoyed the black popular musical imagination of the 1970s, though the decade is marked by the dispersal of blacks from formerly segregated black spaces. Ironically, the limited social gains of the Civil Rights movement stimulated another mass movement within the African-American diaspora, though this movement is associated less with geographical migration than a reformulation of the spatial logic of the black community in response to post–Civil Rights class interests within the black community. Legal attempts at the desegregation of public schools, the moderation of housing discrimination, and the state's positive response to the need for affordable urban

housing stimulated dramatic changes in the notion of the segregated black locale. Black middle-class flight from urban centers eroded the tax base of segregated black areas already burdened by white abandonment in the aftermath of the urban uprisings of the 1960s. Furthermore, these social adjustments occurred precisely at the same moment that the American economy was transformed from an industrial-based economy to a postindustrial, information/service-based economy.[1]

While these labor shifts solidified an expanding black middle class, they proved to be detrimental to the traditional African-American working class still relegated to urban centers. The Black Public Sphere in the 1970s, despite the rhetoric of integration, represented a de facto form of racial segregation that is much more insidious than segregated black spaces prior to the Civil Rights movement. These new social spaces lacked an indigenous economic base—an illicit economy of drugs, petty thievery, and prostitution notwithstanding—and were largely a bureaucratic prop of the federal government. Despite the negative connotations associated with pre-1960s segregated black communities, these spaces did in fact allow for a diversity of interclass relations to thrive within their boundaries. These relations were in fact at the core of the very notion of the Black Public Sphere. By the mid-1970s, the black working class and emerging "underclass" were confined to what David Theo Goldberg calls the "living space of poverty"—a state largely defined by overcrowding, pervasive poverty, restricted private and public institutional space, and popularly represented by the sprawling federal housing project.[2]

By mid-decade, much of the black popular music tradition had been successfully annexed by a small cadre of entertainment conglomerates and thus driven by the logic of mass-market forces. The need to package black popular music as a mass consumable served to constrict the most progressive, both aesthetically and politically, forms of black music during the era. Despite the realities of mass-market forces, several artists and collectives of artists emerged to give voice to the creative and political traditions of black popular music. Most notable among these individual artists are poet/musician Gil Scott-Heron and former Motown child star Stevie Wonder. Scott-Heron's career, to some extent, is exemplary of an artist's successful transition from an independent label to major conglomerate, and his career is representative of the increasing limitations placed on independent labels during the 1970s. Wonder, on the other hand, represented Motown's most successful artist of the decade, premised largely on Motown's grudging willingness to grant Wonder full creative control of his projects. Wonder's experience during the era is a compelling example of an individual's willingness to embrace aesthetic brilliance over commercial acceptance.

Parliament/Funkadelic and Philadelphia International Records represented two separate collectives of artists who fused mass-market sensibilities with strident narrative assertions of community and resistance. Both collec-

tives expanded the traditional soul repertoire, aesthetically frozen by mass-market forces, and arguably helped stimulate the creation of new genres of black popular music. Under the guidance of George Clinton, the Parliament/Funkadelic collective created a dense network of images and narratives, grounded in the American fascination with futuristic living and space travel and augmented by their gratuitous use of electronic instrumentation. Underlying much of the surface imagery of Parliament/Funkadelic were sharp critiques of mass-culture, particularly within the realm of black popular music, and black nationalist rhetoric. Taken at its essence, the music of Parliament/Funkadelic represents the aural and electronic construction of black nationalist urban utopias, best represented in the 1975 recording "Chocolate City."

The brainchild of Kenneth Gamble and Leon Huff, Philadelphia International Records represented the ideal fusion of mass-market sensibilities and communally derived narratives. A collaboration between Gamble and Huff and the CBS/Columbia entertainment conglomerate, Philadelphia International Records was the most popular conduit for black popular music during the 1970s, surpassing Motown in that regard. The commercial success of Philadelphia International Records lay in the company's ability to remain rooted in the diverse and increasingly dispersed communities of the African-American diaspora while offering highly danceable melodies for mass consumption. Many of the company's recordings became the aural sites for a national dialogue on communal values, black-on-black crime, interclass relations, and the diminishing quality of both black public and private life.

The Postindustrial Moment: Black Flight, Communal Dis-location, and the African-American Diaspora

During the 1970s, the quality of public life within the traditional Black Public Sphere was emblematic of fundamental structural and social shifts that had a lasting impact on urban life and on the popular forms of music that emerged within its confines. Though related, the incidence of black middle-class flight and postindustrialism represent two distinct influences on the internal dynamics of the Black Public Sphere. The relocation of black middle-class families beyond the margins of urban centers threatened the historic communal relations inherent to black public life and black survival within urban America, while postindustrialism would provide a lasting and detrimental economic impact on urban communities, creating, in part, America's first underclass—an underclass increasingly interpreted as African-American and deviant.

The communal relations maintained within the traditional Black Public Sphere were largely premised on the presence of a broad range of econom-

ic, political, and social interests, defined by the realities of legal segregation. The legacy of black public life in American cities was the ability of black communities to transcend socially and even legally imposed boundaries to create cultural and social spaces filled with verve and vibrancy. It is not my intention to suggest that the quality of life within segregated black locales was on par with that of middle-class or even working-class whites throughout the twentieth century, but that blacks experienced a sense of autonomy within segregated spaces. Clearly, the historic legacy of integrationist narratives within black public discourse suggest that blacks were keenly aware of the economic and social benefits afforded mainstream lifestyles, but that such benefits were not necessarily incongruous with desires to maintain autonomous segregated institutions.

The urban unrest of the period and access to quality housing outside of the inner city were only two of the myriad of influences that led many within the black middle-class to relocate to the margins of urban centers and into suburbia. More compelling were historic critiques regarding the quality of urban life, particularly within the realms of affordable housing and education. Like the mass migrants of the early twentieth century, black middle-class people in the late 1960s and 1970s were driven by aspirations to improve their quality of life, often at the risk of hurting communal and familial relations. Their flight from the inner city would have a lasting, though often overstated, impact on the quality of black urban life in that such movement presented significant challenges to the maintenance of black communal relations within the traditional Black Public Sphere. The transformation of the Black Public Sphere in this era is better illuminated when considered within the context of larger structural and economic transformations, of which black middle-class flight was only symptomatic.

Black flight from urban centers in the North occurred precisely as the role of the industrial city was being transformed to meet other economic and cultural needs, as the production and distribution of information, particularly that associated with financial institutions, became a primary industry. Furthermore the era witnessed technological advancements in industry—the automobile and steel industries being emblematic—which enhanced the productivity, profitability, and efficiency of industrial processes formerly dependent on low-skilled labor. Within such a context, industrial workers were marginalized from the labor force of many urban centers. William Julius Wilson describes the effects on urban populations in this way: "Urban minorities have been particularly vulnerable to structural economic changes, such as the shift from goods-producing to service-producing industries, the increasing polarization of the labor market into low-wage and high-wage sectors, technological innovations, and the relocation of manufacturing industries out of the central cities."[3] In effect, this transformation answered demands for both a highly trained work force on the high end of the salary

strata and a minimally educated service-oriented workforce that would largely be formed by women previously outside of the labor force.

While these labor shifts offered opportunities for college-educated segments of an expanding black middle class, they would prove to be a definitive threat to a traditional African-American working class in the urban North and Midwest, whose migration from the South was initially driven by the growing labor demands of the industrial city generations earlier. Not just witnessed in the high unemployment rates that challenged already economically taxed communal institutions, the transformation of the urban black working class would also feature shifts in the gender demographics of the postindustrial workforce, leaving lasting impressions on black urban life. Rose Brewer writes of this genderized workforce:

> Economic restructuring, uneven economic growth and internalization of the labor force embody cultural, gender, political and economic moments. The consequence of this now in the USA is that about two-thirds of all working persons are engaged in services. A good number of these are African-American women performing public reproductive work in the form of nurses' aides and old-age assistants, and in fast food outlets and cafeterias. Indeed, nearly all new job growth during the 1970s and 1980s was in the service category. Externally and internally women are filling these new service jobs. They are the new working class. Under conditions of economic restructuring, highly skilled labor is largely technical labor and unskilled labor is largely manual and clerical labor.[4]

Within the context of the postindustrial city, a new working class was generated, one that did not include large numbers of black men displaced by the economic transformations in urban centers, leading to the astounding double-digit unemployment percentages that continue to plague African-American men and ultimately influenced the pervasiveness of female-headed households that dominate the black urban environment. As unemployment was incompatible with the narratives of patriarchy that had defined black male culture throughout the twentieth century, many black men abandoned familial relations when they no longer had the social status afforded wage earners. These issues aside, the structural and institutional erosion of the Black Public Sphere, while impacted by black middle-class flight, was largely instigated by the economic displacement of the larger and more influential black working class. By the mid-1970s, the remnants of the traditional Black Public Sphere would serve as a likely example of pervasive urban decay.

I again maintain, particularly in regards to this era, that the communal relations of the black community are better understood in the concept of an African-American diaspora. This diaspora was initially created through massive northern and western migration and later defined by regional dislocations driven by economic class divisions within the diaspora. By the mid-

1970s, the model of the industrial city could no longer sustain the traditional black communal relationships that the industrial city of the urban North had itself helped to facilitate. New models for community interaction had to be developed and the quality and success of these new institutional structures would directly affect the narrative and aesthetic foci of black popular music. More importantly the success or failure of these models would affect broader communal efforts toward economic and political justice and the definitions of such ideals for a dislocated and fractured African-American diaspora.

Spirits in the Material World: Gil Scott-Heron and Stevie Wonder

By the mid-1970s, the black popular music tradition was under attack by two separate though related forces. Corporate America had begun a successful annexation of the production and distribution of black popular music. The Columbia/CBS conglomerate was the most successful in this regard, with a healthy roster of commercially successful artists like Earth, Wind and Fire, Denice Williams, and The Jacksons. Furthermore the conglomerate was involved in a successful partnership with Gamble and Huff's Philadelphia International recording label. Despite unprecedented mainstream access to black popular music, the production and marketing strategies of corporate entities placed significant limitations on both the narrative and aesthetic content of black popular music. Within this context, much of black popular music became formulaic and stagnant, though commercially successful for both recording companies and artists.

Corporate annexation of the black popular music industry was further compounded by the deterioration of public spaces, which prior to mass-market mediation served as valuable structures of critique and exchange for the black popular music tradition. The intricate and nuanced interactions between artists and community undergirds much of the black popular music tradition and facilitated the role of black popular music as a primary discursive formation within the Black Public Sphere. As Angela Davis relates regarding black music:

> If slaves were permitted to sing as they toiled in the fields and to incorporate music into their religious services, it was because the slaveocracy failed to grasp the social function of music in general and particularly the central role music played in all aspects of life in West African society. As a result black people were able to create with their music an aesthetic community of resistance, which in turn encouraged and nurtured a political community of active struggle for freedom.[5]

The structural and economic transformation of black urban centers, including the demise of organic spaces within the Black Public Sphere like night-

clubs and dance halls, would present the most significant challenge to the traditional relationship of black popular music and its primary constituency. Increasingly, given the mass commodification of black popular music, such relationships were maintained, however tenuously, across the marketplace. Two artists, Gil Scott-Heron and Stevie Wonder, had a significant impact within the African-American diaspora via the marketplace, while functioning in very traditional roles as artists in tune with the social, cultural, and political imagination of the larger African-American community.

Gil Scott-Heron was barely twenty-one when his first recording, *Small Talk at 125th and Lenox,* was released on Bob Thiele's Flying Dutchman Records in 1970. Thiele, who produced many of John Coltrane's most notable works, including *A Love Supreme,* recorded many progressive artists deemed either noncommercial or too progressive for mainstream and independent labels alike. Scott-Heron's eclectic combination of jazz, poetry, and oratory, particularly on his debut, was representative of the taste of the market segment that Thiele courted, and Scott-Heron became one of the label's most popular and stridently political acts. Heavily influenced by the Black Arts poetry of the 1960s, Scott-Heron successfully bridged the gap between the black literary and musical traditions that ground the social movements of the 1960s and early 1970s. As described by poet and publisher Haki Madhubuti, Scott-Heron was

> a young, young griot on the rise. His message was Black, political, historically accurate, urgent, uncompromising, and mature.... Gil Scott-Heron was definitely in the tradition of Amiri Baraka, Sonia Sanchez, Larry Neal and others who brought in the powerful decade of the sixties. He had listened to and digested the works of Malcolm X, Nina Simone, Jimmy Reed, and John Coltrane. In him we saw the poetic storytelling skills of Sterling Brown and the precise word usage of Margaret Alexander Walker and Gwendolyn Brooks.[6]

Aside from the recorded work of Nikki Giovanni, who conflated her poetry with gospel music on two recordings in the early 1970s, no artist better represented the progressive black political tradition in music than Gil Scott-Heron.[7]

Gil Scott-Heron's second release on Flying Dutchman featured a much more accomplished musician, poet, and singer as well as seasoned jazz and soul musicians like former Miles Davis bassist Ron Carter, pianist Brian Jackson, and the Atlantic recording label's house drummer Bernard "Pretty" Purdie. Scott-Heron's *Pieces of a Man* borders on sheer musical and literary genius and includes several classic recordings like the antidrug anthem "Home Is Where the Hatred Is" and "Lady Day and John Coltrane." The latter recording posits the two artists as capable of inducing the spiritual and emotional catharsis needed for a black public in the midst of everyday struggle. The apex of Scott-Heron's second recording is the now-classic "The

Revolution Will Not Be Televised," a trenchant and frank critique of mass consumer culture, particularly as it relates to the black political struggles of the late 1960s and early 1970s.

Scott-Heron's narrative consistently suggests a distinct separation between progressive social movements and mass-market sensibilities, while also acknowledging that the institutional threats to social justice, posed in this case by Richard Nixon's cabinet, will not be mediated by mass-market forces either, though prointegrationist spectacles like Nixon's embracing of Black Power rhetoric would maintain a privileged position on national airwaves. Scott-Heron is, perhaps, also alluding to the role of television during the aftermath of the King assassination, as a James Brown concert was televised over national television in an effort to "cool-out" the masses.

Gil Scott-Heron also critiques the use of high-profile figures to stimulate mass-market exchange as a form of social integration, including cartoons and token black characters from situation comedies like Diahann Carroll's character in *Julia,* while denying blacks access to the type of economic and political power that revolutionary rhetoric targeted. In addition, Scott-Heron separates the emotional attributes of mass-market culture, particularly those associated with personal hygiene and self-esteem, from the reality of progressive social movement. In this regard, he makes a distinction between the manipulative strategies used in mass-culture to project self-esteem as a mass consumable and the real structural changes that revolutionary social action can achieve.

In later stanzas of "The Revolution Will Not Be Televised," Scott-Heron is equally critical of African-American complicity in mass-culture mediation of the African-American experience and social struggles of the era. He points to the reality of police brutality, brutality that cannot be manipulated by the technological advancements within mass-market culture, like the use of instant replay in television viewing. Considered in context, instant replay allowed for the closer viewing of fast-paced events, particularly athletic contest. Scott-Heron's juxtaposition of police brutality with the use of instant replay suggests that police brutality is best understood in the context of a sporting event—a national pastime perhaps—though it is, in fact, an activity that either does not warrant closer inspection according to mainstream sensibilities or represents a normal state of relations between the black masses and police forces. Scott-Heron suggests that other technological advancements, like slow-motion footage and still-life footage, could instead be used to manipulate and to frame the mainstream leader of the African-American community, in this case Roy Wilkens of the NAACP, in a more progressive light, though less of a spectacle. In this regard, Scott-Heron both acknowledges and prophesies the role of mass-culture in validating and privileging mainstream leadership within the black community, without the consensus

of the broader African-American community. Scott-Heron's lyrics suggest that mass-market culture could have an adverse effect on the democratic processes that undergird communal relations within the African-American diaspora, if not the pursuit of justice for a broad range of American constituencies.

Scott-Heron was even more attuned to the fracturing of black communal relations in his later work. *Winter in America* was Scott-Heron's first and only recording for the now defunct Strata-East recording label, after three successful releases on Thiele's Flying Dutchman label. Scott-Heron's recognition of the developing schisms in black communal relations is most stridently articulated on the track "Peace Go With You Brother." The song's opening stanza is repeated in unison and effectively grounds the recording's narrative theme in the very communal interactions that underscore tradition black public life, reflects on the common bonds shared by African-Americans even in an era when separation seemed imminent. The recording respectfully acknowledges the successes of the black middle class, with a cautious recognition of the different realities faced by some segments of African-American diaspora. Embracing a nationalist perspective, Scott-Heron accuses members of the black middle class of renouncing their practical and moral responsibilities to the larger black community, though his accusations convey a basic respect for their accomplishments. Continuing this theme, Scott-Heron suggests that the evolving chasm in communal relations is in fact irreversible, with the responsibility for reconciliation in the hands of the community's progeny. "Peace Go With You Brother" remains one of the most significant pre-hip-hop narratives regarding the class divisions within the African-American Diaspora.

Winter in America was his most popular recording to date. Scott-Heron's relationship with Strata-East was indicative of the limitations faced by independent labels in the era when entertainment conglomerates began to dominate the reproduction and distribution of black musical texts. Strata-East was one of a small cadre of black-owned independent labels, including the Black Jazz label, which attempted to present black music in an authentic context untainted by the constraints of commercialism. The unexpected demand for *Winter in America* damaged Strata-East's relationship with other artists on its roster and its reputation as a viable commercial outlet for black music. In the end the company, like many others with its vision, simply could not live up to the reproduction and distribution demands of the contemporary marketplace. Unlike the early years of rhythm and blues and soul, the marketplace was now dominated by corporate conglomerates whose access to promotional and distribution apparatuses greatly outmatched that of smaller independent companies.[8] Scott-Heron subsequently signed to Arista, a major label whose roster in the late 1970s would include pop-

schlock master Barry Manilow and Dionne Warwick. Scott-Heron recorded ten albums for the label, but Arista could never adequately market his politically trenchant recordings to an increasingly apolitical consumer public.

In contrast, Stevie Wonder benefited from immense popularity and the still formidable production and marketing skills of the Motown recording company. Wonder's mid-1970s trilogy of recordings, 1973's *Innervisions,* the esoteric *Fullfillingness First Finale* in 1974, and perhaps his finest, if not the finest recording of the contemporary black popular tradition, the double album *Songs in the Key of Life* in 1975, were the benchmark for contemporary black musical genius. In the span of three years, Wonder recorded the quintessential black urban narrative with *Innervision's* "Living for the City," issued a thinly veiled political critique of Richard Nixon's presidency on *Fullfillingness First Finale's* "You Haven't Done Nothing," and set the standard for the wholly contained black concept album with *Songs in the Key of Life.* The brilliance of *Songs in the Key of Life* within the confines of black concept recordings had been preceded only by Marvin Gaye's *What's Going On* and arguably matched only by Prince's *Sign of the Times* in 1987. In fact *Songs in the Key of Life,* like Carole King's historic *Tapestry,* defied mainstream critics who did not believe that such tightly conceived projects could generate hit singles. Wonder's recording generated hit singles well into 1978, some three years after the release of the recording.

After a successful career as a child artist, Wonder received the artistic control he craved from the Motown recording company, though it had been grudgingly granted. Using back royalties owed to him upon his twenty-first birthday, Wonder briefly bolted Motown in 1971 and immersed himself in the new technology emerging within electronic instrumentation. Using his own money, Wonder, along with electronic musicians Malcolm Cecil and Robert Margouleff, recorded the instrumentation for more than thirty-five recordings in the period of a year. The bulk of these recordings would be contained on four albums from 1972 to 1974, including *Innervisions* and *Fullfillingness First Finale.* Ultimately it was Wonder's own investment in nationalist ideology that brought him back to the Motown stable, despite offers from other corporate entities, though he returned on his own terms and at the behest of an unprecedented financial commitment from Motown.[9]

In this regard, Wonder was perhaps the only Motown artist cultivated by Motown–Detroit who fully understood the dynamics of the modern music industry and geared his career, both aesthetically and economically, to this new reality. Symbolic of his understanding of the new corporate reality in black music, Wonder created his own publishing company under the name of Black Bull Music. Unlike standard Motown recordings, in which Gordy's own Jobete controlled the publishing rights, Wonder created a publishing entity that shared publishing interests with Gordy's Jobete company. Wonder's business savvy was indicative of a new generation of recording artists who garnered more control of their product. Given his initial status as

a blind child artist on the label, Wonder was the artist least expected to take such a position, though his tremendous commercial successes would ultimately justify Motown's commitment to him.

As Motown split allegiance between its midwestern past and its Hollywood present, Wonder settled in New York, and therein lies the partial inspiration behind the socially conscious narratives that Wonder produced in the mid-1970s. Wonder was profoundly affected by the narrative directions taken by Marvin Gaye on his *What's Going On* recording. Without the success of Gaye's *What's Going On* recording, Wonder simply would not have had the creative currency to create his rich social commentary. Never as materially political as Gaye's singular work, Wonder's work during the era chronicled the spirited actions of common people in exceptional and even absurd situations; a process no doubt inspired by his life in New York. Nowhere were Wonder's talents more on display than his recording "Living for the City," which chronicles the changing dynamics of black urban life through the tale of a single male migrant.

Initially Wonder's narrative locates his protagonist within the confines of what is one of the dominant icons of racial oppression in the South, the state of Mississippi. In this regard, Wonder acknowledges a broader history and broader catalogue of black narratives, including Simone's "Mississippi Goddamn" to frame the experiences of his protagonist. But this is also a Mississippi that cultivated and nurtured rich familial relations. As Ellison suggests in "Golden Age, Time Past," the familial constructs of the black South are the basis for the cultural armor that many southern migrants accessed in the covert social spaces of the urban North. Devoid of any material wealth, this cultural armor is in fact the lone gift that the protagonist's parents could afford to bequeath to their children. The trip north is in this era necessitated not so much by the historical experiences of racial oppression in the South, but by the economic transformations of the New South, brought on in part by changes in the technology associated with agrarian-based industries, effectively ending sharecropping.[10]

As in earlier eras, this late-stage migration was stimulated by the quest for economic stability. But unlike earlier eras, the protagonist migrates to an urban setting also transformed by technological advancements, best represented in the concept of the postindustrial city. Wonder's protagonist is immediately introduced to the realities of contemporary black urban life, via the informal and illicit economy largely maintained by the postindustrial city's most marginalized populace. This network of informal economic activities within the urban landscape, best exemplified in activities like numbers running and drug dealing, is of course not new to Wonder's contemporary era, but is pervasive in the context of the postindustrial city.

Wonder effectively captures the tricks and traps of the industrial city, using the classic trope of the black migrant in the fast-paced and unforgiving northern city.[11] While the black migrant's initial relationship to the urban ter-

rain is perhaps unchanged in the postindustrial moment, the swift pace of urban justice is perhaps the most startling feature of Wonder's characterization of this event. Wonder's willingness to document the often illegal and informal economy of the urban landscape suggests the pervasiveness of these activities in a contemporary urban context. Wonder's narrative of course mirrors the reality of the proliferation of recreational drugs in black communities and the alarming increase of black male incarceration in relation to the drug trade.[12]

The events experienced by Wonder's migrant represent the broader transformation of the spaces inherited by black publics in the urban North. In this regard, the migrant personifies the transformative effects on the traditional Black Public Sphere, particularly within the realm of communal interaction. As Farah Jasmine Griffin suggests in her work on migration narratives, Wonder's narrative asserts "that the tremendous drive for the city was a misdirected goal. The lyrics stress the loss of values and humanity in the process of migration."[13] Wonder's last stanza foretells the emergence of an urban underclass, largely produced in the shadows of the postindustrial city.

Wonder's migrant has been transformed into one of the walking dead that often inhabit the public spaces of the postindustrial city. Wonder's narrative alludes to both the failure of electoral politics as a conduit for black empowerment and the presence of environmental racism. Wonder's last line, unlike previous stanzas, is directed at his audience. Given the reality of urban deterioration, this line could have been specifically directed at the architects of public policy regarding urban life in America, as Wonder emphatically states, "Stop giving jus enuff for the city." Like Scott-Heron's work, "Living for the City" provided a glimpse into a not-so-distant future for black inhabitants of the postindustrial city. Excepting the work produced for Gamble and Huff's Philadelphia International Records label and the Parliament/Funkadelic collective, many of the narrative themes addressed by Scott-Heron and Wonder would remain dormant in black popular music until the emergence of hip-hop music in the late 1970s and early 1980s.

In Search of Chocolate Cities: Parliament/Funkadelic and Black Nationalist Urban Utopias

The music of Parliament/Funkadelic is best considered within the contexts of Motown's waning hegemony within black popular music, the effects of mass-culture mediation and the continued popularity of black nationalist discourse. The collective created musical and lyrical texts that challenged the "assembly-line" production process at Motown and the corporate imperialism that mined a valuable landscape of black cultural expression. In both cases, artists were exploited financially and restricted aesthetically. In this regard, Parliament/Funkadelic's embracing of black nationalist rhetoric was

the logical manifestation of its experiences within the recording industry, representing trenchant critiques of black middle-class isolation and mass-market-driven aesthetics. From the perspective of the Parliament/Funkadelic collective, rhythm and blues had been reduced to "rhythm and business" or "rhythm and bullshit."[14]

The epicenter of the Parliament/Funkadelic movement was the creative imagination of George Clinton. A former staff worker at Motown–Detroit—The Jackson Five recorded Clinton's "I'll Bet You" on their *ABC* release in 1970—Clinton intimately understood the Motown process, particularly as it dulled the creative impulses of artists, producers, and writers in the name of commercial viability.[15] Clinton was heavily influenced by the work of renegades James Brown and Jimi Hendrix, both of whom rejected the aesthetic limitations placed upon black musicians. While Brown was revered by the black community, Hendrix was never claimed by the black community, in large part because of his own refusal to have his music reduced into any specific genre. Thus while Brown remained rooted in the syncopated rhythms of the black public, Hendrix experimented with alternative aesthetic sensibilities. Clinton, for his part, attempted to expand notions of funk music rooted in Brown's heavily syncopated rhythms by embracing other musical influences in the context of funk music. In regard to the Parliament/Funkadelic collective's music, Cornel West writes:

> The emergence of technofunk is not simply a repetition of black escapism nor an adolescent obsession with "Star Trek." In addition to being a product of the genius of George Clinton, technofunk constitutes the second grand break of Afro-American musicians from American mainstream music, especially imitated and co-opted Afro-American popular music.... Similar to bebop, technofunk unabashedly exacerbates and accentuates the 'blackness' of black music, the "Afro-Americaness" of Afro-American music—its irreducibility, inimitability, and uniqueness.[16]

Parliament/Funkadelic attempted to rearticulate the relationship between black popular music and a mass production method that continued to exploit black artists. In the process and very much like the bebop era, the collective created a musical sound that was virtually incomprehensible to mainstream audiences and represented a cultural space for specific urban constituencies, particularly black youth whose cultural memories and musical taste, in the face of corporate annexation and diminishing public venues to access black popular music, were no longer solely rooted in the soul music genre. Eschewing popular constructions of black musical groups, the Parliament/Funkadelic collective included the same cadre of artists though the two groups were independently signed to two different labels. Parliament had its roots in the vocal doo-wop group The Parliaments, which recorded during the 1950s and 1960s. Funkadelic was their live band, which

during the 1970s primarily recorded instrumental tracks highlighting the musicianship of guitarist Eddie Hazel and keyboardist Bernie Worrel. This of course gave the total collective considerable artistic and fiscal freedom. In this regard, Parliament/Funkadelic practiced the very nationalist impulses that undergird much of its music.

Shrouded in mystery and mysticism and generally ignored by the majority of music consumers outside of the black community, Clinton and his "P-Funk" cohorts fashioned a self-sustaining musical movement, not beholden to record sales and chart positions, but aimed at bringing the black community together in a moment when the black middle class was redefining its relationship with the black masses and postindustrial America was beginning to impact upon black communities still recovering from the physical and spiritual repression of the Civil Rights/Black Power era. I maintain that the work of Parliament/ Funkadelic is premised on the creation of what I call "Black Nationalist Urban Utopias." Paul Gilroy's work on utopias is useful in interpreting P-Funk in such a context:

> The issue of how utopias are conceived is more complex not least because they strive continually to move beyond the grasp of the merely linguistic, textual, and discursive. The invocation of utopia ... emphasizes the emergence of qualitatively new desires, social relations, and modes of association within the racial community of interpretation and resistance and between that group and its erstwhile oppressors. It points specifically to the formation of a community of needs and solidarity which is magically made audible in the music itself and palpable in the social relations of its cultural utility and reproduction. Created under the nose of the overseers, the utopian desires which fuel the complementary politics of transfiguration must be invoked by the more deliberately opaque means. This politics exists on a lower frequency where it is played, danced, and acted, as well as sung and sung about, because words, even words stretched by melisma and supplemented or mutated by the screams which still index the conspicuous power of the slave sublime will never be enough to communicate its unsayable claims.... This is not counter-discourse but a counterculture that defiantly reconstructs its own critical, intellectual, and moral genealogy in a partially hidden public sphere of its own. [17]

Parliament/Funkadelic's use of electronic instrumentation and its reliance on the iconography of futuristic space travel are indicative of Gilroy's notion of utopian desires that exist beyond the grasp of mainstream sensibilities. These desires aurally and metaphorically constructed communities that countered mainstream political rhetoric regarding race relations, trumpeting nationalist inclinations surfacing among black middle-class sensibilities. Despite symbolic references of post-twentieth-century futures, the rhetoric of Parliament/Funkadelic was clearly rooted in a contemporary reevaluation

of life within the African-American diaspora, in which evocations of inter-stellar relationship could be reduced to intradiasporic relations.

Parliament/Funkadelic's construction of black nationalist utopias is per-haps most evident on the Parliament recording "Chocolate City." "Chocolate City" is of course a euphemism for black-dominated urban spaces, best rep-resented by Washington, D.C. Narrator George Clinton uses a radio broad-cast as a device through which to instruct his audiences about the burgeon-ing black nationalism of the urban terrain. Clinton's narrative privileges elec-toral politics as the site of a nationalist assault on the urban landscape. In the opening stanza, Clinton cites Newark, Gary, Los Angeles, and Atlanta, as examples of existing "chocolate cities." The respective mayors of those cities, Kenneth Gibson, Richard Hatcher, Tom Bradley, and Maynard Jackson were representative of the first generation of black mayoral candidates elected to lead large urban municipalities, though all would be accused, at some junc-ture, of undermining nationalist agendas in their personal or political lives.[18] Clinton's allusion to the White House suggests that the early successes of col-lective struggle via the ballot box shows that a black person could win the presidency. In the following stanza, Clinton juxtaposes the negative conno-tations associated with contemporary black urban life to the failure nine-teenth-century Reconstruction initiatives to adequately address the econom-ic and educational needs of the newly freed slaves. Within this context, black urban empowerment is viewed as a delayed response to demands for "40 acres and a mule" after the Emancipation Proclamation.

In the closing stanza, Clinton elevates black cultural elites to the status of political elites, ambitiously suggesting that Muhammad Ali would become president, Rev. Ike the secretary of the treasury, Richard Pryor, the education secretary, and Aretha Franklin the first lady. Clinton's referencing of this elite cadre of cultural workers underscored the role that all played in the con-struction of a communal persona of struggle and resistance, while using the democratic tenets of the transformed Black Public Sphere to bestow the recognition upon them that an undemocratic mainstream critical establish-ment was unwilling to grant. Clinton's narrative, while acknowledging the realities of post–World War II migration patterns, fails to acknowledge the increased class divisions of black public life and the increased tensions faced by a largely working-class and working-poor inner city, dislocated and dis-placed from the economic and social engines of the postindustrial moment. "Chocolate City" then, represents the utopian possibilities of a transformed and enlightened inner city, which concedes the collective use electoral pol-itics as the most likely conduit for attaining black empowerment.

The collective tried to salve the intraclass tensions of African-American diasporic life by collapsing black relations into the realm of the shared aes-thetics that were historically maintained within the context of covert social

spaces within segregated black locales. "One Nation Under a Groove," released in 1978, at once highlighted the continued strength of the Parliament/Funkadelic collective, while also affirming nationalist tendencies under the guise of an irrepressible funk groove. "One Nation Under a Groove" highlights the significance of social dance in the maintenance of African-American diasporic relations. Clinton's notion of "getting down on the one which we believe in" highlights the significance of the accented first beat of most funk recordings. The accented "one" is in fact a determining feature in syncopated forms of black music. Recorded during the height of the disco age, the track suggests that intradiasporic relations could be reaffirmed through the reclamation of the black popular music tradition. Unfortunately Clinton's framework did not acknowledge the popular reality within black urban spaces during this period, choosing instead, like Donny Hathaway, to celebrate black urban spaces as sites of empowerment in and of themselves.

Black nationalist rhetoric and dance floor anthems which affirmed communal relations were not the exclusive domain of the Parliament/Funkadelic collective. Perhaps no single industry entity best represented this mission than the Philadelphia International Record (PIR) label.

Dancing Across the Diaspora: Philadelphia International Records and Black Communal Exchange

One of the challenges faced by corporations in their efforts to annex the black popular music industry was to deliver a commercial product that would be deemed authentic, particularly to black audiences. I am well aware that the term *authentic* carries loaded meanings, particularly as notions of "authentic" black culture, in the eyes of corporate America, very rarely have basis in the realities of the black communal experience, but rather in the perceptions of black culture and black people held by mainstream white consumers and informed by popular racist discourse. Thus when I use the term *authentic* to describe black popular music during the 1970s, I am alluding to forms of expression that resonated among a broad range of African-American listening audiences. While a definition of soul music is in part an acknowledgment of its broad communal appeal, in the aftermath of the Civil Rights movement, taste and styles of black music began to segment according to increased class divisions and spatial dislocations within the African-American diaspora, though many corporate entities failed to acknowledge this diversity for some time. In the past, one of the strengths of independent black record labels was their ability to locate authentic aesthetic movements within the black community, well before they would be commercially viable to those outside of segregated black communities.

Ultimately, corporate entities were able to attract authentic black artists, by employing a cadre of ghetto merchants who parlayed their abilities to

identify, develop, and promote authentic black talent into A&R (artist and repertoire) positions at major corporations. Black radio executives LeBaron Taylor and Vernon Slaughter, who was literally recruited off a southwestern college campus in the late 1960s, were among the first generation of executives employed in newly developed black music divisions at major corporate labels. While such efforts produced, at least symbolically, the very diversified middle-management workforce that was at the crux of mainstream Civil Rights initiatives, they highlighted the increasing paradoxes associated with post–Civil Rights commerce. As a minority of black executives were hired at major labels, a larger number of A&R and promotion veterans integral to the black popular music industry prior to the Civil Rights movement were marginalized from the popular recording industry.

On a more extensive scale, the integration of the popular music industry significantly eroded African-American financial control over a segment of the industry that segregation had empowered them to control. This is a lasting legacy that the black popular music industry shares with the Negro Leagues and historically black colleges and universities: the integration of each industry's "stars" has strengthened mainstream institutions at the expense of black institutions, whose primary constituents remained rooted in segregated black locales. Broadly considered, this was not simply an issue of who would financially benefit most from the reproduction and distribution of black popular music—independent black labels were as notorious as major corporate labels in their exploitation of artists—but rather an issue that also encompassed questions of artistic integrity, creative autonomy, communal influence, and general aesthetic quality as these themes related to the larger tradition(s) of black popular expression. The reality is that in the post–Civil Rights integrated workforce of corporate America, no black music executive would wield the power of Berry Gordy at Motown, Vivian and James Bracken at Chicago's Vee-Jay label, or contemporary white executives like Clive Davis.

In the early 1970s, the CBS conglomerate would enter into a unique relationship with two songwriters and producers that appeared promising; it would allow CBS to produce authentic commercial product while black executives and artists retained aesthetic and financial control. Kenneth Gamble and Leon Huff, progenitors of the "Philly" sound, launched Philadelphia International Records (PIR) in 1971. Gamble and Huff came to prominence cowriting and coproducing black acts like Jerry Butler, The Intruders, and Wilson Pickett during the mid- to late 1960s. The duo's well-chronicled production efforts on Wilson Pickett's *In Philadelphia,* became a metaphor for the emerging changes in soul music, as they successfully translated the gritty southern soul of Pickett into an early hybrid of the stylish, urbane dance style that would become their signature. Like their Motown predecessors of the 1960s and early 1970s, Gamble and Huff created a self-contained and highly identifiable sound that made ample use of horn lines

and strings. Gamble and Huff specialized in recordings that featured power-ful male voices who often reinforced patriarchal norms and captivated their audiences through the use of slow, deliberate ballads, gospel-tinged dance-floor anthems, and a preacherlike mystique. Upscale in sound and image, PIR represented the very real possibilities and reservations of a new and vis-ible black middle class.

Though the label was in fact controlled by Gamble and Huff, the label's recordings were distributed and promoted by the CBS/Columbia label. What Columbia gained in this relationship was access to an authentic and popular sound with writers and producers knowledgeable in the taste of an evolving black musical audience and an ability to produce music with a mainstream commercial appeal. At its best, the music of PIR offered an honest appraisal of life and relations across the African-American diaspora with narratives that functioned beyond romantic appraisals of black urban life, to offer valuable critiques of life within the urban landscape, particularly as issues like black-on-black crime, poverty, and materialism affected the working class and remnants of the middle class still located within the parameters of the postin-dustrial city.

Emblematic of the PIR project are recordings like Harold Melvin and the Blue Notes's "Be For Real." Recorded in 1975 the recording features a single male narrator who castigates his female partner for "showing off" around his friends, many of whom which still lived in the 'hood. Conscious of the guilt experienced by some segments of the black middle class regarding their pur-ported abandonment of their urban-defined brethren, the recording cautions the black elite to remain cognizant of the full range of class interests within the African-American diaspora and warns against the dangers of their mate-rial and professional success as related to instigating divisions within the diaspora. As lead singer Teddy Pendergrass asserts, "You better dig yourself now, Woman! Puttin people down that has less, less than you, it just don't pay."[19] Within such a context, Gamble and Huff were also conscious of the instability of black middle-class expansion as Pendergrass further warns, "The best I can tell ya is what my momma told me when I was coming up. Chances go 'round, the same people that you meet on your way up, she said, you meet the same ole faces coming down."[20] While the recording offers valuable insights into intraclass relations, it is somewhat problematic in that the specific context(s) of the recording and the general patriarchy that grounded many Gamble and Huff narratives feminizes black middle-class materialism. In that the above quote was attributed to the narrator's mother, the larger narrative functions as a subtle critique of the black feminist move-ment, at least as it was popularly represented within mainstream culture, in that popular black feminist discourse was a primary ideological strain that separated black women who came to maturity before the Civil Rights era and those who came of age after the era. Within the context of "Be for Real,"

Gamble and Huff suggest, however subtly, that the black feminist movement could be a threat to the maintenance of community.

But the narratives of Gamble and Huff functioned beyond romantic appraisals of the black working poor to offer valuable critiques of life within the urban landscape, particularly as issues like black-on-black crime affected the working class and remnants of the middle class still located within the parameters of the postindustrial city. The O'Jays recording "Don't Call Me Brother" is representative of such critiques. Songwriter Kenneth Gamble's ironic use of the term *brother,* one of the more popular salutations within the colloquialisms of black collective struggle, deconstructs the language and the iconography of the black protest movement, illuminating the deteriorating nature of relationships within the diaspora. Gamble offers a broader critique of the failures of the black protest movement, as the Black Power fist is representative of a slippery iconography that could be manipulated by small-time hustlers and corporate entities alike. Within this narrative Gamble rejects the simplistic articulations of nationalism that often embraced or romanticized criminal elements within black community as a response to white racist agendas, including police brutality. Gamble, instead, references the type of autonomous black communities that existed prior to the Civil Rights movement, where material differences within the black community were not as pronounced. Despite Gamble's nostalgia, Gamble's lyrics underscored the tenuous predicament of an urban-based working class faced with the reality of pervasive crime within the postindustrial city. While petty crime and hustling have arguably been a fixture within black urban life, the economic transformation of the industrial city is directly correlated with the heightening of black-on-black crime. In this regard, the recording serves to forecast the epidemic proportions of black-on-black crime during the 1980s.

By the mid-1970s, Gamble and Huff attempted to further critique many of these intradiasporic tensions by supplementing their recordings with Kenneth Gamble's pseudo-black-nationalist/capitalist prose, which placed a dispersed black community at the center of its critiques. As witnessed in the immense popularity of many of the recordings, ultimately it was the music itself that did more to address black communal relations in an era when significant chasms were developing. With a keen sense of the changing dynamics of the black community, Gamble and Huff created a musical sound that would cater to an African-American diaspora displaced by postindustrialism, urbanization, and black middle-class flight. While producers of black popular music in past eras correctly understood the role of the black church as the dominant Black Public Sphere institution, Gamble and Huff understood the role of the dance floor in the maintenance of black communal relations. Harking back to the 1930s and the 1940s, where large New York ballrooms like the Savoy and Audobon served as communal spaces for a deteriorating Harlem community, Gamble and Huff created dance-floor anthems which

critiqued mass consumer culture and affirmed black communal and familial relations. The Gamble and Huff composition "For the Love of Money," recorded by the O'Jays in 1973, is an example of such endeavors.

"For the Love of Money" provides insight into the harmful impact of materialism on familial structures within the Black Public Sphere. Its poisonous effect on the traditional family structures serves as a foundation for materialism's effects on broader communal relations. Gamble and Huff identify the severe economic limitations placed on black urban dwellers through the acknowledgment of the underground illicit economy of prostitution, particularly as it affects black women within such spaces. From Gamble and Huff's vantage point, such behavior is the natural manifestation of the rampant materialism of the contemporary moment and emblematic of some forms of psychic pain. Within such a context, it is very difficult to separate the materialism that the duo critiques from the mass consumer markets that stimulated grandiose desire(s) in those with limited financial means.

Gamble and Huff intuitively understood the centrality of social dance in the formation of black communal ethics. As *Soul Train* represented a dynamic visually mediated example of the power of black social dance, Gamble and Huff produced dance-floor anthems tailored for one of the more vibrant remnants of the traditional Black Public Sphere. While dance halls and house parties have historically stimulated communal exchange, the dance hall's role in such exchanges intensified during the decade of the 1970s, as the dance hall represented one of the primary institutions which attracted the black middle class back to the very urban spaces that they abandoned. This phenomenon was largely inspired by the inability of the black middle-class to create and maintain social and cultural institutions, excepting possibly the black church, within their own middle-class enclaves. As the dance floor itself become a site where the African-American diaspora reintegrated with itself, Gamble and Huff simply created a soundtrack aimed at repairing and sustaining communal relations across the chasms of class and geography. Thus dance-floor anthems like the O'Jays' "I Love Music," McFadden and Whitehead's "Ain't No Stopping Us Now," or Harold Melvin and the Blue Notes's "Bad Luck" conveyed rich narratives of community, hope, and tradition as well as trenchant critiques of life within and beyond the Black Public Sphere.

The popularity of PIR, which by 1975/76 rivaled that of Motown during the late 1960s, instigated a string of copycat producers and artists. While Gamble and Huff did not have exclusive access to the black, Latino, and gay spaces that incubated disco, they were the most accomplished and visible producers of 1970s dance music. By the late 1970s, American popular culture was thoroughly inundated with the sound and imagery of disco culture, owed in part to the international popularity of disco diva Donna Summer. Groups like the SalSoul Orchestra, many of whom were disgruntled former

PIR session musicians, appropriated the Gamble and Huff sound minus its pseudoblack nationalist rhetoric and infused it with all the banality that befitted 1970s American pop culture. The ultimate appropriation occurred when the Aussie band The Bee Gees teamed with RSO records to produce the soundtrack for the film *Saturday Night Fever.* A logical star vehicle for John Travolta, the film depicts a Brooklyn-born Italian-American youth who frequents the local disco scene. The success of the film and, in particular, the soundtrack recording, provoked a corporate rush to reproduce this sound. The genre's commercial viability inspired large, glitzy dance halls, like the famed and notorious Studio 54, an ill-advised disco comedy series starring David Naughton, a cinematic star vehicle for Summer called *Thank God It's Friday,* and a bevy of bad recordings like Rick Dees's woeful "Disco Duck."

That the most visible icons for this musical genre were the Australian Gibb brothers, a teenage actor from Brooklyn, and a duck speaks volumes of the extent to which this musical genre was commodified and relatively easily appropriated and distanced from its organic roots. As Nelson George relates, "So the new dance music inspired by the inventions of Gamble and Huff came to celebrate a hedonism and androgyny that contradicted their patriarchal philosophy."[21] Ironically, despite the generally apolitical nature of disco music, many of its purveyors, like Gamble and Huff, understood the presence of the dance floor as a site of black public exchange. As Gamble and Huff unwittingly constructed patriarchal notions of "dance floor as site of public exchange"—think here of the predominanely male voices that narrate Gamble and Huff critiques of intradiasporic relations—many disco artists, like the working-class audiences of the Apollo Theater during the 1940s and 1950s, democratized the site to reflect the broader realities of black public life. Nowhere was this more apparent than the willing and however fleeting construction of black women and black homosexuals as sexual subjects within black dance narratives.

Donna Summer's eighteen-minute classic "Love to Love You Baby" was released in an era when several traditional soul artists were embracing more sexually explicit narratives. Marvin Gaye's *I Want You* and former Delfonics lead Major Harris's "Love Won't Let Me Wait" are the among the most popular in this realm. Toward the late 1970s, Teddy Pendergrass became the personification of such narratives with tracks like "Turn off the Lights" and "Come on and Go with Me." Paul Gilroy suggests that these narratives possess political connotations:

> The love stories ... are a place in which the black vernacular has been able to preserve and cultivate both the distinctive rapport with the presence of death which derives from slavery and a related ontological state that I want to call the condition of being in pain. Being in pain encompasses both a radical, personalised en-registration of time and a diachronic understanding of language whose

most enduring effects are the games black people in all western cultures play with names and naming.[22]

Very often, particularly given the national politics of the post–Civil Rights/Black Power era in which black voices were often silenced, these narratives remained the sole domain for black male constructs of patriarchy and hypermasculinity. The celebration of black male sexual prowess had been a seminal activity within black popular culture since the release of Melvin Van Peebles *Sweet Sweetbacks Baadasssss Song* in 1971, though in the context of Gaye's "Since I Had You" and Harris's "Love Won't Let Me Wait," both of which feature background singers parroting female orgasms, patriarchal constructs of struggle and survival were premised on the sexual objectification of women.

Summer's work is a reversal of this recording strategy. In her "Love to Love You Baby," like much of her early work and that of black women performers during the urban blues era of the 1920s, Summer, as representative of black women, is transformed from sexual object into a sexual subject. Summer's early willingness to embrace eroticism as a vehicle of black feminine expression, a strategy that late-1970s disco diva Grace Jones would further advance, clearly represents a counternarrative to the patriarchal constructs of the traditional male soul singer. In a well-regarded quote, the late Audre Lorde stated:

> The erotic has often been misnamed by men and used against women. It has been made into the confused, the trivial, the psychotic, the plasticized sensation. For this reason, we have often turned away from the exploration and consideration of the erotic as a source of power and information, confusing it with its opposite, the pornographic. But pornography is a direct denial of the power of the erotic, for it represents the suppression of true feeling.[23]

It is not my intention to suggest that such narratives liberated black women from the realities of sexism or misogyny, particularly given the hypersexuality attributed to black women within popular culture—the "Venus Hottentot" Josephine Baker and Dorothy Dandridge come to mind—which often rendered them sexual "creatures" instead of women and justified sexual violence against black women both within and beyond the black community. Instead, Summer's narrative is representative of the fleeting democratization of the "dance floor as site of public exchange"—a site that provided some space for black women to construct themselves as agents in their experiences and pleasure and to critique patriarchal constructs within the African-American diaspora. Summer's own image was hypersexualized later in her career on recordings like "Bad Girls," which celebrated prostitution as a liberatory activity.

South Shore Commission's 1975 recording "Free Man" is representative of other musical narratives that critiqued and questioned the dominant construction of heterosexual patriarchs in the black community. "Free Man" brilliantly appropriates the language and style of black nationalist rhetoric to celebrate the homosexual presence in the black community, undermining the potency of the very rhetoric that it appropriates. Removed from its specific context, the rich tenors that announce "I'm a Free Man, Girl I'm a Free Man and Talkin' bout it" in the recording's chorus could easily be taken as an affirmation of black male patriarchy. Representative of the formal narratives of black struggle and survival, particularly as constructed by the dominant patriarchy of the black community, "Free Man" represents a revision in which free men are willing to express the realities of their sexual preferences both within and beyond the confines of black public life, as traditional free men publicly voiced narratives of militancy and resistance in earlier eras. In this regard, "Free Man" gave voice to the many homosexual and lesbian artists who were not allowed to safely express their sexual preference within earlier constructs of black public life. Describing this process of critical signification Henry Louis Gates Jr. writes:

> It functions to redress an imbalance of power, to clear a space, rhetorically. To achieve occupancy in this desired space, the monkey rewrites the received order by exploiting the Lion's hubris and his inability to read the figurative other than as the literal. Writers Signify upon each other's texts by rewriting the received textual tradition. This can be accomplished by the revision of tropes. This sort of Signifyin(g) revision serves, if successful, to create a space for revising texts. It also alters fundamentally the way we read the tradition, by defining the relation of the text at hand to the tradition.[24]

The tradition of critical signifying is one of the defining traits of African-American genius and is a tradition that is active in the contemporary moment. Given the pervasiveness of mass-market mediation, critical signification allows for a momentary subversion of mass-culture limitations, creating, however fleetingly, broader communities of knowledge and understanding.

Singular moments in the disco tradition, the early projects of Donna Summer and South Shore Commission were replaced by the mass-commodified and -accessible camp of Mystique's "In the Bush" and The Village People. In the arms of mass-culture, Summer's politicized embracing of the erotic was reduced to the pervasive constructs of insatiable women, who are objectified by the pulsating and repetitive rhythms of the dance floor. The Donna Pescow character from *Saturday Night Fever* is but the most notorious example of the "disco slut" which dominated disco narratives in the late 1970s. For their part, The Village People reduced the celebratory militant nar-

ratives of South Shore Commission and others, like Sylvester, into one-line tropes that reinforced stereotypical notions of homosexuality. Thus recordings like "YMCA" and "In the Navy" simple reconstruct old patriarchal notions of homosexuality for humorous mass consumption.

By the time the antidisco backlash set in and "Disco Sucks" T-shirts were all the rage, disco was primarily identified, like swing music generations earlier, with the rampant nihilism and drug addiction of a white counterculture wrongly invested in the locales of black expressive culture. This is of course is a critique that would again emerge a decade later when gangsta rap became a valued commodity for corporate America. These racial and class dynamics were further realized in that many of the most severe antidisco critiques emanated from the audiences, artists, and radio stations that supported Album Oriented Rock (AOR). Mainstream rejection of disco occurred as the recording industry itself was experiencing a decline. As Vernon Slaughter related in an interview with Nelson George, "This industry had always been known as a growth industry of unlimited potential.... In '74, the recession had some effect on the recording industry.... But things got better, and it took '78 and '79 before they finally realized that the record industry was subject to shifts in the ages of population and other economic factors just like everybody else."[25]

As the baby-boom generation became the Yuppies of the 1980s, their taste in music and in what they deemed acceptable listening material for their young children were increasingly more conservative than during their youth. Thus the very difference that corporate America used to entice white consumers to black popular expression was now a marker of fear and deviance that was not as easily mediated for mass consumption. Since black consumption of goods and services had never been a primary impetus for corporate efforts to annex the black popular music industry, many labels were willing to neglect their black music division in lieu of emerging genres and audiences like those associated with college/alternative rock. Despite the obvious benefits associated with PIR's relationship with CBS, particularly when buoyed by Gamble and Huff's own middle-class-driven black nationalist rhetoric, in hindsight, given the dynamics of the late 1970s, the relationship was little more than a late-twentieth-century sharecropping system in which popular recordings were the cash crop. Much like the technological transformations that made cotton pickers expendable in the mid-1940s, market demands for popular music made black music divisions at corporate labels obsolete as the 1980s began.

Postindustrial Soul: Black Popular Music at the Crossroads

Life on the margins of postindustrial urban America is inscribed in hip hop style, sound, lyric and thematics. Situated at the "crossroads of lack and desire," hip hop emerges from the deindustrialized melt-down where social alienation, prophetic imagination, and yearning intersect. Hip hop is a cultural form that attempts to negotiate the experiences of marginalization, brutally truncated opportunity, and oppression within the cultural imperatives of African-American and Caribbean history, identity, and community. It is the tension between the cultural fractures produced by postindustrial oppression and the binding ties of black cultural expressivity that sets the critical frame for the development of hip hop.

—Tricia Rose*

The emergence of the postindustrial city radically altered black communal sensibilities in the late 1970s and 1980s. Intense poverty, economic collapse, and the erosion of viable public space were part and parcel of the new urban terrain that African-Americans confronted. Culled from the discourse of the postindustrial city, hip-hop reflected the growing visibility of a young, urban, and often angry so-called "underclass." Aesthetically the genre drew on diverse musical sensibilities like James Brown and the Parliament/Funkadelic collective and on black oral traditions like the prison toasts, "The Dozens," and the Black Arts poets of the 1960s. As the genre represented a counternarrative to black middle-class mobility, it also represented a counternarrative to the emergence of a corporate-driven music industry and the

mass commodification of black expression. Relying largely on word of mouth and live performance as a means of promotion, hip-hop may represent the last black popular form to be wholly derived from the experiences and texts of the black urban landscape.

The emergence of hip-hop in the postindustrial city was far removed from the daily realities of an expanding black middle class. Inspired, in part, by Smokey Robinson's *A Quiet Storm* and the lusher recordings of Gamble and Huff, black popular recordings began to reflect the sensibilities of the black middle class. The subsequent Quiet Storm format, popularized on many radio stations with a large black audience, allowed the black middle class the cultural grounding that suburban life could not afford them, while maintaining a distinct musical subculture that affirmed their middle-class status and distanced them from the sonic rumblings of an urban underclass.

By the mid-1980s, both an urban-based working class/underclass and suburban middle class exhibited symptoms of "postindustrial nostalgia." Loosely defined as a nostalgia that has its basis in the postindustrial transformations of black urban life during the 1970s, many contemporary cultural workers began to appropriate the narratives and styles of black life in black urban spaces prior to the structural and economic changes of postindustrial transformations. While most visible in the burgeoning new black cinema of the late 1980s and 1990s, postindustrial nostalgia is also reflected in the popular music industry. The prevalence of nostalgia-based narratives in black popular culture would have particular effects on the maintenance of intra-diasporic relations, at once providing the aural and visual bridge to reaffirm diverse communal relations, particularly those across the generational divide, while underscoring the black middle class' general refusal to adequately engage the realities of the Black Public Sphere in the postindustrial era.

Quiet Storms: Soul and Survival in the Suburbs

Excepting the trio of Holland, Dozier, and Holland, William "Smokey" Robinson has been the most influential black singer/songwriter/producer of his generation. After a long and productive collaboration with the Miracles, Robinson embarked upon a solo career in the early 1970s. Possessing one of the most gifted and distinct falsettos in the history of popular music, Robinson's songwriting skills, best exemplified by songs like "My Girl," "Ooh Baby, Baby," and "Shop Around," were no longer on the critical edge in the early 1970s. Momentarily regaining his creative energies, Robinson released his first "concept" recording with the 1975 classic *A Quiet Storm*. *A Quiet Storm* reflected the changing dynamics of popular music in the 1970s.

Some twenty years plus after the emergence of the 33-rpm long-playing format, artists began experimenting with longer recordings that often fea-

tured self-contained themes examined over the course of the entire album. This was a concept that Album Oriented Rock (AOR) exploited to its fullest commercial potential with groups like Led Zeppelin and The Eagles. Marvin Gaye was the first black artist to embrace this concept with large commercial success with his 1971 recording *What's Going On,* though Isaac Hayes's groundbreaking *Hot Buttered Soul* charted this territory with some success among black audiences before Gaye's crossover success. These changes in popular music represented the first opportunities for black artists to experiment with improvisation and arrangement outside of the genre of jazz and partially ended the reign of the 45-rpm recording as the only viable commercial format for popular music. Hayes's eighteen-minute reworking of Jimmy Webb's "By the Time I Get to Phoenix," and Donny Hathaway's gospel-tinged recording of Bobby Scott's "He Ain't Heavy, He's My Brother," from *Donny Hathaway* (1970) are two of the best examples of this new creative terrain for black artists. Though neither attracted mainstream appeal—Hayes commercial breakthrough occurred with the soundtrack to *Shaft* and Hathaway's only mainstream success occurs with pop-soul duets with Roberta Flack—these recordings laid the foundation for the later artistic achievements of Flack, Earth, Wind and Fire, and Barry White. It was in this context that Robinson made his own self-contained suite of romance recordings in 1975.

Robinson's seven-minute title track to *A Quiet Storm* suprised him by becoming the aesthetic cornerstone of a more upscale and sophisticated soul sound that would captivate an older, mature, and largely black middle-class audience that relished its distance from a deteriorating urban landscape. The cover art to *A Quiet Storm* finds a pensive Robinson examining woodland terrain with a black Shetland pony, an image that was unthinkable as cover art for a black recording artist a generation earlier, though Robinson's cover photo appealed to the sensibilities and desires of a newly emerging black middle class. Covering traditional soul themes like love lost, love found, and love betrayed, the entire first side of the album, recorded as a suite, is held together by the sounds of whispering winds, hence the recording's title.

As important as the recording was to Robinson's then-fading career, it proved more important to black radio programmers searching for programming that would appeal to a growing black middle class with disposable income, as a Howard University communications student appropriated Robinson's title and introduced the Quiet Storm format to black radio programmers. The generally late-night format basically consisted of soul ballads interspersed with some jazz and possibly a little contemporary blues. By the early 1980s, the format was a fixture in virtually every major radio market that programmed black or, as it came to be known by the late 1980s, urban contemporary music.[1] For Quiet Storm audiences, this format offered a welcome reprieve from disco and funk, both of which were arguably driven by

working-class youth audiences. While the Quiet Storm format was in part shaped by middle-class sensibilities, particularly given its Howard University roots, it cut across class lines because it appealed to adult sensibilities. Most notably, these recordings were in most cases devoid of any significant political commentary and maintained a strict aesthetic and narrative distance from issues relating to black urban life.

Artists like PIR stalwarts Harold Melvin and the Blue Notes and the O'Jays were all at home in this format. The solo careers of Patti Labelle and Teddy Pendergrass were in part shaped by their appeal to Quiet Storm audiences. Tracks like Labelle's "If Only You Knew" and Pendergrass's "Turn Out the Lights" are still Quiet Storm staples. Vocal groups like Atlantic Starr, The Whispers, Frankie Beverly, and Maze as well as solo acts like Denice Williams, Peabo Bryson, Stephanie Mills, Roberta Flack, and Jeffrey Osborne offered Quiet Storm audiences an aesthetic connection to the traditions of black popular music, particularly as postindustrial transformations further eroded public spaces in black communities and disco dance clubs migrated from black locales into more mainstream provinces. Furthermore, as time passed, some elements of the black middle class were decreasingly responsible for familial relations in black urban centers and began to successfully develop institutions within their own provinces, like churches and other social groups predicated on a common middle-class experience.

Gamble and Huff perhaps exploited this phenomenon best by always carefully packaging their recordings with potential pop Top-40 singles and Quiet Storm type album cuts. The O'Jays 1978 release *So Much Love,* is a case in point. Though the infectious pop-soul ditty "Use Ta Be My Girl" is still their highest charting single, the album's "Cry Together" has gone on to become a Quiet Storm classic. More importantly, much of this was occurring with little or no corporate interference, in that this market, dominated by black middle-class consumers who often equated consumption with acceptance in "integrated" America, was virtually ignored by the major corporate labels. Veteran soul singer Tyrone Davis's 1979 release "In the Mood" is such an example. Signed to the Columbia/CBS label, promotion of Davis's album *In the Mood* was lost in the shuffle of releases by younger black artists like Earth, Wind and Fire and Michael Jackson. Despite this the title track found a market niche among black audiences who were attracted to Davis's old-styled soul balladry.

By the mid-1980s, Luther Vandross and Anita Baker were perhaps the two artists who most benefited from the development of Quiet Storm radio. A veteran of stage musicals and commercials, Vandross achieved some success with his guest appearance with the disco group Change on its 1980 release *The Glow of Love,* in which Vandross sang lead vocals on the title track and the exquisite "Searching." While "Never Too Much," the lead sin-

gle of his first Epic/CBS recording, garnered considerable support from black and white audiences alike, it was Vandross's own seven-minute arrangement of the Hal David and Burt Bacharach song "A House Is Not a Home," that gave him his reputation as a definitive soul balladeer. On subsequent releases like *Forever, For Always, For Love* (1982), *Busy Body* (1984) which included a startling remake of the Carpenters's "Superstar," and *The Night I Fell in Love* (1985), Vandross established himself as an innovative singer/arranger and producer, particularly within the context of Quiet Storm radio.

With stellar sales among black listeners, Vandross's crossover success began with the release of his fifth recording, *Give Me the Reason,* in 1986. This success occurs at precisely the same moment crossover audiences were embracing Anita Baker's 1986 release *Rapture.* Possessing limited vocal range but a highly distinctive vocal quality, Baker attracted attention among black audiences as lead singer of the group Chapter 8 during the late 1970s and with her debut solo release, *The Songstress,* on the independent Beverly Glen label in 1983. Baker's jazz-flavored major label debut on the Elektra/Warner label found support among black radio and contemporary jazz stations that were embracing the pop-jazz of artists like David Sanborn, Grover Washington Jr. and a still relatively unknown Kenny G. What is notable here is that the commercial successes of Vandross and Baker were overshadowed by the commercial appeal of another form of black music that developed largely in the shadows of black middle-class mobility and in the ruins of an eroding urban landscape. While mature black audiences supported the music and performances of what Nelson George has called "retro-nuevo" soul, corporate labels focused their attention on the crossover appeal of three young black men from Hollis, Queens, Run-DMC, who along with their white protégés, The Beastie Boys, sold more than six million records of a "new" genre of music known as hip-hop or rap.[2]

Postindustrial Context(s): Hip-Hop, Postindustrialism, and the Commodification of the Black Underclass

Despite national rhetoric that suggested the contrary, the Black Public Sphere of the postindustrial city represented a de facto state of racial segregation that was, arguably, much more insidious than segregated black spaces prior to the Civil Rights movement. Lacking an indigenous economic base, these new social constructs developed largely as bureaucratic props of the federal government, as the postindustrial economy institutionalized a veritable nation of displaced workers, as integral cogs in the federal government's economy and industry of misery.[3] Meanwhile public institutions, already taxed by black middle-class flight and the inability of the black working class

to negotiate the economic burdens of community maintenance, were literal-
ly destroyed as part of the spatial logic of the postindustrial city. As Tricia
Rose relates in her seminal text on hip-hop music:

> The city's poorest residents paid the highest price for deindustrialization and
> economic restructuring.... In the case of the South Bronx, which has frequently
> been dubbed the "home of hip-hop culture," these larger postindustrial condi-
> tions were exacerbated by disruptions considered an "unexpected side effect" of
> the larger politically motivated policies of "urban renewal." In the early 1970s,
> this renewal [sic] project involved massive relocations of economically fragile
> people of color from different areas of New York City into parts of the South
> Bronx. Subsequent ethnic and racial transition in the South Bronx was not a
> gradual process that might have allowed already taxed social and cultural insti-
> tutions to respond self-protectively; instead, it was a brutal process of commu-
> nity destruction and relocation executed by municipal officials.[4]

Thus black urban populations were affected by economic and social trans-
formations both internal and external to the traditional Black Public Sphere.
In the quest to create a functional postindustrial environment, the masses of
multiracial working-class and working-poor people were some of the most
expendable urban resources human resources that, a half century earlier
were enticed to migrate to urban spaces in support of industrial develop-
ment. As urban development changed in response to technological
"advancement" and economic restructuring, so did social and economic
investment in working-class communities. As John Mollenkopf suggests in
his texts on the emergence of postindustrial cities like New York, "The mag-
nificence of the Manhattan central business and shopping district and the
resurgence of luxury residential areas may be juxtaposed to the massive
decay of the city's public facilities and poor neighborhoods."[5] Many work-
ing-class communities and their inhabitants were deemed as peripheral to
the mechanisms of the postindustrial city as high finance and the con-
sumerist desires of a growing managerial class influenced municipal devel-
opment, including well-publicized tax breaks to corporate entities that
remained within certain municipalities without any specific commitment to
their lower-tier workers. This phenomenon further challenged working-class
communities as a diminishing taxbase led to cuts in municipal and later fed-
eral aid, thus instigating a further spiral into poverty and community erosion
for many working-class communities. Under the banner of "urban renewal,"
the black working class and working poor were marginalized and isolated
from the engines of the postindustrial city—the privatization of public space
in downtown areas being emblematic—and instead exposed to intense
poverty and rampant unemployment, which subsequently challenged tradi-
tional desires to maintain community.

Poverty within the postindustrial city featured spatial dimensions that also altered African-American efforts to build and maintain urban communities. As David Theo Goldberg states, "The segregated space of formalized racism is over-determined. Not only is private space restricted by the constraints of poverty, so too is public institutional space."[6] By the mid-1970s, Goldberg's thesis found its logical icon in the sprawling federal housing projects that largely replaced the kitchenette tenements of black urban spaces in the North and Midwest.[7] Goldberg's "living space of poverty" acknowledges an urban landscape that privileges the private and the local—the manifestation of fractured communal relations and the pervasive aura of social isolation. Though many federal housing projects represented a marked improvement over the quality of urban housing prior to the Civil Rights movement, the very logic of federally subsidized "low-income" housing meant that the poorest blacks would be socially and economically isolated from the mechanisms of the postindustrial city in neighborhoods that were acutely overcrowded and lacked the necessary public and institutional space to build and maintain communal sensibilities. This social isolation has been defined by sociologist William Julius Wilson as "lack of contact or of sustained interaction with individuals and institutions that represent mainstream society."[8] Though isolation from mainstream culture remains a substantial barrier to survival in the postindustrial city, the fracturing of communal relations within the African-American diaspora has had a more profound effect on the black poor as communal exchange, critique, and other communal relations that were integral to black survival in the industrial era were severed by regional and spatial dislocations within the Black Public Sphere and economic and political transformations beyond it.

Given the paucity of private and public space, it was no surprise that the private and the public began to conflate, as the familial, communal, and social "dysfunction" of the African-American experience entered into mainstream public discourse. While dysfunction exists in many communal settings, regardless of race, class, and social location, African-American dysfunction was mass mediated and commodified for mass consumption via network news programs, Hollywood films like *Fort Apache,* and television programs like *Starsky and Hutch* and *Baretta.* By the late 1970s, the commodification of the black poor or underclass as human spectacle became a standard trope of mass culture, parlaying a clear sense of social difference from "blackness" for many mainstream consumers, including an emerging black middle class. My point is not to suggest that "dysfunction" among white communities was not present in mass culture, but that the mass-mediated images of the black underclass often served as the only images available to mainstream consumers, whereas a diversity of images for the white ethnic experience was often presented for consumption, albeit rife with its own

internal markers of class and social difference. Many of the experiences of the "ghettocentric" poor were essentialized as a representative sample of the broader black community, to the obvious detriment of many segments of the African-American diaspora including the black poor. For instance, mass-mediated misrepresentations of the black poor often validated the rhetoric of conservative politicians like Ronald Reagan who opposed increased federal spending for social programs, by deemphasizing the roles of racism, poor education, inadequate health care, and the collapse of industrial-based economies and by instead projecting drug addiction, laziness, and the inferiority of African-American culture as the primary culprits of black misery.

The rather vivid imagery of black urban spaces within mass culture was further enhanced by the layout of communal spaces in many urban communities. For example, many of the federally subsidized housing projects of the Northeast and Midwest—Chicago's Cabrini-Greene comes to mind—represented the inverted logic of Jeremy Bentham's Panopticon, by providing surveillance from the bottom. Though I am not suggesting that the federal housing projects were part of some conspiracy to manage the black masses, the high visibility of such housing, with its distinct architecture that privileged more efficient use of urban space over livability and the concentration of the black poor within such spaces, increased notions that such communities were socially isolated from mainstream life and thus to be feared and neglected. Of course, in many locales like the Compton and Watts districts in Los Angeles, technological advancements in policing have allowed many police departments the ability to "patrol" black urban spaces via helicopters or "ghetto-birds."[9] Such developments countered historical examples where black isolation was often accompanied and defined by invisibility. To the contrary, in the postindustrial era, the black masses continued to be marginalized but remained highly visible within varying social constructs.

In response to poverty and unemployment, an illicit economy emerged as a primary conduit for economic survival among some segments of the postindustrial city. Illicit activities like petty thievery, numbers running, prostitution, and even drug dealing had been a small part of the informal economy of segregated black spaces throughout the twentieth century. For example, one of the few black patrons of the "Harlem Renaissance" was West Indian numbers runner Casper Holstein, who helped finance the Urban League's literary awards in 1926 from his profits.[10] What radically changed the nature of the informal economy of the Black Public Sphere in the post–Civil Rights era is the intensity of the economic collapse, accompanied by massive unemployment within those spaces and the emergence of an illegal drug that is perhaps the most destructive element to emerge within the contemporary Black Public Sphere.

Crack cocaine was a unique drug; its emergence exemplified the paradox of consumptionist desire in the midst of intense poverty. In his exhaus-

tive examination of postindustrial Los Angeles, Mike Davis writes of the cocaine trade:

> Like any "ordinary business" in an initial sales boom, the cocaine trade had to contend with changing relations of supply and demand.... Despite the monopsonistic position of the cartels vis-á-vis the producers, the wholesale price of cocaine fell by half. This, in turn, dictated a transformation in sales strategy and market structure. The result was a switch from *haute cuisine* to fast food, as the Medellin Cartel, starting in 1981 or 83 (accounts differ), designated Los Angeles as a proving ground for the mass sales of rock cocaine or crack.[11]

To counter the flattening of demand for cocaine, a less expensive form of cocaine was introduced into poor communities within postindustrial cities like Los Angeles, New York, and Detroit in an effort to expand markets. Not only did crack cocaine increase demand for cocaine nationally, crack cocaine created its own thriving market. It featured a short, intense high that was highly addictive and thus offered "more bang for the buck." As Cornel West has suggested, the intensity of crack cocaine addiction mirrored the intensity of consumptionist desire in America.[12] The craving for the type of stimulant that crack cocaine provided made it popular among those who desired transcendence from the everyday misery of postindustrial life. In this regard, crack cocaine addiction resembled the historical examples of religion, recreational sex, and dancing as temporal releases from the realities of African-American life in the twentieth century. Crack cocaine differed from these aforementioned examples in that it also helped destroy communal relations within the Black Public Sphere as crack cocaine addiction led to increased black-on-black crime and the emergence of illicit sex acts "performed" within distinctly public forums where sex acts where exchanged often for drug money or drugs themselves.

More compellingly, the crack cocaine trade was attractive as a counter to poverty within the postindustrial city. As Davis maintains in *City of Quartz,* the crack cocaine industry was introduced to postindustrial Los Angeles after large numbers of bluecollar workers were displaced from the industrial plant economy that was largely responsible for black migration from the South into Los Angeles immediately after World War II. The postindustrial transformation of Los Angeles, including the emergence of Japanese imports, effectively mitigated many of the economic and social gains made by the black working class in the post–World War II era. Furthermore, many African-Americans, particularly young black men, were excluded from both the service and the high-tech industries that were developing in the region, leading to unemployment rates well over 40 percent among black youth.[13] The significant demand for crack cocaine and the relative ease with which in could be produced on-site made the crack cocaine trade an attractive alternative to

the abject poverty that defined the postindustrial experience for many blacks.

What was unique about the crack cocaine industry for many African-Americans is that it attempted to counter a poverty that was itself constructed against commodified images of wealth and consumption. Unlike previous periods of widespread poverty that existed somewhat in isolation of mainstream wealth, the impoverished masses within America generally faced a barrage of commodified images of wealth and consumption via television, film, and other organs of mass culture, as self-worth increasingly came to be defined by the ability to consume. African-American youth were particularly subject to this barrage of wealth and consumption as part of the first real generation of American youth socialized by television.[14] As mentioned previously, African-American youth investment in television was intensified as a corollary to corporate annexation of black popular expression, marking the post–Civil Rights generation(s) of African-American youth as the first who could readily consume the iconography of "blackness." As street-level sellers and producers of crack cocaine, African-American youth found a way to escape poverty and to consume as a measurement of self-worth. Thus unlike other ethnic groups who used the drug trade as a foundation to build upon "legitimate wealth"—Mario Puzo's examples in the *Godfather* chronicles immediately come to mind—African-American youth involved in the crack cocaine industry simply invested in material icons of wealth like cars, cellular phones, jewelry, and au couture fashions instead of transforming such wealth into familial or communal efforts to rebuild community. Furthermore, African-American youth interest in the crack cocaine industry was particularly profound because of the "juvenization of poverty" among many urban groups. In Los Angeles County, for instance, more than 40 percent of children lived below or just above the official poverty line. This mirrored a doubling of children in poverty across the state of California in just a generation.[15] Theses trends were further realized in many postindustrial urban environments across the nation.

What emerged in the shadows of many of these developments was a distinct African-American youth culture whose basic sentiments were often incompatible with mainstream African-American leadership and mainstream culture in general. In its worst case, it was a culture personified by gang turf wars over the control of the crack cocaine industry, a culture described by Michael Eric Dyson as a "ghettocentric juvenocracy" where economic rule and illegal tyranny is exercised by a cadre of young African-American males over a significant portion of the black urban landscape.[16] It is at this end of the spectrum that the postindustrial realities of black life continue to challenge the very idea of community as drive-by shootings and subsequent police occupation continue to rip communities apart by militarizing public spaces. At the more positive end of the spectrum a distinct discourse of

African-American youth, with obvious regional variations, emerged to narrate, critique, challenge, and deconstruct the realities of postindustrial life. Hip-hop music and culture represented such a discourse.

The Discourse(s) of Hip-Hop: Resistance, Consumption, and African-American Youth Culture

While many African-American youth were not privy to the everyday realities of the black urban experience, a distinct urban-based African-American youth culture emerged in the mid- to late 1970s. Prior to World War II African-American youth culture was largely hidden from mainstream culture, subsumed within the parameters of segregated black spaces. The zoot suit riots and explosion of bebop music represented the first real glimpse into African-American youth culture for those beyond the confines of segregated urban spaces. Though bebop was essentially an aesthetic movement driven by the sensibilities of black male musicians, some well into their thirties who were reacting to racism in the North, the movement was given its energy and stylistic acumen by African-American youth who embraced the movement as a form of transcendence/resistance from the everyday drudgery of their existence. Zoot suits, the lindy-hop, and jive were all the nuances that African-American youth brought to the subculture of bebop music.

Historically African-American youth culture has rarely been driven by ideological concerns, but instead has embraced, appropriated, and reanimated existing structures, organizations, and institutions that African-American youth perceived as empowering them within various social, cultural, and economic constructs. Many of the stylistic excesses associated with African-American youth culture were conscious efforts to deconstruct and critique mass-mediated images of African-American youth. The impact of African-American youth culture on existing political and social movements was perhaps most profound when black youth embraced the Civil Rights movement of the early 1960s. The lunch-counter sit-ins, marches, and Freedom Summer bus rides were all emblematic of the impact of black youth culture on the movement. The development of the Student Nonviolent Coordinating Committee (SNCC), often referred to as the youth wing of the traditional Civil Rights movement, was a recognition on the part of the traditional leadership of the importance of black youth to mass social movement.

That importance was further realized when African-American youth begin to reject the strategies of the traditional Civil Rights leadership and embraced the nationalist leanings of the Nation of Islam and later the Black Panther Party. The Black Panther Party, whose members were often culled from youth street gangs like the Slausons in south-central Los Angeles and the Blackstone Rangers in Chicago, personified African-American youth cul-

ture's ability to impact upon mainstream culture both within and beyond the Black Public Sphere.[17] Not surprisingly, such overtly political organizations gave way to less-inspiring constructs as a direct response to the collapse of the Civil Rights/Black Power movements and the increased commodification of wealth and consumption within mass culture. Thus the return to street-level gangs like the Crips and Bloods in Los Angeles or the Black Spades in New York City were emblematic of the belief within African-American youth culture that mass consumption and the accumulation of wealth for mass consumption were the most viable means of social transcendence afforded them in the post–Civil Rights era. The introduction of the crack cocaine industry into black urban spaces further enhanced such notions well into the 1990s.

Hip-hop music and culture emerged as a narrative and stylistic distillation of African-American youth sensibilities in the late 1970s. Hip-hop differed from previous structures influenced by African-American youth in that it was largely predicated and driven by black youth culture itself. The fact that hip-hop emerged as a culture organic to African-American youth in urban spaces reflects the aforementioned social isolation afforded black youth and the conscious effort by many corporate capitalists to develop a popular music industry largely anchored by the sensibilities of American youth. Given this context, it was perfectly natural that the most profound aesthetic movement in black popular music in the post–Civil Rights era would be profoundly influenced black youth culture. In reality, African-American youth appropriated many diverse examples of black expressive culture, including the Jamaican Toast tradition, and created an aesthetic movement that was uniquely tailored to their historic moment and their own existential desires.

I maintain that the emergence of hip-hop, which appeared in a rudimentary state in the mid-1970s, was representative of a concerted effort by young urban blacks to use mass-culture to facilitate communal discourse across a fractured and dislocated national community. As Rose states, "Rappers' emphasis on posses and neighborhoods has brought the ghetto back into the public consciousness. It satisfies poor young black people's profound need to have their territories acknowledged, recognized and celebrated."[18] While much of this activity was driven by the need to give voice to issues that privilege the local and the private within the postindustrial city—thus the overdetermined constructions of masculinity, sexuality, criminality, and even an urban patriarchy—hip-hop's best attempts at social commentary and critique represented traditions normalized and privileged historically in the Black Public Sphere of the urban North. Arguably the most significant form of counterhegemonic art in the black community over the last twenty years, the genre's project questions power and influence politically in the contexts of American culture and capitalism, the dominance of

black middle-class discourse, but most notably the "death of community" witnessed by African-American youth in the postindustrial era.

Despite its intense commodification, hip-hop has managed to continuously subvert mass-market limitations by investing in its own philosophical groundings. Like bebop before it, hip-hop's politics was initially a politics of style that created an aural and stylistic community in response to the erosion of community with the postindustrial city. Perhaps more that any other previous popular form, hip-hop thrived on its own creative and aesthetic volatility by embracing such volatility as part of its stylistic traditions. This has allowed the form to maintain an aesthetic and narrative distance from mass-market limitations, though I must acknowledge that it is often a transient moment. As Tricia Rose suggests, "Developing a style nobody can deal with—a style that cannot be easily understood or erased, a style that has the reflexivity to create counter-dominant narratives against a mobile and shifting enemy—may be one of the most effective ways to fortify communities of resistance and *simultaneously* reserve the right to communal pleasure."[19]

Commercial disinterest in the form during its developing years, allowed for its relatively autonomous development. Relying largely on word of mouth and live performance as a means of promotion, hip-hop represents the last black popular form to be wholly derived from the experiences and texts of the black urban landscape. In the aftermath of disco and corporate America's considerable retreat from its commitment to producing and distributing black popular music, hip-hop was allowed to flourish in public spaces and on several independent recording labels. Hip-hop's live performances were largely predicated on the recovery of commodified black musical texts, for the purpose of reintegrating these texts into the organic terrain of black urban communities. According to critic Paul Gilroy:

> Music recorded on disk loses its preordained authority as it is transformed and adapted.... A range of de/reconstructive procedures—scratch mixing, dubbing, toasting, rapping, and beatboxing—contribute to new layers of local meaning. The original performance trapped in plastic is supplemented by new contributions at every stage. Performer and audience alike strive to create pleasures that can evade capture and sale as cultural commodities.[20]

Like bebop, hip-hop appropriated popular texts, often refiguring them to serve hip-hop sensibilities. This phenomenon contextually questions and ultimately undermines the notion of corporate ownership of popular music and would have legal ramifications well into the decade of the 1990s.[21] Gilroy's comments are instructive in that even as hip-hop became a thoroughly commodified form in the late 1980s, its ability to mine the rich musical traditions of the African-American diaspora through the process of sam-

pling allowed the form to privilege local and specific meanings historically aligned with organic sites of resistance and recovery.

For African-American youth, hip-hop music also allowed them to counter the iconography of fear, menace, and spectacle that dominated mass-mediated perceptions of contemporary black life by giving voice to the everyday human realities of black life in ways that could not be easily reduced to commodifiable stereotypes. The release of Grandmaster Flash and the Furious Five's "The Message" was a prime example of these sensibilities in the early stages of hip-hop. Recorded and released in 1982 to mainstream critical acclaim, it is the first hip-hop recording to be accorded such praise. Part of the recording's obvious appeal to mainstream critics was its unmitigated and "authentic" portrayal of contemporary black urban life. "The Message" was the first significant political recording produced in the postsoul era, representing an astute critique of the rise and impact of the Reagan right on working-class and urban locales.

Melle Mel's narrative portrays the transformation of the individual spirit within a context that offers little or no choice or freedom for those contained within it. Within Melle Mel's text, the fate of the individual spirit living within the parameters of the postindustrial urban landscape has been consigned at birth to live a short and miserable life. Representative of the genre, hip-hop was perhaps the first popular form of black music that offered little or no hope to its audience. The fatalistic experience has become a standard trope of urban-based hip-hop—"The Message" is but one clarion example of this. Juxtaposing diminishing hope and the rampant materialism of the underground economy of the urban landscape, Melle Mel identifies a ghetto hierarchy that ghetto youth have little choice but to invest in. Here, Melle Mel is cognizant of the "role model" void produced by middle-class flight and the lack of quality institutions to offset the influence of the ilicit underground economy. In this context, Melle Mel identifies the failure of inner-city schools to provide a necessary buffer against urban malaise.

Seven years after the release of "The Message," more than 600,000 black men ages twenty to twenty-nine were either incarcerated, paroled, or on probation. The American prison population doubled over the twelve-year period from 1977 to 1989.[22] What Stevie Wonder had emphatically prophesied in "Living for the City" had become a stark and inescapable reality for the urban constituency that Melle Mel represented in "The Message." Using dated tropes of black masculinity and political resistance, Melle Mel considers a penal system that is incapable of producing rehabilitated individuals and has become a site of sexual violence between men. If the ideological imagination of the Black Power movement was partially related to the reintroduction of a hypermasculine patriarchy within the black community, Melle Mel's imagery of black male rape is an assertion that the Civil Rights/Black Power eras were far removed historically and intellectually from the landscape of the postindustrial city. In the end, Melle Mel trans-

forms his ghetto narrative into a contemporary slave narrative, in which the protagonist chooses death at his own hands as opposed to incarceration and enslavement.[23]

The closing moments of "The Message" finds members of Grandmaster Flash and the Furious Five engaged in casual banter on a street corner in New York. The group is shortly confronted by members of the NYPD who immediately accuse and arrest them for some unnamed crime. In a comic moment, one of the group members asserts, "But we're Grandmaster Flash and the Furious Five," to which a cop responds, "What is that, a gang?" and proceeds with his arrest. While the scene on one level acknowledges the lack of status afforded hip-hop artists within mainstream culture, a recurring theme in hip-hop, it also is a thinly veiled appropriation of a similar moment during Stevie Wonder's "Living for the City." I suggest that a comparison of the two recordings adequately details the changes within the postindustrial urban landscape over a period of nine years.

The most significant difference in the two texts is the fact that Wonder's protagonist migrates from the American South, during what is the very last stages of the black migration from the South in the twentieth century. Melle Mel's protagonist was born in the urban North, and thus could never invest in the type of promise that was articulated in the oppositional meanings of the mass migration. It is this lack of hope that remains a constant marker of the differences detailed in both narratives. While Wonder's protagonist is unwittingly introduced to the economic subculture of the urban North, Melle Mel's protagonist makes a conscious choice to invest in the economic subculture of the postindustrial city, precisely because of the lack of educational and economic opportunities that Wonder's protagonist envisioned in the urban North in the first place. Both artists are critical of the lack of rehabilitation that takes place in the American penal system, though the world that Wonder's protagonist returns to after prison is more closely aligned to the world that Melle Mel's character is born into.

The death of Melle Mel's protagonist suggests that the continuing transformation of the urban landscape will produce an environment that is as unlivable as it is unbearable and perhaps unnameable, within Melle Mel's narrative imagination. For example, neither Wonder nor Grandmaster Flash could foretell the coming threat of crack addiction within the black community, though Melle Mel would document its presence on his solo recording "King of the Streets" in 1984, almost two years before mainstream culture would acknowledge the presence of what is defined as a "smokable, efficient, and inexpensive" drug, that produces "hyperactive, paranoid, psychotic, and extremely violent" addicts.[24] The introduction of crack cocaine into the black urban landscape would arguably have as much effect on the quality of life within the postindustrial city as black middle-class flights and the postindustrial economy. Hip-hop music and the burgeoning "ghetto" cinema that emerges from within its traditions were both uniquely poised to

represent the realities of contemporary black urban life within mainstream culture. In their best moments, these cultural narratives create critical exchange within the vast constituencies of the African-American diaspora. In their worse moments, these narratives were too often interpreted by a dislocated black middle-class as the products of individuals who lack the civility and determination that befit their middle class sensibilities. Almost a full century after the first articulation of the "New Negro," the old Negro had been transformed from southern migrant to urban ghetto dweller, and the black middle class was equally disdainful of both.

Despite recordings like "The Message," early hip-hop recordings rarely ventured beyond themes associated with the everyday experiences of urban-based African-American youth. Because of hip-hop's intimate connection to African-American youth culture, its narratives usually mirrored whatever concerns were deemed crucial to black youth. Like the music that echoed throughout black dance halls in the 1930s and 1940s, the "party and bullshit" themes of most early hip-hip represented efforts to transcend the dull realties of urban life, including body-numbing experiences within low-wage service industries and inferior and condescending urban school systems. Though hip-hop represented an art form that countered mainstream sensibilities and clearly could be construed as a mode of social resistance, in and of itself, it was not invested with political dimensions, at least not any more so than African-American youth culture contained within itself. At best hip-hop represented a distinct mode of youthful expression primed to serve as a conduit for political discourse as it coincided with the sensibilities of black youth. Jesse Jackson's first presidential campaign in 1984 and the reemergence of Louis Farrakhan and the Nation of Islam represented two distinct though related phenomena that would politicize black youth and thus politicize some aspects of hip-hop music in the early to mid-1980s.

On the surface Jesse Jackson's presidential campaign in 1984 was largely rooted in the discourse of the traditional Civil Rights movement and thus was not initially attractive to hip-hop's primary constituency. The Civil Rights movement and electoral politics, for that matter, were often interpreted as being marginal to the primary concerns of the black urban poor. The failure of the increased numbers of black elected officials in various municipalities to adequately empower the black poor in those municipalities is one of many issues responsible for such interpretations. But Jackson's campaign, which was publicly parlayed as the first serious attempt at the presidency by an African-American—Shirley Chisholm's efforts in 1972 largely removed the black political landscape—attracted tacit support throughout the African-American diaspora because of its historic meaning.

Louis Farrakhan's public support of Jackson's efforts offered the Nation of Islam leader the mainstream visibility, if not credibility, that the Nation of Islam had not been afforded since the death of Malcolm X. Though Farrakhan's black nationalist politics and critiques of white supremacy were

often oppositional to the broad mainstream appeal that Jackson craved and needed to be seriously considered for the presidency, his momentary alliance with Jackson gave him access to the black masses, particularly the urban masses who had long rejected the style of political activism that Jackson personified. Particularly appealing to black urban youth was Farrakhan's willingness, like his late mentor Malcolm X, to speak forcefully about the nature of American race relations and the evils of white supremacy. Farrakhan's penchant for rhetoric, which often bordered on anti-Semitism, effectively demonized him among mainstream pundits, and his subsequent outlaw status further attracted black youths who felt themselves demonized in mainstream culture. Farrakhan's inability to project lasting solutions to the problems that face the urban poor did not deter support from black youth, in that his channeling of black rage in a national context validated the black rage that black youth often expressed within their own personal and local contexts. Farrakhan's rage, within the context of the increasing misery of urban life, provided the impetus for segments of the hip-hop community channel their own critiques of white supremacy and expressions of black rage into their music.

The group Public Enemy was perhaps the most accomplished at projecting black rage as a political discourse that would prove attractive to the youth audiences that hip-hop garnered. Born and raised on the fringes of the Black Panther Party, Public Enemy leader Chuck D intuitively understood the attractiveness of black nationalism to urban youth in the 1960s and attempted to reintroduce many of those themes to black youth within a contemporary social and aesthetic context. Chuck D's political rhetoric for the Reagan era was initially and cautiously presented on Public Enemy's first recording, *Yo! Bum Rush the Show,* in 1986. It failed to attract black youth audiences, mostly because much of the music was undanceable, heresy for those who are serious about making music popular among black youth. Moreover, given black radio's initial rejection of hip-hop and the subtle transformation of the music from a live/public form of expression to one increasingly produced in a studio for mass consumption, it was imperative for its survival that hip-hop be conducive to the types of public spaces where black youth were most likely to convene. Dance halls or clubs continued to be the most accessible spaces for black youth to congregate, so the challenge for those who were interested in presenting hip-hop as political discourse was to make sure the music was danceable. Public Enemy later recorded a succession of twelve-inch releases that were not necessarily any more danceable than those found on *Yo! Bum Rush the Show,* but instead challenged and dared black youth to dance to them, much the way bebop artists dared black youth to lindy-hop to their self-styled musical tomes.

The sonic cacophony of "Rebel Without a Pause" and "Bring the Noise" represented the vanguard of hip-hop production styles. Chuck D's driving baritone was the perfect foil for the "organized confusion" that was a staple

of Public Enemy's producers, The Bomb Squad. These innovations proved enticing to both a mainstream public and black youth, who were perhaps tired of the unimaginative drum machine programming that had come to dominate the genre. *It Takes a Nation to Hold Us Back,* released in the late spring of 1988, represented Public Enemy's vision for hip-hop's role in galvanizing a political vanguard in the post–Civil Rights era. As Greg Tate wrote at the time of the recordings release:

> Nation of Millions is a declaration of war on the federal government, and that unholy trinity—black radio programmers, crack dealers, and rock critics…. For sheer audacity and specificity Chuck D's enemies list rivals anything produced by the Black Liberation Army or punk—rallying for retribution against the Feds for the Panthers' fall ("Party for your Right to Fight"), slapping murder charges on the FBI and CIA for the assassinations of MLK and Malcolm X ("Black Steel in the Hour of Chaos"), assailing copyright law and the court system ("Caught, Can I Get a Witness").[25]

Chuck D's call for truth, justice, and a black nationalist way of life was perhaps the most potent of any political narratives that had appeared on a black popular recording. Public Enemy very consciously attempted to have hip-hop serve the revolutionary vanguard, the way soul did during the 1960s. Despite Public Enemy's vast popularity among black and white youth audiences, their 1960s-style rhetoric raised old antagonisms from those further on the political right as well as mainstream African-American leaders concerned about both the group's militancy and its obvious connections to Farrakhan and the Nation of Islam.

Chuck D clearly saw hip-hop as an alternative medium for black youth and their fellow travelers to access political and social reality as constructed by Public Enemy. Nowhere was this more evident than on the song "Don't Believe the Hype," where Chuck D offers a compelling argument for media education. Chuck D characterizes mainstream media as misinformed and malicious in their distribution of misinformation. Chuck D's narrative constitutes a counternarrative to mainstream attacks on the social and political commentary reflected in the work of the group. In an effort to democratize the mainstream critical establishment, the Public Enemy front man links his experiences to John Coltrane. Coltrane's jazz explorations in the 1960s were also criticized by a biased and misinformed critical establishment. Chuck D embraces a nationalist argument that suggests that critiques of black popular culture are best performed by those immersed in the organic culture that produces it. Within Chuck D's worldview, hip-hop represents the most natural environment in which to critique the social and political experiences of an urban-based African-American constituency. Black radio's early rejection of hip-hop, excepting the few late-night programming slots given to well-

known hip-hop DJs in the major markets, reflected the sentiments of the black middle class regarding hip-hop and in part reflected a historical trend among the black middle class regarding popular art forms that emerge from the black working-class experience.

But Public Enemy's resuscitation of 1960s-style black political rhetoric was often problematic, particularly when considering that the group's primary constituents were not likely to provide the type of critique that was necessary to realize Chuck D's lofty goals. Chuck D's politics were particularly problematic in the area of gender, where tracks like "She Watch Channel Zero" could have been used as a chorus for Reagan's attacks on "welfare queens," as the track suggested that black women who watch soap operas are partially to blame for the precarious predicament of black children. Public Enemy's failure to adequately critique the ideals they espoused was of course logical in the type of vacuum that their rhetoric was reproduced in. The erosion of communal exchange that marked the post–Civil Rights period, also denied the movement the ability to critique itself in ways that would allow it to be self-sustaining and progressive. Thus a younger generation of activists emerged, many of whom were not privy to the type of communal processes that were crucial to black political discourse prior to the Civil Rights movement, and they appropriated the ideological themes of the era without the benefit of critiquing these themes to make them more applicable to a contemporary context. The fact that groups like Public Enemy were unable to critique the sexism inherent to much of black political thought in the 1960s is particularly disheartening in that black women have been the most outspoken critics of the movement's shortcomings, particularly in regard to gender issues.[26] Unfortunately, Public Enemy's political shortcomings were easy to ignore, as Greg Tate relates: "Were it not for the fact that Nation is the most hellacious and hilarious dance record of the decade, nobody but the converted would give two hoots about PE's millenary desires."[27]

The release of *It Takes a Nation of Millions to Hold Us Back* coincided with several industry initiatives that offered hip-hop much more accessibility and visibility. Two years after the release of Run-DMC's landmark *Raisin' Hell* recording, many independent recording labels that featured hip-hop entered into distribution deals with corporate conglomerates. The Def Jam label's sale to conglomerate CBS/Columbia was strikingly reminiscent of the conglomerate's relationship with Gamble and Huff more than a decade earlier. With distribution outlets increased and cooperate labels having more money to spend on artist development, hip-hop began its growth as one of the more popular music genres, this despite all of the negative connotations associated with it within mainstream society. Never radio-friendly, hip-hop got a necessary promotional boost with the debut of *Yo MTV Raps* on MTV in the fall of 1988. Music video opened hip-hop to an audience of mid-

American youths, who relished in the subversive "otherness" that the music and its purveyors represented. By the time Gangsta rap (an often cartoonish portrayal of black masculinity, ghetto realism, and gangster sensibilities) became one of the most popular genres of hip-hop, a significant portion of the music was largely supported by young white Americans.

Despite such successful recordings as *Fear of a Black Planet* (1990) and *Apocalypse '91 ... The Enemy Strikes Black* (1991), *It Takes a Nation ...*, would be the apex of politically infused hip-hop and Public Enemy's popularity among black youth. The failure of explicit political discourse to remain an integral part of hip-hop was influenced by various dynamics. Placing a premium on lyrical content, artists like Public Enemy, Boogie Down Productions featuring KRS-One, Paris, X-Clan, former Public Enemy member Professor Griff, and Michael Franti and the Disposable Heroes of Hiphoprisy all failed to grasp the significance of producing music that would be considered danceable by the black masses they aimed to attract. As Tate surmised about Public Enemy's first recording, many of these artists produced music that consistently "moved the crowd off the floor."[28] The simultaneous emergence of NWA (Niggas with Attitude), whose production by Dr. Dre effectively altered the hop-hop landscape by removing the industry focus away from the East Coast and New York specifically, should have been instructive to artists with explicit political designs. Lacking a cohesive ideology but possessing an accessible critique of poverty, economic exploitation, and police brutality in postindustrial Los Angeles, NWA recordings like "Fuck the Police," from *Straight Out of Compton* (1988), ingratiated them to those who shared their experience and craved a funky beat. Ironically it was NWA's antipolice anthem that drew the most attention from federal agencies like the FBI and not the more ideologically sound rhetoric of groups like Public Enemy or Boogie Down Productions.

Ultimately, political hip-hop was undermined by hip-hop's own internal logic which often privileged constant stylistic innovation, both in narrative and musical content, as a response to intense commodification. Thus as Todd Boyd suggests, political hip-hop "seems to have functioned as a genre whose popularity had passed, instead of a sustained movement which connected both cultural artifacts and 'real' political events."[29] But political hip-hop was also challenged by efforts of segments of mainstream culture to control or "police" hip-hop, efforts that would ultimately transfer control of the genre away from its organic purveyors and limit access to the form in communal settings where alternative interpretations could be derived which countered mass-mediated presentations of the genre. These threats to hip-hop's ability to function as conduit for communal exchange came from those already entrusted to police black youth, the insurance industry and corporate America, the latter of which slowly began to continue their aborted effort to fully annex the black popular recording industry.

*Fear of a Black Commodity: The Policing,
Criminalization, and Commodification
of Hip-Hop Culture*

In November 1992, Spike Lee produced and directed the cinematic epic *Malcolm X*. The fact that the most visible icon of black political resistance over the past thirty years was the focus of a Hollywood film would suggest that the efforts of groups like Public Enemy and X-Clan had successfully altered the landscape of mainstream American culture. Only three years earlier another Spike Lee film, *Do the Right Thing,* which featured Public Enemy's now-classic recording "Fight the Power," was criticized for potentially stirring the black masses to violence in response to the film's vivid portrayal of race relations in a fictional Brooklyn neighborhood.[30] Several months before the release of Lee's *Malcolm X,* the city of Los Angeles exploded in violence in response to the acquittal of the police officers involved in the videotaped beating of black motorist Rodney King. On the surface the communal response to the highly controversial court decision further suggested that hip-hop had succeeded in producing a visible and influential political vanguard. But *Malcolm X* was instead released to much mainstream acclaim for the film, its director, and its star, Denzel Washington, who earned an Academy Award nomination for his portrayal of the black nationalist icon. The revolutionary vanguard that Lee, Public Enemy, Louis Farrakhan, and Malcolm X's memory supposedly inspired were instead to found "Rolling wit Dre." While such a reality clearly suggests that the political expediency that some hip-hop artists tried to instill in black expressive culture had been subsumed by the economic interests of a cadre of middle-class black artists driven by the demands of corporate capitalism, it also reflected the limits placed on political expression in an era where public expressions of identity and self-determination are so readily commodified and mediated for mass consumption, particularly when such consumption could in fact distribute values contrary to those valued in mainstream culture.

Following the highly influential solo efforts of former NWA comrade Ice Cube, whose recordings *AmeriKKKa's Most Wanted* (1990), *Death Certificate* (1991), and *The Predator* (1992) captured hip-hop's creative imagination, Dr. Dre released his first solo recording, The *Chronic,* in the autumn of 1992. Dr. Dre's musical ode to "good weed" and the self-styled lifestyles of postindustrial gangsters had all but solidified the Los Angeles area as the dominant creative and commercial force in hip-hop and the "G-Funk" of Dr. Dre and his protégés Snoop Doggy Dog and Warren G as the dominant production style. The underlying influences of G-Funk, or as it came to be known among mainstreams pundits, "gangsta rap," included narratives as diverse as the fiction of Iceberg Slim, the music of Parliament-Funkadelic, and Brian De Palma's 1983 remake of the film *Scarface.* Within

contemporary black male culture, particularly that located within poverty-stricken urban spaces, the film had long been embraced as a contemporary example of a postimmigration attempt at pursuing the American Dream. Like the cocaine industry that framed the film's core themes, crack cocaine served a similar purpose in the real-life narratives of the young black men that the film appealed to. The culture and industry of crack's intimate relationship to the culture and industry of hip-hop would be realized with *The Chronic* and Dr. Dre's stirring production style.

The introduction of the G-Funk was largely framed by efforts of various social forces to curtail and control the popularity of hip-hop and its potential use as a conduit for oppositional discourse(s). Though Public Enemy's efforts to create a political insurgency for the 1980s were destined to fail because they existed beyond an actual political movement rooted in legitimate political concerns, and the efforts of NWA, while more closely aligned to sensibilities of black urban youth, ultimately lacked the political sophistication to be a legitimate threat to mainstream society, both efforts held the potential to galvanize popular resistance to some of mainstream culture's core sensibilities. Nowhere was this more evident than the response from law enforcement agencies in the aftermath of NWA's "Fuck tha Police." The circulation of the recording, which critiques police violence against black youth, instigated an unprecedented response from the assistant director of the FBI, who charged the group with advocating violence against law enforcement officers. The notoriety of the song was used against the group as law enforcement officers in several cities openly challenged the group to perform the song in concert with threats of detaining them or shutting down their shows.[31]

The policing of NWA reflected an increasingly common trend to criminalize hip-hop artists, their audiences, and the music itself. Thus seemingly random, incidental acts of violence and criminal activity occurring at hip-hop concerts were characterized as socially intolerable communal acts capable of destroying the civility of mainstream society. Very often these random exchanges were instigated by the treatment that young concertgoers received from arena security, as many venues forced ticket holders to be searched for drugs, weapons, or any other paraphernalia that could be defined as counter to mainstream sensibilities. As Tricia Rose relates:

> The public school system, the police, and the popular media perceive and construct young African Americans as a dangerous internal element in urban America; an element that, if allowed to roam freely, will threaten the social order; an element that must be policed. Since rap music is understood as the predominate symbolic voice of black urban males, it heightens this sense of threat and reinforces dominant white middle class objections to urban black youths who do not aspire to (but are haunted by) white middle class standards.[32]

Mainstream reaction to hip-hop concerts, particularly the reactions of law enforcement agencies, was rooted in deeply held historical concerns about the congregation of African-Americans in public spaces. These concerns were heightened and legitimized within mainstream society in the post–World War II period as African-American youth began to assert themselves socially, culturally, and politically and in the process publicly question various forms of social authority that countered their own desires. Thus the criminalization of African-American youth in mass media contributed to the type of social paranoia already existent in American society, particularly since most major concert venues were in locations most suitable for access by white middle-class suburbanites. Thus in the eyes of many suburban whites, hip-hop concerts in places like Long Island's Nassau Coliseum represented a temporary threat to the day-to-day stability of white suburban life. The historic policing of public spaces where blacks often congregated often had a profound impact on the ability of African-Americans to build and maintain community, and such was the case when young African-Americans congregated at the local clubs and concert venues where the core values of the "hip-hop" generation were distributed and critiqued.

Despite such efforts to curtail community building within the hip-hop "community," hip-hop concerts remained a thriving industry for various promoters, performers, and venue operators, though increased collusion on the part of venue operators, the insurance industry, and law enforcement agencies began to erode acceptable public spaces for an art form, itself predicated on the lack of viable public space in black communities. The insurance industry had a particularly compelling impact by raising venue insurance rates for hip-hop concerts in relation to the public paranoia associated with hip-hop performances, in effect making the promotion of such events a distinct financial risk. Common strategies included the denial of insurance for any promoter who promoted a show where "significant" violence erupted or even a tenfold increase in the minimum insurance allowed to cover a hip-hop event. What was insidious about this practice is that the criminalization of hip-hop in mainstream society effectively helped mask racist efforts to deny black expression, as venue operators and insurance companies regularly facilitated concerts by white acts whose concerts also featured random and incidental acts of criminality, without the constraints placed on hip-hop artists. As Tricia Rose suggest, such efforts mirrored previous efforts to control the influence of jazz music via cabaret laws.[33]

As the number of venues willing to present hip-hop concerts evaporated, mass media increasingly dominated the presentation of not only mainstream critiques of hip-hop, but hip-hop itself. The social and public policing of hip-hop and its audiences coincided with the corporate annexation of the hip-hop industry and a subsequent period of intense commodification. Increasingly as programs like MTV's *Yo! MTV Raps* and major recording

labels like SONY and Warner Brothers became the primary outlets to access hip-hop discourse, the discourse itself was subject to social controls rooted in corporate attempts to mainstream hip-hip for mass consumption. So successful were these efforts initially that Oakland-based rapper MC Hammer could legitimately claim Michael Jackson's "King of Pop" title, as he attempted to do upon the release of his 1991 recording *Too Legit to Quit.*[34] Part and parcel of Hammer's success was the mainstreaming of the iconography of black youth culture—Hammer's clothes and hairstyles were as appealing to young whites as his music—and the distribution of narratives that were palatable to mainstream sensibilities even if they were often nonsensical.

But hip-hop's notoriety was also a stimulus for its own commercialization as recording labels carefully distributed recordings and videos to be accessed via alternative video outlets like the Black Entertainment Channel's (BET) *Rap City* or viewer request channels like *The Box,* who were more willing to present videos from artists who rejected mainstream impositions. This was particularly effective in the marketing of "gangsta rap" as the subgenre's notoriety and the notoriety of its artists correlated directly to recording sales. Like the jazz performers that Norman Mailer so eloquently describes in his essay "The White Negro," the apolitical "G," who stood at the center of the G-funk universe, proved attractive to young whites who viewed hip-hop as a conduit for oppositional expression and the "G" as a model for oppositional behavior. Via hip-hop music and videos, the antisocial behavior of "fictional" black drug dealers was embraced by many young whites as a mode of social resistance, though this influence was manifested in stylistic acumen and not political mobilization.

Hip-hop artists became the spokespersons for stylistic developments within black youth culture and hip-hop the vehicle for which these styles would be commodified for mass consumption both within and beyond mainstream culture. Clothing designers and companies as diverse as Timberland, Starter, Tommy Hilfinger, and even au couture designers like Versace benefited from the visibility of hip-hop artists who willingly used their bodies, music, and videos—often without remuneration—to market these products. Of course the attraction of black youth to these products is the manifestation of complex identity issues where black youth equate social status with mass consumerism. Much of what is today a multibillion-dollar industry was stabilized when the black middle-class entrepreneurial spirit collided with corporate capitalist desire as hip-hop artists and fellow travelers begin to exploit hip-hop's mainstream influence for financial gain beyond recording contracts. Thus black entrepreneurs like Karl Kani and hip-hop artists like the WU-Tang Clan, who started a line of clothing called WU Wear, became petit bourgeois exploiters of hip-hop's popularity. These developments mirrored changes from within the recording industry itself that would have tremendous impact on hip-hop culture.

Reflecting the furious consolidation that has taken place in the entertainment industry, more than 80 percent of all music recorded in the United States was controlled by six major corporate entities. Black popular forms accounted for approximately 25 percent of the total sales of recorded music. Exploiting the black nationalist/capitalist rhetoric among the black working class and middle-class elite, still marginalized even after two decades of Civil Rights legislation, many corporate entities would turn "ghetto pop" producers into contemporary ghetto merchants. Arista/BMG for example, run by Clive Davis, was once home to three distinct boutique labels run by Antonio Reid and Kenneth Edmonds (LaFace), Sean "Puffy" Combs (Bad Boy) and until recently, Dallas Austin (Rowdy). While Quincy Jones and Gamble and Huff were seasoned songwriters, producers, and businesspersons, many of the ghetto pop vanguard were only a few years removed from high school and lacked any definitive critical perspectives beyond the marketing of their respective boutique labels. Many of these artist/producers remain distanced from the real seats of power within their respective corporate homes—power that could be defined along the lines of joint or sole ownership of recording masters, control over production and promotional costs, and the authority to hire and replace internal staff members.[35] In many regards, many of these ghetto merchants are little more than glorified managers or overseers, involved in what was little more than a twenty-first century plantation operation,

Stephen Haymes's work on urban pedagogy and resistance constructs a broader paradigm to interpret the connection between contemporary hip-hop and mass consumer culture. In his work Haymes suggests that the intense commodification of African-American culture and the changes in the consumption habits of the black masses is rooted in structural changes linked to the process of American Fordism.[36] Historically linked to efforts to raise workers' wages as a vehicle to increase consumption, Fordism is the concept around which much of the industrial labor force has been structured throughout the twentieth century, as higher wages and concepts of leisure helped promote the burgeoning advertising industry, which emerged to help stimulate and institutionalize consumptionist desire in industrial workers. The consumptionist ethic became as valuable as the work ethic in the construction of Americanness. But as Haymes further suggests, the failure of the Fordist model to counter market saturation in the post–Civil Rights era led to the emergence of a subsequent model, which he refers to as neo-Fordism, designed to both integrate the black populace into mainstream markets and increase consumption. As he states, "Unlike the strategy of Fordism, which sought to fuel demand by integrating the industrial working class via higher wages, neo-Fordism aimed, through an expanded welfare state, to fuel demand and economic growth by also integrating poor and working-class blacks into the American Dream."[37]

Of course much of this state-sanctioned expansion collapsed with the emergence of the Reagan right in the early 1980s, though the logic of neo-Fordism continued as the advertising industry increasingly became the vehicle by which not only goods and services were promoted but lifestyles and identities were constructed and consumed. This was partially achieved through the process of niche marketing, where specific products were aimed at various populations based on income, social status, race, gender, and ethnicity. What is important here is that individuals no longer consumed products, but also the social status and lifestyle that particular products represented. Accordingly, the high visibility of au couture fashions and other emblems of conspicuous wealth within hip-hop served to stimulate desire and consumption that transcended the structural realities of many black urban youth; processes that were often construed as forms of resistance against the invisibility and misery associated with black urban life. Not surprisingly, such marketing trends occur during an era when much of black popular expression has in fact been annexed by the engines of corporate capitalism and thus black popular expression is placed in the service of stimulating consumption among the very masses for whom the American Dream was inaccessible throughout much of the twentieth century.

In less than a decade, hip-hop culture had been transformed from a subculture primarily influenced by the responses of black urban youth to postindustrialization into a billion-dollar industry in which such responses were exploited by corporate capitalist and the petit bourgeois desires of the black middle class. The latter developments offered little relief to the realities of black urban youth who remained hip-hop's core constituents, though the economic successes of hip-hop artists and the black entrepreneurs associated with contemporary black popular music were often used to counter public discussions about the negative realities of black urban life. Economic issues aside, corporate control of black popular expression, often heightened the contradictions inherent in music produced across an economically deprived and racially delimited urban landscape. As Rose relates:

> In the case of rap music, which takes place under intense public surveillance.... contradictions regarding class, gender, and race are highlighted, decontextualized, and manipulated so as to destabilize rap's resistive elements. Rap's resistive, yet contradictory, positions were waged in the face of a powerful, media-supported construction of black urban America as a source of urban social ills that threaten social order. Rappers' speech acts are heavily shaped by music industry demands, sanctions, and prerogatives. These discursive wars are waged in the face of sexist and patriarchal assumptions that support and promote verbal abuse of black women.[38]

Within this context, discourse(s) of resistance were undermined by narratives which privileged patriarchal, sexist, and even misogynistic ideals, that

were themselves taken out of their organic contexts. In the past, socially problematic narratives were critiqued and distributed according to communal sensibilities in a process that maintained the contextual integrity in which the narratives were produced. Ironically the most visible critiques of hip-hop and ghetto pop emit from black middle-class groups who are in part responsible for the fractured quality of social and political narratives produced by black urban youths in the postindustrial city.

Postindustrial Nostalgia: Mass Media, Memory, and Community

In the spring of 1994, talk show host Arsenio Hall ended his successful run as host of *The Arsenio Hall Show,* a nighttime talk and variety show. Only a year earlier, Hall had celebrated the fifth anniversary of his show with a rousing rendition of Sly Stone's "Thank You (Falettinme Be Mice Elf Agin)" led by soul singer Bobby Womack and soul recluse Sly Stone himself. The song's performance was a metaphor for the show itself, as the show served as a vehicle for the presentation of black popular culture on black popular culture's own terms. Though Hall's own hyperblack antics often broached the worst stereotypes associated with black men, including his insatiable desire to fawn over white women guests, Hall and his audiences reveled in the insiderisms that mainstream America was not privy, but was so willing to consume. For a six-year period, *The Arsenio Hall Show* remained a fixture in African-American households, precisely because it represented a link to community and black expressive culture, as Hall used his own memories of black Cleveland as a springboard to personify contemporary black anxieties and concerns through humor. *The Arsenio Hall Show* was crucial to the hip-hop community because Hall allowed his show to be a forum for their concerns, not just as performers, but as public spokespersons and critics for their communities. Thus is was not unusual for Hall to interview the likes of KRS-One or female hip-hop artist YO-YO about the complexities of hip-hop and black urban life. Like *Soul Train* a generation earlier, Hall's show was an audiovisual remnant to seminal black public spaces that promoted communal exchange and critique. Though Hall's interviews often lacked depth, he covered an astounding diversity of issues and personalities.

Hall's late-night television show ended as Spike Lee premiered his seventh film, his first since *Malcolm X* appeared in late 1992. Personified by cultural workers like filmmaker Lee, the black middle class responded to the proliferation of ghetto imagery and "ghetto pop" that appeared in commodified form on television, film, and black radio stations with a nostalgic return to the 1970s. Lee's 1994 film *Crooklyn* is an example of what I call postindustrial nostalgia, loosely described as a nostalgia that has its basis in the

postindustrial transformations of black urban life during the 1970s. While the pop-cultural texts of the 1970s have proved to be huge commodities for this generation of black cultural producers, I maintain that these nostalgic turns yearn more for the historic period they consume as opposed to the profit motives that inspire their appropriation and reanimation, as the decade of the 1970s marked the increasing tensions of a burgeoning postindustrial economy and the continued erosion of the Black Public Sphere. It is the realization of these tensions that frame the major concerns of the largely autobiographical *Crooklyn*.

Perhaps it is the opening sequence of *Crooklyn* that best suggests Lee's foci for the film. Minus Lee's usual bravado and self-indulged wit, the film opens with the sounds of Russell Thompkins Jr.'s stirring falsetto from the recording, "People Make the World Go 'Round." Very clearly a film more about people than ideas, community than ideology, *Crooklyn* places the black family and community at the center of the film. Notions of people and community resonate throughout the film from the imagery of the opening sequence to continuous musical reminders like the Stylistics's "People Make the World Go 'Round" and Sly Stone's "Everyday People." Indeed as the closing credits begin to roll and we are treated to a "Soul Train line" circa 1975, one is reminded of the centrality of music and dance to black life and of the communal purposes such cultural activities have historically played for people within the African-American diaspora. Films like Lee's *Crooklyn* or Robert Townsend's nostalgic *The Five Heartbeats,* were clearly intended to counter the influence of ghettocentric filmmaking as represented by *New Jack City, Boyz N the Hood,* and *Menace II Society.*

Crooklyn introduces us to the Carmichael family as they attempt to negotiate the schisms of the postindustrial urban North and an eroding public sphere, as such schisms begin to threaten their multiethnic Brooklyn community. The Carmichael family members represent animate metaphors for the realities of postindustrial Black America. Both mother and father figures represent complex issues regarding the location of black women and men in the workforce, the potential effects of integration, and the challenges faced by organic cultural producers, who can no longer be sustained by the community they live in and have little or no value in the marketplace. Meanwhile, the unbridled fascination of the Carmichael children when confronting black images on television in the form of *Soul Train* and Afro-sheen commercials portends the uncritical consumption of black images and sounds that stifle contemporary black youth sensibilities. The family patriarch, Woody Carmichael, is in many ways a living embodiment of the marginalization of high African-American art in the black community as well as a useful example of the lack of public spaces provided specifically for jazz music and jazz musicians. Woody confronts a world where the valued practice of African-American musicianship has given way to the demands of a

recording industry that values less experimental and more formulaic approaches to popular music as well as an eroding public sphere that can no longer economically sustain jazz musicians.

The changes in the recording industry during that era are reflected in the two-volume soundtrack of classic soul from the late 1960s and 1970s, a period marked by corporate efforts to annex the black popular music industry. The two-decades-old catalogs of artists like Marvin Gaye, Teddy Pendergrass, and the O'Jays sold more than one hundred thousand units apiece in early 1995 to a largely black middle class consumer base weary of contemporary black popular music. Black radio would in turn respond to this commercial shift by radically changing programming formats to acquiesce to the taste and buying power of their middle-class audiences. Under the banner of "Classic Soul and Progressive R&B," many urban contemporary stations would begin programming classic soul recordings with upscale and less offensive (read: more adult) contemporary R&B. RKO Broadcasting, in a fairly interesting and innovative move, would purchase a rival station that exclusively featured "ghetto pop," transfer many of their younger DJs to the newly acquired station, and change the initial station's format to the "Classic Soul and Progressive R&B" format. This of course gave the parent company the opportunity to nurture two distinctly different audiences bases.[39]

Within the context of the black popular music tradition, this trend toward "nostalgia programming" provided invaluable access to a digitized aural Chitlin' Circuit for younger generations of artists and audiences. Part of this curiosity was peaked initially by the use of classic soul and soul jazz samples by innovative hip-hop producers who may have been introduced to the musical texts as kids. Within the context of a middle-class critique of contemporary black popular culture, the emergence of "postindustrial" narratives offers few lasting solutions to the continued erosion of African-American diasporic relations. By embracing the soul narratives of twenty years ago, the black middle class yearns for a social and cultural landscape that they were, in part, responsible for transforming. In addition, while there should be some balance in the marketing and production of black popular music forms, ghetto pop, and hip-hop, particularly that which is derived from the real-life tension of young urban life, deserve to be supported. The production of many of these ghettocentric narratives partially reflects the black middle class' refusal to address these issues within the context of African-American diasporic relations.

Postindustrial nostalgia was not limited to the social imagination of the black middle class, however. It was also a construct of contemporary black youth, who attempted to reconstruct community, history, and memory by embracing communal models from previous historical eras. The erosion of the Black Public Sphere provided the chasm in which the hip-hop genera-

tion was denied access to the bevy of communally derived social, aesthetic, cultural, and political sensibilities that undergirded much of black communal struggle throughout the twentieth century, fracturing the hip-hip generation and the generations that will follow from the real communal history of the African-American diaspora. It is within this context that mass culture fills the void of both community and history for contemporary black youth, as it becomes the terrain in which contemporary hip-hop artists conflate history and memory in an effort to reconstruct community. The recording "Things Done Changed" from the debut release of the late Notorious B.I.G. (aka Biggie Smalls) is such an example. Within his narrative, the Notorious B.I.G. reconstructs a community where young children engaged in games in various public spaces and where a communal ethic existed to support activities like cookouts and block parties. Though the artist was raised in the postindustrial era in a black urban community that was not immune to poverty, crime, or random violence, he chose to highlight the type of communal exchanges that dominated his childhood experiences. Even in his memories of hanging on street corners and drinking beer, he chose to forget the high unemployment and school dropout rates that black urban youth have faced for the past twenty-five years, effectively affording many black youths of Notorious B.I.G.'s generation the time to hang out on street corners.

The point here is not to question the accuracy of the narrative but to note that it contains a sense of community that the author clearly finds missing within black urban life in the 1990s. Even more telling is his reading of how these changing dynamics have altered familial relations as a segment of black youth prey on their parents and other adults within the community. This aspect of communal erosion is so significant that many black adults have chosen to ignore decades of police brutality and have subjected their communities to an intensified police presence in order to control black youth. While Notorious B.I.G.'s narrative fails to convey some of the complexities of this reality, he clearly articulates a sense of community collapse and suggests that this collapse is partially connected to a generational divide within the African-American diaspora. While "Things Done Change" adequately documents the impact of community erosion, other hip-hop artists used other modes nostalgia to advance solutions to the plight of contemporary blacks.

The release of Arrested Development's *3 Years 5 Months and 2 Days in the Life of ...* in 1992 represented a challenge to the status quo in hip-hop as its Afrocentric "grunge" style distanced them from both gangsta rap and the political narratives of Public Enemy and KRS-One. As Todd Boyd suggests, Arrested Development shared its context with the emergence of a generation of black collegiates who used African garb and hairstyles to articulate their connection to the African continent.[40] As the group's name suggests, many of the recording's tracks were critical of the impact of migration and urban-

ization on the black community. Throughout the recording, but especially on tracks like "People Everyday" and "Tennessee," the group's lead vocalist articulated a notion of difference within the African-American diaspora that has its basis in class difference but is articulated as a difference between black rural and urban culture. The recording represented a clear revision of historic class sensibilities that posited southern migrants as the primary threat to black middle-class development in the urban North and Midwest. Within Arrested Development's framework, urbanization had clearly destroyed traditional black communal and familial sensibilities.

The track "Tennessee" perhaps best exemplified Arrested Development's use of nostalgia to counter the impact of urbanization on the black community. The track, which shares its postmigration theme with songs like the Gladys Knight and the Pips classic "Midnight Train to Georgia," represents an open rejection of black urban life. As many black creative artists and intellectuals ponder a vision of communal empowerment on par with the role "Promised Land" migration narratives played in the early to mid-twentieth century and emancipation narratives played in the antebellum period, Arrested Development lead vocalist Speech asserts that the American South will be the focus of the next stage of communal movement.[42] Using Tennessee as a symbol for this movement, Speech articulates his concern for his peers and his desire to reconnect with an African-American spiritual past. Speech's use of the American South as a metaphor for black homespaces is of course nothing new. As Farah Jasmine Griffin and Ralph Ellison both suggested, many migrants attempted to re-create southern homespaces within industrialized urban spaces, but the migrants were also clear about their memories of the Deep South's racial oppression, violence, and segregation.

As a postmigration narrative, "Tennessee" differs from traditional migration narratives in its suggestion that traditional black communal and familial values had been lost precisely because the most malicious aspects of the American South are no longer present to galvanize the black community as witnessed in the charcoal drawing of a lynching that serves as a subtext for the song's music video. But to read "Tennessee" as a rejection of the hard-fought political and social gains won as a corollary to mass migration and urbanization is to misread the song's text. Given the proliferation of Afrocentric iconography that was present in the group's music videos and publicity photos, "Tennessee" clearly represents a contemporary metaphor for the African continent, as is suggested in the song's chorus, which states, "Take me to another place/Take me to another land...." While a mass-migration movement to the African continent is perhaps more politically credible in the late twentieth century than it was in Marcus Garvey's era, Speech is not suggesting a return to Africa but instead posits the American South and its physical terrain as the connection to forms of African spirituality that have been lost to migration and urbanization. The point here is not whether a

return to the South would stimulate economic development in the black community, decrease homelessness, or affect public policy in any way, but rather how African spirituality could be one of the vehicles by which community could be reconstructed.

Several artists would embrace various modes of nostalgia to reconstruct a seminal relationship within the African-American diaspora. For instance, bisexual artist Me'Shell Ndegeocello uses the iconography of black plantation life to affirm same-sex love in a period of heightened homophobia. On the track "Mary Magdalene" from her recording *Peace Beyond Passion,* she states, "I imagine us jumpin' the broom." The phrase "jumpin' the broom" was initially used by enslaved blacks in the antebellum period to signify marriage between slaves, when the legality of such was severely challenged. Here the phrase is appropriated to signify lesbian marriage in an era when the idea of homosexual and lesbian marriages is being sharply criticized and attacked in mainstream culture. Ndegeocello's use of the symbolic imagery of black marriage at once reaffirms her status in the African-American diaspora, even as black homosexuals and lesbians are being marginalized within that community, while linking the struggles of contemporary homosexuals and lesbians to the African-American tradition of social protest and resistance.

In another example, hip-hop artist Method Man appropriated the melody of the Marvin Gaye and Tammi Terrell's classic "You're All I Need to Get By" for his recording "I'll Be There for You/You're All I Need to Get By." The recording, which featured contemporary soul vocalist Mary J. Blige, used the Ashford and Simpson composition to reaffirm heterosexual relationships in the postindustrial era. The recording, which represented one of the more popular affirmations of the continuity of African-American expressive culture, highlights the role of popular music as a primary conduit to express various continuities within the African-American diaspora. Such continuities were perhaps undermined when the Coca-Cola Co. used both the original Gaye/Terrell recording and Method Man/Blige update in a commercial to signify a generation gap within the black community, a generation gap that was bridged according to the company, because of the continuity of Coca-Cola in the lives of black families. The commercial again highlights the increasingly intimate relationship between memory, history, and the marketplace.

Driven by his own realization of the commercial value of ghetto narratives and his own middle-class and nationalistic sensibilities, Spike Lee has been one of the few contemporary black cultural workers to successfully integrate the often oppositional taste within both urban working-class/underclass locales and segments of the black middle class. The first volume of the *Crooklyn* soundtrack contains a hip-hop recording from a trio of solo artists, Buckshot, Special Ed, and Masta Ace, who combine their

efforts under the banner of the Crooklyn Dodgers. The recording entitled "Crooklyn" is a stunning acknowledgment of postindustrial transformation within black urban spaces as mediated through the increased presence of mass culture. Within the context of the "Crooklyn Dodger" narrative, the erosion of black public life is represented by television sitcoms, in an interesting conflation of contemporary communal crises, 1970s television icons, and designer fashions. The memories of the traditional Black Public Sphere of the early 1970s are contained, specifically in the narrative of a black sitcom like *What's Happening*. In one regard, this narrative serves to deconstruct romantic recollections of black public life, while also identifying the pervasive impact of mass culture on the lives of African-Americans. Consistent with hip-hop's own project, the artists use mass-market-produced imagery and meanings to parlay their narrative concerns.

The recording, which is sandwiched between broadcast accounts of the 1955 World Series, including Jackie Robinson at bat, highlights a phenomenon perhaps organic to post–Civil Rights generations of African-American youth. While memories of national and international events have been mass-mediated in the twentieth century through print organs, radio, and later television —how many people remember World War II via *Life* magazine's coverage?—*Crooklyn* highlights how some of the seminal memories of community life are mass-mediated via television for the generation of black youth that emerged immediately after the Civil Rights era. My point here is not to delegitimize these memories, particularly given the role television has played in socializing African-American youth since the early 1970s, but to suggest that contemporary efforts to reconstruct community would most likely also be mediated through mass culture, though not necessarily via television.

Postindustrial Postscript: The Digitized Aural Urban Landscape

Their music and expressive styles have literally become weapons in a battle over the right to occupy public space. Frequently employing high-decibel car stereos and boom boxes, black youth not only "pump up the volume" for their own listening pleasure, but also as part of an indirect, ad hoc war of position. The noise constitutes a form of cultural resistance that should not be ignored.

—*Robin D. G. Kelley**

Hip-hop's commercial success occurred precisely as the recording industry was in a process of transformation. The stimulus for this development was the standardization of the digitized recording process. The digitized recording process, as opposed to the analog recording process, offered a greater range of sound quality in the reproduction of recorded music. The primary format of this new technology, the compact disc, offered both easy accessibility and longevity for consumers, particularly in comparison to the often precarious life span of more traditional formats like vinyl disc and cassette tapes. The mass acceptance of the new recording technology reenergized the recording industry, which was still recovering from the market saturation of the disco era.

It is useful to acknowledge that part of hip-hop's commercial appeal was stimulated by its accessibility in the new recording format. As hip-hop emerged as a communally derived discourse produced in the chasm of technological transformations, its ability to distribute critiques of the postindustrial city, was made possible by some of the very technological advancements it tacitly critiqued. As Tricia Rose suggests:

Many of its musical practitioners were trained to repair and maintain new tech-
nologies for the privileged but instead used these technologies as primarily tools
for alternative cultural expression. This advanced technology has not been
straight-forwardly adopted; it has been significantly revised in ways that are
keeping with long-standing black cultural priorities, particularly regarding
approaches to sound organization.[1]

Like previous technological advancements related to popular music, hip-
hop's commercial viability is largely contingent on the success of new tech-
nologies in recorded music. In the case of the urban blues, which received
stimulus from the development of the phonograph, and rhythm and blues,
which benefited from the electrification of instruments and the development
of the transistor, advancements in technology have often served to distribute
the popular narratives of African-Americans beyond the limits of their insu-
lar communities, often to the detriment to those communities. Given the
structural transformations that hip-hop was in part a response to, digitized
recordings of hip-hop theoretically served to distribute the critical narratives
of an isolated working class and underclass youth culture across the a dis-
jointed African-American diaspora via the marketplace.

Hip-hop's use of cutting-edge technology, both in the production and
reproduction processes, is striking in that hip-hop emerged as the first black
popular music form to develop largely unmediated by modes of communal
critique rooted in the formal and informal traditions of the Black Public
Sphere. While institutions like the Apollo Theater, Regal Theater, and other
Chitlin' Circuit institutions afforded the black masses ample opportunity to
critique black popular expression in an organic context, hip-hop was often
predicated on the ability for both corporate and independent labels to sign
and record hip-hip acts without the formalized or informal modes of com-
munal critique that defined black popular expression in previous eras. This
is not to suggest that hip-hop was produced in a critical vacuum; most hip-
hop artists were clearly influenced by exchanges in the few spaces where
hip-hop audiences could access the music, particularly during the genre's
early stages of development. But I am suggesting that hip-hop was not privy
to the type of broad-based communal processes that were integral to segre-
gated black spaces in previous eras. This form of fractured critique is of
course symbolic of the dislocation and erosion that was inherent to postin-
dustrial transformations of black urban spaces and the market forces that
have been brought to bear on black popular culture. Hip-hop instead
emerges as a response to the chasms created by eroding public institutions
and the spatial logic of the postindustrial city. Ironically, while hip-hop was
not afforded very valuable communal forms of critique, the genre itself
emerged as a vehicle for forms of critique uniquely suited for the dispersed
and disjointed nature of contemporary black communal formations.

Postindustrial Critique: Hip-Hop as Public Sphere

Long regarded as part of hip-hop's alternative or even avant-garde community, hip-hop group De La Soul issued a strong critique of hip-hop with its 1996 release *Stakes Is High*. Beginning with their debut release, 3 *Feet High and Rising,* in 1988, which openly challenged essentialism in both the hip-hop community and recording industry, De La Soul consistently questioned hip-hop's status quo, serving in many regards as a critical vanguard within the genre. By 1996, De La Soul's efforts were commonplace in the industry as many artists challenged the proliferation of violence, misogyny, and fast-money schemes in hip-hop, personified in part by the "Players Rap" of Bad Boy Entertainment mogul Sean "Puffy" Combs, by using their own recordings as the vehicles to openly critique the hip-hop community. Arguably, no popular genre of music has been as self-consciously critical of itself as hip-hop. In many regards the hip-hop community began to take on many of the attributes of the traditional Black Public Sphere. Hip-hop recordings began to resemble digitized town meetings in which black community and the very traditions of hip-hop were open to debate and critique.

I maintain that in the absence of formal structures of critique across the diaspora, the hip-hop tradition has emerged as a digitized aural facsimile of the traditional black urban landscape, or what I refer to as the Digitized Aural Urban Landscape (DAUL). In this regard, hip-hop artists have reclaimed the critical possibilities of popular culture, by using popular culture and the marketplace as the forum to stimulate a broad discussion and critique about critical issues that most affect their constituencies. Hip-hop's commitment to aurally and visually locate and reconstruct its regional constituencies via music videos, live performance, and recordings is further acknowledgment of this strategy. Thus when an artist like Chuck D of Public Enemy posits hip-hop as the "CNN" of black urban terrain, it is an acknowledgment of the changing dynamics of black urban life and the centrality of the black popular recording tradition and mass culture within these dynamics.

Given the fluidity of the concept of community within mass culture, the authenticity of the critical discourse of the hip-hop community remains a central tension, particularly given the use of spectacle by both corporate entities and black artists themselves to caricature and stylize the reality of the black urban experience. Much of the black popular music tradition has, of course, been subjected to questions of authenticity, particularly as market forces undermine the rather intimate relationship between popular traditions and the expressive culture of the communities where such music forms were birthed, sustained, and distributed. As Todd Boyd rightly asserts in his work on gangsta rap:

In the past, this popularity would have been a sure sign of accommodation, as the music would have to be compromised in some major way in order to be made mainstream. Gangsta rap has come to prominence because of its unwillingness to do so. The music and culture industries have found ways to sell this extreme nonconformity, while many rappers have successfully packaged their mediated rage for a mass audience.[2]

Within the context of black youth culture in the early 1990s, though, hip-hop that was considered more authentic was often that which existed beyond the grasp of mainstream commodification, including black radio, and instead was retrieved across the fiercely contested terrain of black urban spaces, even as hip-hop posited mainstream culture as the vehicle for its discursive concerns. What I am suggesting is that even though some forms of hip-hop craved the prestige and visibility that mainstream culture afforded, especially in its capacity to articulate hip-hop's core concerns to those beyond the postindustrial city, hip-hop was dually concerned with remaining authentic to its core constituency of black youth located across various and often transitory urban spaces. What is notable is that the parameters of these urban spaces were often defined by the sonic reach of the electronic audio systems found in the cars and utility vehicles inhabited by black urban youth as LL Cool J's 1990 recording "Booming System" suggests in its refrain "cars drive by with the booming systems."

The purchase of high-powered and expensive audio equipment for motor vehicles became an unwitting stimulus for the constitution of community for those within the reach of the various cassette recordings and later compact discs that blared hip-hop and other urban forms from moving and parked vehicles, at least for those who appreciated and desired such aural interventions into the general cacophony of urban spaces. In many regards these "communities" were no different from the aural "publics" that blacks constituted on plantations during the antebellum period, affording both communities a concept of community that transcended the political and structural constraints of their respective historical eras. These aural urban communities differ from the constituency of consumers comprising the broader hip-hop community in that they are not simply constructed as consumers, but as the organic audience from which the genre is produced and critiqued in the absence of formalized sites of exchanges like concert halls, dance halls, and even community parks. This audience differs from those of traditional sites of communal critique like the Apollo's amateur-night shows, in that they offer critique of commodified products as opposed to the organic, though commodified—if one considers the selling of tickets for activities like amateur night—processes that segregated black audiences critiqued during earlier periods. The latter audiences also differ from more traditional audiences in that they are not necessarily consumers at all, but instead criti-

cally responsive to the incidental presence of hip-hop discourse within daily urban life.

Nevertheless, I am suggesting that such aural urban communities, along with the broader communities of hip-hop artists, producers, critics, consumers, and industry people, form the basis of a community continuously engaged in forms of communal critique, some of which is self-critical of the genre itself, though such critique is largely rooted in the production, distribution, and commodification of digitized sound. The track "Ya Playin' Yourself" from Jeru the Damaja's most recent release, *Wrath of the Math,* is but one example of the complex critical exchanges that foreground contemporary hip-hop discourse, as the track serves as a critique of the Junior M.A.F.I.A's recording "Player's Anthem." The Junior M.A.F.I.A. track is but one example of the "Player's Rap" that has come to prominence in mainstream hip-hop, featuring ample examples of Mafioso fantasies, au couture commodities, and other standard "Big Willie-isms." Appropriating the same base line sampled by Junior M.A.F.I.A., "Ya Playin' Yourself" functions not only as a critique of such lifestyles but also of the proliferation of such narratives in hip-hop discourse. Jeru's critique juxtaposes the real-life experiences of black urban youth, particularly those who choose a life of drug dealing and other forms of petty criminality and the stylized violence and criminality often associated with contemporary action-fantasy films like those made by actors Steven Sagal or Jean-Claude Van Damme, a genre whose audience base includes young black men and in which black actors, with the exception of Wesley Snipes, have very rarely been at the center of. In the absence of real access to the film industry, hip-hop recordings and videos became the vehicles for a "ghetto noir" aesthetic. Snoop Doggy Dogg's "Murder Was the Case" video is but one example of this, as hip-hop artists seemed to value the higher prestige film afforded their narratives. The number of hip-hop artists featured in Hollywood films like *Menace II Society* or *Juice* and hip-hop-artists-turned-video-directors is but another example of this trend, which at its crux attempts to conflate the real-life narratives of black urban youth with the spectacle and notoriety of the film industry.

Jeru's narrative also offers commentary on the proliferation of criminal activity within hip-hop, effectively linking the criminal fantasies of ex-drug-dealers-turned-hip-hop-artists to the examples of real criminal activity within black urban spaces. Junior M.A.F.I.A. members Lil' Caesar and Lil' Kim are both protégés of the late Christopher Wallace, better known as the Notorious B.I.G., and who also appears on the "Player's Anthem" track. Wallace's activities as a drug dealer in Brooklyn prior to his emergence as one of the hip-hop elite were widely publicized in many circles, including his own debut recording, *Ready to Die.* In fact, Wallace's story has been characterized as one of the few uplift narratives afforded black urban youth within hip-hop discourse. Jeru's critique of Junior M.A.F.I.A.'s stylized criminality perhaps

differs from that generated from within mainstream society in that he is not necessarily critiquing the presence of the drug trade in the informal economy of the postindustrial city, but is instead critical of the role of hip-hop artists in popularizing such lifestyles, particularly since such narratives are rarely based on reality but constructed as part of the "ghetto fantastic" discourse that has dominated hip-hop's most recent evolution. Such a critique would seem to suggest that despite the demonizaton of hip-hop in the mainstream and its arguably oppositional potential for black youth, the hip-hop community seems to embrace values that would be found in both traditional African-American communities and mainstream American culture.

The failure of some hip-hop artists to problematize the allure of urban criminality is informed by various sensibilities, including the status afforded black criminals as oppositional figures, particularly within the context of police brutality and poverty in urban spaces, and also the commercial value historically associated with exaggerated caricatures of black urban icons, like the drug dealer and pimp, who are both well represented in contemporary hip-hop discourse. The contemporary construction of these figures as oppositional is largely rooted in the blaxploitation industry of the 1970s where such icons were cinematic staples. Given the prevalence of nostalgia narratives and the resurgence of often crude forms of nationalist expression, these hypersexualized and ultramasculine blaxploitation icons have been reclaimed and reconstructed as postindustrial folk heroes. Such efforts also serve to racialize ethnic uplift narratives like Brian De Palma's *Scarface,* by placing them in the context of black expressive culture. The video for the Firm's "Firm Biz" recording, where group members Nas, AZ, and Foxy Brown outwit a fictional Mafioso figure named "Donnie Brasco," is a good example of such trends. It cannot be overstated that such narratives are clearly linked to the extraordinary access that black urban youths have to mass culture and that many of these narratives, no matter how exaggerated, serve as the discursive space where black youth culture constructs models of "temporal" transcendence.

Subjected to the paradox(es) of mass culture, hip-hop has become the very spectacle that it attempts to counter. Such contradictions have also become core tensions in contemporary hip-hop narratives as the genre becomes arguably the first form of popular expression to actively confront issues of commodification and commercialization as narrative themes. Common Sense's recording "I Use to Love Her" which is included on his 1994 release *Resurrection* is an extraordinary example of hip-hop's own cognizance of these issues. Using a former girlfriend as a metaphor for the commercialization of hip-hop, Common Sense charts the trajectory of a failed relationship. Within this context, he suggests that hip-hop has failed to remain rooted to its organic concerns and has instead offered itself to the pretensions of the marketplace. While Common Sense's characterization of hip-hop as Woman is problematic given the suggestions of prostitution that

serve as the narrative's subtext and the fact that it feminizes material desire and social dysfunction in the hip-hop community, it does highlight the gender dynamics associated with hip-hop discourse. Like hard-bop jazz a generation earlier, hip-hop serves as the soundtrack of a generally male-defined urban landscape, though it is obviously a space generally shared, though rarely defined or narrated, by young black women.

Recently, the musical narratives of hip-hop discourse have begun to mine the familiar sounds of the hard-bop and soul jazz traditions. Such efforts should be understood as a subtle effort to attract a broad range of listeners across the diaspora. Given that hip-hop has largely remained the domain of black male expression, hip-hop's appropriation of the modern jazz tradition should be viewed more as an effort to aurally re-create black male "safe spaces" like the jazz club. Hip-hop music, with its willingness to make any sound or text malleable to the sensibilities of a brash, angry, and often reflective male urban constituency, has appropriated hard-bop narratives that in their own historical context were efforts to reintegrate jazz into black public life. Thus the production genius of artists like Ali Shaheed Muhammad and the Ummah production collective, DJ Premiere, and Pete Rock, have unwittingly reintegrated the sound of jazz—albeit on their own terms—into the public life of black youth who did not have the opportunity the witness the music's development in black public spaces. This process has partially afforded these artists the opportunity to aurally revisit organic spaces that influenced the cultural landscape of the traditional Black Public Sphere.

Though hip-hop has yet to confirm its singular role in the production and distribution of a broad-based diasporic dialogue, perhaps the willingness to reimagine these texts, along with the changing dynamics of the urban landscape, will help to further that process. In its essence, the hip-hop/jazz fusion aurally re-creates a safe space or bridge for interdiasporic relations among black men. Pete Rock and CL Smooth's "They Reminisce Over You" is instructive in this regard. Dedicated to late hip-hop artist Trouble T-Roy, the recording, with its cascading horn lines reminiscent of mid-'70s Eddie Harris and Rahsaan Roland Kirk, serves as a meditation on contemporary black manhood, in which jazz and hip-hop serve as the active subtexts for essential relations among black men. In the course of five minutes the duo confront the issues of female-headed households, the significance of extended family, the treasured relations between father-son/father figure-son, and the death of a close friend.

The centrality of music to essential black male relations is perhaps most evidenced when the narrator responds to his grandfather, who has fallen asleep in the living room while listening to jazz. The moment, which is captured with an intimacy that betrays contemporary depictions of African-American men, captures a full range of narratives among two males figures, particularly in regard to issues of personal responsibilities. The moment is

encapsulated by the narrative presence of jazz and the aural presence of jazz-influenced hip-hop.

As the black community confronts crises, both internal and external to black public life, the hip-hop/jazz fusion may represent the first black popular music genre since soul to resonate among the varying classes, ages, and genders distinctions the African-American diaspora. This is in part reflected by the numerical success of the Million Man March. Clearly hip-hop aesthetics—witness the metaphorical presence of Malcolm X (el Hajj Malik el-Shabazz) within the form—provided a fertile landscape for the organizational efforts of the march's leaders. Hip-hop's willingness, and again this is largely a male construction, to parlay the critical discourse of black urban spaces into musical forms was critical to the success of future efforts like the Million Man March. Such efforts are articulated across the diaspora through digitized hip-hop recordings like "Pop's Rap," which appears on Common Sense's *Resurrection*. Written largely in response to the continual and random gang violence that afflicts many black urban centers, "Pop's Rap" is a stunning affirmation of the generational bridges that can be aurally constructed and mass mediated by efforts like hip-hop/jazz fusion. Theoretically, the hip-hop/jazz fusion mirrors the blues and gospel fusion that produced the soul tradition so integral to the traditional Civil Rights movement. "Pop's Rap" constructs a digitized aural space, that distributes information within a nontraditional public sphere, much the way barbershops did a half century ago. The recording represents the kind of necessary constructive criticism that hip-hop explicitly craves and attempts to instigate, delivered in a context privileged by urban youth culture.

Given the narrative focus of most hip-hop, the hip-hop/jazz fusion is perhaps the foundation for a more broad-based politicization of black popular music. Much like the hard-bop tradition of the 1950s, this music must be malleable to the wide range of communal tastes and provide aural spaces for the construction of memory and community, spaces that privilege the presence of diverse political and social perspectives. This evolving tradition must also maintain commercial credibility while remaining askance from the constraining and often oppositional discourse of mass-market culture. Of course such a construction of hip-hop is problematized by the lack of significant presence of black women's voices within the genre.

The voices of black women have obviously always been present within hip-hop discourse as witnessed by the popularity of artists like Salt 'N' Pepa, Queen Latifah, MC Lyte, and the recent emergence of Missy Elliot, Lil' Kim, and Foxy Brown, though such voices have often been marginalized. Like the blues tradition of the early twentieth century and the soul tradition of the late 1960s and early 1970s, the discourse of black women in hip-hop represents the most pronounced "counterpublic" that exists within the genre, though such a public, as Tricia Rose suggests in her work, is not simply constituted

as oppositional to the black male discourse(s) that dominate hip-hop. Like the voices of Aretha Franklin and Roberta Flack a generation ago, much of black female hip-hop aims to construct an alternative view of the postindustrial landscape. Tricia Rose describes the female presence in hip-hop this way:

> Three central themes predominate in the works of black female rappers: heterosexual courtship, the importance of the female voice, and mastery in women's rap and black female public displays of physical and sexual freedom. Here these themes are contextualized in two ways; first in dialogue with rappers' sexual discourses, and then with larger social discourses, including feminism.[3]

Rose's distinctions are important because the black female discourse(s) of hip-hop, however oppositional and counter to male discourse(s), exist within the broader contexts that produces hip-hop and don't simply constitute black female voices reacting to the narratives of black men, but instead the various discursive formations that affect both experiences. Thus Queen Latifah's now-classic "Ladies First" is not simply a critique of the rigid gender expectations associated with some forms of black nationalist expression, but the refusal of the larger society to view black women as insurgent intellectuals and political strategists.

Another example of these exchanges are Salt 'N' Pepa, whose well-chronicled sexual politics regarding AIDs, infidelity, and sexism also informs their efforts to counter the demonization of black masculinity in mainstream culture, by celebrating black masculinity and black male sexuality via recordings like "Shoop" and "Whatta Man." The video for the latter recording, a collaboration with female vocalists En Vogue, featured a cameo appearance by the late Tupac Amaru Shakur, who was arguably one of the most demonized black male icons of the past generation. Unfortunately though, in an industry that thrives on gimmicks, black women artists have very often had to rely on such gimmicks to create space and agency for black women's concerns within hip-hop discourse. Thus Queen Latiah's construction as "matriarch" or Salt 'N' Pepa's even more commercially viable "Saffire" image has been as important to their popularity as the quality of their narratives. Artists like Boss and MC Lyte have often eschewed more feminine presentations of themselves and embraced a distinctly more masculine aesthetic in an effort to be taken seriously. Such agency has been afforded to black female singers like Mary J. Blige whose 1990s neosoul style is drenched in hip-hop sensibility or artistic hybrids like Lauryn Hill of the Fugees, Missy Elliot, Erykah Badu, and Queen Latifah, who exist across the hip-hop landscape as vocalists and rappers, though their singing skills, particularly in the cases of Hill and Badu, are what is privileged within hip-hop discourse.

Perhaps the relative explosion of popular fiction by black women writers like Terri McMillan and Bebe Moore Campbell, whose core constituency is constructed similarly to those supportive of hip-hop—namely, a community of black women who transcend class and social divisions—constitutes the counterdiscourse(s) of contemporary black popular expression. McMillan's *Waiting to Exhale*, arguably the most popular of the genre, was made into a film in 1996. The film's all-women soundtrack, largely written and produced by Kenny "Babyface" Edmonds, was the antithesis of much that was produced in hip-hop during the period. The urban fiction of a writer like Sapphire, whose debut novel, *Push*, was published in June 1996, is perhaps much more representative of the narratives of black women that should have more of a presence within contemporary hip-hop. Hip-hop's willingness to present a broader spectrum of the black urban experience remains to be seen. With the exception of blatant articulations of homophobia, hip-hip narratives have been silent regarding sexual identity and preference either within the hip-hop community or the broader communities that hip-hop critiques. Clearly this latter phenomenon is rooted in the tensions and fears associated with contemporary black masculinity that are often articulated in the homophobia, sexism, and misogyny that litters hip-hop narratives.

Many of these tensions are associated with the historic unresolved gender and sexuality issues in the black community that have been heightened by structural change and economic transformations that have altered traditional relations within the black family, community, and labor force.[4] These tensions are also witnessed in the now-legendary diatribes of black male writers and critics Ishmael Reed and Stanley Crouch over the works of black women writers and critics Michele Wallace, Alice Walker, and Toni Morrison. Given the role that the collapsing of public and civil spaces within the Black Public Sphere has played in the development of hip-hop, clearly the genre cannot be expected to transcend some of the core ailments associated with contemporary black life, like sexism, homophobia, and misogyny, and thus should not be blamed as the sole repository of such anxieties, though hip-hop's continuous desire to create and maintain community could provide the necessary space for more diverse constructions of identity within the African-American diaspora.

Kirk Franklin's Nu Nation: One Diaspora Under a Groove

As the nature of the traditional black public sphere began to change in the early 1970s, so did the role of historically black churches. No longer faced with the open hostility associated with Jim Crow segregation in the South or racial and economic apartheid of the North, many blacks, in particular black youth, perceived the black church as being out of step with the challenges

of the post–Civil Rights world. In response many black churches transformed themselves into diversified economic institutions, which featured credit unions, senior citizen housing, and various commercial venues. Steven Gregory suggests that such a shift in the role of the black church was also stimulated by state efforts to control and curtail social and political movement within the black community by shifting focus to "forms of political discourse, subjectivity and activism that emphasize the defense of household equity and residential privilege"[5] As social and economic stratification intensified within the African-American diaspora, the black church began to embody the concerns of black middle-class homeowners. Thus the black church was transformed from simply a safe haven and repository for the core values and morals of the black community into a site where black middle-class uplift narratives were reproduced and institutionalized.

The transmission of middle-class uplift narratives within the black church has obviously occurred since emancipation as "many black elites sought status. moral authority, and recognition of their humanity by distinguishing themselves, as bourgeois agents of civilization, from the presumably undeveloped black majority," as Kevin Gaines relates in his work on black middle-class ideology.[6] Though the black middle class of the early twentieth century was little more than a professional service class whose very survival was largely predicated on segregation, the black middle class of the post–Civil Rights era was legitimately integrated into the mainstream economy and thus its promotion of racial uplift narratives was more pronounced and validated by figures on the right who desired to eliminate the threat of mass social movement in the black community. The black church's rejection of the protest tradition, particularly in regard to issues that transcended economic development, placed it at odds with black youth and many within the black working poor and underclass.

Arguably the more profound distances exist between the black church and black youth. Clearly part of the alienation and isolation experienced by black youth in urban spaces are predicated on the failure of black institutions to embrace them and address many of their core concerns. While black institutions have historically been taxed to provide the social and moral space to reproduce the core values and sensibilities of the black public sphere in black youth, the contemporary rift between the black church and black youth is experienced within the context of morality. As Michael Eric Dyson writes:

> At base, the perception of the aesthetic alienation of hip-hop culture is linked to a perception that black youth are moral strangers. I mean by "moral strangers" that black youth are believed to be ethically estranged from the moral practices and spiritual beliefs that have seen previous black generations through harsh and dangerous times. The violence of black youth culture is pointed to as a major symptom of moral strangeness. Heartless black-on-black murder, escalat-

ing rates of rape, rising incidents of drug abuse, and the immense popularity of hip-hop culture reinforce the perception of an ethical estrangement among black youth.[7]

Ironically, as black youths embrace hip-hop in response to their experiences of alienation, the black church has furthered their isolation by harshly critiquing hip-hop, which is viewed as a metaphor for many aspects of black youth culture. At root, perhaps is the failure of the black middle class and older generations of blacks to recognize and respect contemporary social paradigms; paradigms that are responsible for the crises experienced by black youth. At issue was not whether the hip-hip generation could submit itself to the ideals of a supreme being, but rather that the contemporary black church, which historically served as a haven for progressive social forces and the black community's marginalized constituents, could no longer submit itself to the needs of the hip-hop generation.

Of course many of these tensions were visited by the black community in the late 1940s and early 1950s, when a distinct youth culture emerged in response to migration, dislocation, urbanization, and the beginning stages of deindustrialization. The defining rifts of black generations during the 1950s were largely coalesced, though not totally, when the black church submitted itself to the progressive desires of the black poor and black youth, and provided the necessary social, moral, and political space to facilitate the definitive social movement of the twentieth century. As mentioned earlier in the text, these efforts were also manifested in the creolization of the black gospel and rhythm and blues traditions creating what is now referred to as soul music. Ironically a unique fusion of hip-hop and gospel emerged in the mid-1990s to attempt to reintegrate the tenets of the black church into black youth culture, in the form of God's Property from Kirk Franklin's Nu Nation.

God's Property's eponymous debut was not the first effort to fuse what most perceived as disparate if not oppositional discourses. Many contemporary black artists have chosen to include at least one gospel-inspired recording, calling into question whether "Booty Calls" could coexist with calls for Jesus. Artists as diverse as MC Hammer and A Tribe Called Quest had interjected contemporary hip-hop discourse with praises to a supreme being, though many outside of hip-hop's constituency viewed such attempts as mocking black Christian traditions. Ironically, many of the tenets of Islam had been successfully introduced in hip-hop narratives via members of the Five Percent Nation, like Rakim Allah, Brand Nubian, Lakim Shabazz, and the Poor Righteous Teachers. Kirk Franklin began to mine this territory with his group Kirk Franklin and Family on their recordings *Kirk Franklin and the Family* (1993) and *Whatcha Lookin' 4* (1995). They were perhaps the first gospel recordings to receive regular airplay on urban contemporary radio stations in more than a decade, effectively making Kirk Franklin the

Edward Hawkins of the hip-hop generation. Hawkins, of course, helped mainstream gospel music in 1969 with the recording "Oh Happy Day," which featured a very young Tramaine Hawkins on lead vocals. Franklin's efforts perhaps differed from recordings during the late 1980s and early 1990s, by Tramaine Hawkins, the Winans, and Be Be and Ce Ce Winans, in that his recordings featured Christian narratives, as opposed to "crossover" efforts which often deemphasized specific mentioning of Christian doctrine in order to increase commercial appeal.[11]

Franklin's efforts were roundly criticized, not for their content, but for his willingness to embrace contemporary forms of "ghetto pop" and hip-hop to articulate his message, even though most traditional gospel recordings are products of various genres of black popular music from the 1960s and 1970s. "Oh Happy Day" was criticized by gospel traditionalists upon its release, though by contemporary standards the recording sounds antiquated. Hawkins understood, as Franklin clearly does, that music is a vehicle to attract and keep black youths in the church, but in order to pique their attention, the church has to be willing to inhabit the aural spaces that black youth culture constructs. Kirk Franklin found such a vehicle in God's Property, a Houston-based choir founded by Linda Searight and that included former gangbangers and drug dealers. While many of the group's members embraced Christian doctrine as an act of redemption, they did so without relinquishing ties to the urban youth culture that produced them. Franklin, for his part, lent his talents and sensibilities to helping the group with its debut release, *God's Property* (1997).

The group's mission was blatantly apparent on their first single release, a remix of the song "Stomp," which featured a bass line appropriated from Funkadelic's "One Nation Under a Groove" and liberal use of urban slang, Christian doctrine, and the simulated gunshots, which had become popular in many Dancehall Reggae recordings. Franklin's use of black urban slang in the service of the black church mirrors the many rhetorical strategies used by black ministers in order reach nontraditional audiences. More interestingly, the track's appropriation of "One Nation Under a Groove," clearly suggest that Franklin and God's Property view black popular music as a vehicle toward community building and that the contemporary dance hall is one of the spaces where the black church will have to extend its ministry in order to more thoroughly integrate the aural spaces of black youth culture. The group's project aims to marry the discourse(s) of black urban youth with the dominant institution of the traditional Black Public Sphere.

More important, Franklin clearly doesn't see this recording as a singular intervention into two disparate communities, but as the foundation for a movement aimed at strengthening black community; hence the title of the song "Stomp," which suggests the possibility of masses of black youths marching toward the black church to help sensitize it to the realities of

postindustrial urban spaces. Such ideals are also reflected in the name of Franklin's organization Nu Nation, of which God's Property are integral members, that aims to erode the superficial obstructions associated with black youth perceptions of the black church and create a new image to encourage renewed nation building within the African-American diaspora. Franklin's sense that "Stomp" serves as the basis of both a social movement and aesthetic movement are also reflected in his statement "It Ain't Over," which was borrowed from the recording "Groove Me" by Teddy Riley and Guy from their debut release in 1988.[12] Riley is generally regarded as the architect of "New Jack Swing," a fusion of contemporary rhythm and blues and hip-hop, that I refer to as "ghetto pop." Franklin's statement pays tribute to Riley's innovations, while also suggesting that "Stomp" is the basis for new aesthetic developments within the hybrid genre.

While the success of Franklin's efforts remain to be seen, the efforts of God's Property and other artists within hip-hop's constituency continue to embody the communities of resistance and support that have been historically relevant to black survival. Despite massive structural transformations and social decay, the black community continues its struggle to create social spaces to help buffer black folks from the threats of contemporary American society, by producing, reproducing, and allowing the commodification of popular music narratives, which transmit, via the process of critique, the core values and sensibilities of the African-American diaspora.

ENDNOTES

Introduction

* (Ralph Ellision) Included in Current Bibliography.
1. Ellison's "The Golden Age, Time Past," from his 1964 text *Shadow and Act,* is an excellent foray into the concept of memory as it relates to the reconstruction of historic events.
2. See Evelyn Brooks Higginbotham's *Righteous Discontent,* an examination of the Black Women's Club Movement and the singular role of the black church is the development of a black public.
3. Hazzard-Gordon's work *Jookin'* examines the role of social dance among the existing class structure of the black community.
4. Smitherman, *Talkin' and Testifyin',* 48.
5. Scott, *Domination and the Arts of Resistance,* 14.
6. Higginbotham's *Righteous Discontent* is a seminal text on black women and the Baptist tradition.
7. Michael Dawson raises the issue of a black counterpublic in his essay "A Black Counterpublic?: Economic Earthquakes, Racial Agenda(s), and Black Politics" from *The Black Public Sphere.* In the essay, Dawson constructs a traditional Black Public Sphere largely influenced by Habermas's model, but also acknowledges the black public's rejection of the liberal bourgeois model. Though I accept Dawson's notion of black counterpublics and subaltern counterpublics, it is my intention to construct a Black Public Sphere in which all of these distinctions are structural components. This is in part because of my decision to deemphasize European theoretical discourse in the examination of African-American culture, and to give more agency to the communal efforts of African-Americans in their own right.
8. Higginbotham, *Righteous Discontent,* 7.
9. Elsa Barkley Brown's "Negotiating and Transforming the Public Sphere: African-American Political Life in the Transition from Slavery to Freedom," published in *The Black Public Sphere,* is an excellent examination of the post–Civil War public sphere of black Richmond, and it gives support to the very broad-based notion of democracy that existed within black communities.
10. Ibid., 128
11. Hazzard-Gordon, *Jookin',* 76–77.
12. *Blues People,* Amiri Baraka's (LeRoi Jones's) examination of the black musical tradition, sheds particular light on the demonization of black music during and after chattel slavery.

13. Langston Hughes's polemic "The Negro and the Racial Mountain" and George Schuyler's equally polemic retort, "Negro Art Hokum," are examples of the quality of debate within black publics regarding black cultural production.

14. Hazzard-Gordon, *Jookin',* 84

15. James Weldon Johnson's *Black Manhattan* is an indispensable text in the examination of African-American presence in New York prior to World War I, particularly chapters 1–7 (1–73).

16. Ibid., 74.

17. Johnson, *The Autobiography of an Ex-Colored Man,* 72–73.

18. Ibid., 154.

19. Early, "Pulp and Circumstances: The Story of Jazz in High Places," *The Culture of Bruising,* 163–205.

20. To be clearer on this, Johnson's *The Autobiography of an Ex-Colored Man* highlights the role that popular culture plays in the construction of black working-class utopias. Within this context, success as a musician, dancer, or NBA basketball player is seen as the primary vehicle for black working-class mobility.

21. I define black public discourse as public articulations that are easily accessed within mainstream culture and are largely defined by market forces. This is distinct from the public discourse of the Black Public Sphere, which functioned specifically within the confines of the Black Public Sphere.

22. Stuart Ewen and Elizabeth Ewen, *Channels of Desire: Mass Images and the Shaping of American Consciousness.*

23. Griffin suggests in her work on black migration narratives, *Who Set You Flowin'?: The African-American Migration Narrative,* that southern migrants negotiated the often hostile terrain of the city by asserting—often through memory—southern cultural and social sensibilities in these urban spaces. The development of the urban blues tradition of the '20s is a prime example of this.

24. West, *Keeping the Faith,* xiii.

25. Malaika Adero, ed. *Up South: Stories, Studies, and Letters of This Century's Black Migrations.*

26. Ottley, *New World A-Coming: Inside Black America,* 268.

27. W. A. Domingo and A. Philip Randolph were both proponents of the "New Negro" discourse of the early '20s. The two were linked during the teens to the African Blood Brotherhood, a radical communist organization based in Harlem. Their rhetoric is representative of the counternarratives, particularly after the liberal bourgeois elements within the black community in the persons of Alain Locke and Charles S. Johnson appropriated the rubric of "New Negro" for their mainstream agenda.

28. Griffin, *Who Set You Flowin'?,* 52.

29. Ibid, 48–52.

30. Lewis, *When Harlem was in Vogue,* 108.

31. Ibid., 107–8.

32. Griffith, *Who Set You Flowin'?,* 52.

33. George, *The Death of Rhythm and Blues,* 9

34. Thus the centrality of the urban blues within the development of the phonograph begins a process that is logically followed by rhythm and blues' emer-

gence during technological advances of the '40s and early '50s, the Motown record company's reliance on these advances, and hip-hop's mass consumer acceptance during the midst of advances in the production and reproduction of popular music. These latter developments I will examine more fully in the following chapters.

35. One of the basic assumptions of the highbrow Harlem Renaissance movement was the positive ramifications of cross-cultural exchange. See Lewis, *When Harlem was in Vogue,* 97–99.

36. Nelson George, "Philosophy, Money and Music," *The Death of Rhythm and Blues,* 11–12

37. Ewen and Ewen, "The Magic of the Marketplace," *Channels of Desire: Mass Images and the Shaping of American Consciousness,* 57.

38. Ibid., 58.

39. Ibid., 72.

40. The logical manifestation of this process in our contemporary moment is that full African-American citizenship is generally the construct of mass consumer culture, which stifles voices of critique and dissent. Thus while a majority of African-Americans continue to struggle, mass consumer culture creates an imagery of deceit and misinformation that deconstructs black misery.

41. Barlow, *Split Image: African American in the Mass Media,* 175.

42. Gerald Early examines Paul Whiteman's role in the development of jazz in the 1920s in his essay "Pulp and Circumstances: The Story of Jazz in High Places," in *The Culture of Bruising,* 163–205.

43. Bernard Gendron, "Moldy Figs and Modernists: Jazz at War (1942–1946)" in *Jazz Among the Discourses,* 31–52

44. Nat Brandt, *Harlem at War: The Black Experience in WWII,* 40–41.

45. Ibid., 41.

46. Quoted from Ottley, *New World A-Coming: Inside Black America,* 289.

47. Ibid., 306.

48. David Levering Lewis, "We Return Fighting," *When Harlem Was in Vogue,* 3–24.

49. Gendron, "Double V, Double-Time: Bebop's Politics of Style," *Jazz Among the Discourses,* 243–55.

50. Amiri Baraka, in an interview with Lorenzo Thomas, suggests that bebop may be the last form of black popular music to be crafted from the daily relations of the black working class. He said this before hip-hop had reached national prominence; I would suggest that hip-hop has emerged as another such form.

51. Griffin, *Who Set You Flowin'?,* 100–40.

52. Gendron, "Moldy Figs," 31–52.

53. Capeci, *The Harlem Riot of 1943,* 177.

54. Paul Chevigney, *Gigs: Jazz and the Cabaret Laws in New York City,* 41.

55. Mailer's oft-cited "White Negro," despite its problematic nature, remains valuable text in understanding relations between black-derived expressive arts and white Americans.

56. Chevigney, *Gigs,* 41.

57. Gendron, "Moldy Figs," 31

Chapter 1

* (Cheryl A Kirk-Duggan) Included in Current Bibliography.

1. Garofalo, "Crossing Over," *Split Image: African Americans in the Mass Media,* 57–121.

2. Early, *One Nation Under a Groove,* 61.

3. Nelson George, *The Death of Rhythm and Blues,* 15–58.

4. Besides George, both Garofalo's "Crossing Over" and Shaw's "Mama's Got Rhythm and Papa's Got the Blues," from his text *Black Popular Music in America,* point to the centrality of Louis Jordan in the rise of rhythm and blues.

5. Shaw, *Honkers and Shouters,* 92.

6. Shaw, "Mama's Got Rhythm and Papa's Got the Blues," *Black Popular Music in America,* 165–208.

7. Johnson, *Black Manhattan,* 93.

8. George, *The Death of Rhythm and Blues,* 19.

9. Gilroy, "One Nation Under a Groove," *Small Acts,* 38.

10. Rosenthal, *Hard Bop,* 101–17.

11. Ibid., 110.

12. I would be remiss not to acknowledge my debt to Baraka's work.

13. Thomas, "Ascension: Music and the Black Arts Movement," *Jazz Among the Discourses,* 256-57.

14. Baraka, *The Music.*

15. Interview with the author in 1996.

16. Vincent, *Funk: The Music, the People, and the Rhythm of the One,* 69.

17. Interview with author in 1996.

18. Vincent, *Funk: The Music, the People, and the Rhythm of the One,* 69.

19. Hazzard-Gordon, "Dancing to Rebalance the Universe: African American Secular Dance and Spirituality," *Black Sacred Music* 7, no.1 (spring 1993: 25.

20. Porter suggests this in the linear notes to the reissue of Donaldson's *Scorpion* recording.

21. Davis, *Paris Without Regret.*

22. Marable, *Race, Reform and Rebellion,* 45.

23. Higginbotham, *Righteous Discontent,* 9.

24. Smitherman, *Talkin' and Testifyin',* 135.

25. Scarry, *The Body in Pain,* 54.

26. Ibid., 5–6.

27. West, "On Afro-American Popular Music: From Be-Bop to Rap," *Prophetic Fragments,* 178–79.

28. Scarry, *The Body in Pain,* 6.

29. George, *The Death of Rhythm and Blues,* 70.

30. Dyson, "The Soul of Sam Cooke," *Between God and Gangsta Rap: Bearing Witness to Black Culture,* 60–61.

31. George Lipsitz suggests that Elvis Presley owed a huge debt to the various forms of southern music that he more that adequately parlayed into commercial success. *Rainbow at Midnight,* 324–26.

32. Early, *One Nation Under a Groove,* 53–54.

33. Garofalo, *Split Image,* 90.

34. It is not my intention to characterize Motown recordings as not being authentic

to the black experience. What I am really suggesting is that many of the record-
ings from Stax, Atlantic, and Chicago's "Record Row" companies eschewed the
glossier production styles that Gordy believed were crucial to mass acceptance
of Motown. Think here of the space that Smokey Robinson occupied between,
say, Johnny Mathis or Chuck Jackson on the smooth end, and Otis Redding or
Freddie Scott on the rougher end.

35. Cashmore, *The Black Culture Industry*, 70.
36. This irony is at the crux of Cashmore's thesis in *The Black Culture Industry*,
 where he raises questions as to whether or not black popular culture is as
 authentic as it claims. My thesis here is more concerned with how blacks have
 appropriated a bevy of forms, genres, tools, and spaces that may or may not
 have been organic or authentic to black culture. Cashmore's thesis is secondary
 to my concerns.
37. Kelley, *Race Rebels*, 89.
38. Ibid., 87–100.
39. Bennett, *Before the Mayflower: A History of Black America*, 407.
40. Simone, *I Put a Spell on You*, 89–90.
41. Horne, *Fire This Time: Watts Uprising and the 1960s*, 27.
42. Garrow, *The FBI and Martin Luther King, Jr.*, 208.
43. Hill-Collins, "The Power of Self Definition," *Black Feminist Thought*, 108.
44. Williams, "The Blues Roots of African-American Poetry," *Chant of Saints: A
 Gathering of Afro-American Literature, Art, and Scholarship*, edited by Michael
 S. Harper and Robert B. Steptoe, 124.
45. See Pruter's work *Chicago Soul*, particularly chapters 6 and 13, which examine
 the career of Curtis Mayfield.
46. Turner, "Keep On Pushing: The Impressions," *Black Sacred Music* 6, no. 1
 (spring 1992): 208.

Chapter 2

 * King, Martin Luther. *Trumpet of Consciousness*. New York: Random House,
 1968.
 1. Manning Marable's widely cited text *Race, Reform and Rebellion: The Second
 Reconstruction in Black America, 1945–1990* is largely premised on the notion
 of a twentieth-century "Reconstruction" period.
 2. David Garrow's *The FBI and Martin Luther King, Jr.* is an excellent overview of
 the FBI's surveillance of King and the SCLC. Chapter 1, 21–77, discusses
 Levinson's role in the early years of the movement and the subsequent attention
 his role brought to the movement from within the intelligence community.
 3. Meredith was literally gunned down moments into his march. Though his
 wounds were not fatal, the dispersed Civil Rights leadership immediately gath-
 ered in Mississippi to continue the march that Meredith was unable to.
 4. SNCC leaders Stokely Carmichael (Kwame Toure) and H. Rap Brown were
 closely aligned to the party after King's death—Carmichael, for example, served
 as the organization's honorary prime minister. SNCC ties to the Black Panthers
 would erode in part because of the efforts of Hoover and his FBI agents.
 5. Ward Churchill and Jim Vander Wall, *Agents of Repression: The FBI's Secret Wars*

Against the Black Panther Party and the American Indian Movement, 63, 397. Churchill quotes Hoover as stating that FBI field operatives should "exploit all avenues of creating … dissension within the ranks of the BPP" in a memo to the field office in Baltimore, dated 11/25/68 and later distributed to forty other field offices. Churchill and Wall's book is perhaps the most expansive study of the FBI's concerted efforts to disrupt progressive political movements in the late 1960s and early 1970s.

6. Ibid., 49.

7. Ibid., 42–53. The notorious skirmishes between the Oakland-based Black Panther Party chapter and Ron Karenga's United Slaves organization are proto-typical examples of the effectiveness of disinformation and bad-jacketing. The bad-jacketing of Stokely Carmichael was largely responsible for the fracture of SNCC and the Black Panther Party's historic, though short-lived alliance. SNCC's close ties to white members of the radical left made them a ready prey for Hoover's disruptive activities, particularly as the Black Nationalist movement began to instinctively protect itself by purging "fellow travelers" and closing ranks.

8. Ibid., 65. O'Neal had been arrested in early 1968 on charges of impersonating an FBI agent. His role as Black Panther infiltrator was part of a plea bargain he was offered by the FBI.

9. Ibid., 68–69. Central to these activities were efforts to destroy the party's highly acclaimed breakfast programs, political education classes, and its Liberation School.

10. Ibid., 69.

11. Ibid., 64–77. This sordid ordeal is also recounted in the documentary series *Eyes on the Prize, Part II.*

12. David Ritz's *Divided Soul* is the definitive biography of Marvin Gaye.

13. Crouch is quoted in Nelson George's *Buppies, Baps, B-Boys and Bohos: Notes on Post-Soul Culture.*

14. Clayborne Carson examines many of these dynamics in his text *In Struggle: SNCC and the Black Awakening of the 1960s.*

15. Robin Kelley's essay "Birmingham's Untouchables: The Black Poor in the Age of Civil Rights," *Race Rebels: Culture, Politics, and the Black Working Class,* 77–100, offers extraordinary insight to the sensibilities of blacks marginalized from the mainstream Civil Rights movements. I maintain that such trends were further enhanced when coupled with the fractures produced by migration and urban life.

16. William Julius Wilson, *The Truly Disadvantaged,* 38–42.

17. An unknown jazz band would score Melvin Van Peebles film *Sweet Sweetbacks's Baadasssss Song,* and introduce the blaxploitation soundtrack in the process. The group Earth, Wind and Fire would have a highly successful recording career, predicated in part on their ability to synthesize contemporary jazz with rhythm and blues and soul. In this regard, both the group and soundtrack became mod-els for highly creative, though often obscure recordings.

18. George, *Where Did Our Love Go,* 142. Motown, which had considerable reser-vations about the release of *What's Going On,* was obviously concerned that Gaye's newfound social criticism could not be sustained without generating

commercially viable product. Gaye's decision to record a largely instrumental recording further enhanced those fears.

19. *Marvin Gaye: The Master, 1961–1984* (Motown-31453-0492-2).
20. Ibid.
21. Ibid.
22. Manning Marable, *Race, Reform and Rebellion: The Second Reconstruction in Black America. 123-124.*
23. Gilroy, *The Black Atlantic,* 85.
24. Gaye, *Let's Get It On* (Motown-31453-0055-2).
25. *T. S. Eliot: The Complete Poems and Plays, 1909–1950,* 80.
26. In an address to audiences in Louisville, Kentucky in May 1967, Martin Luther King suggested that black urban spaces were little more than a "domestic colony."
27. Cleaver ran as a candidate of the Peace and Freedom Party on an antiwar platform.
28. Paula Giddings, *When and Where I Enter,* 339–40.
29. Gidding's *When and Where I Enter* and Clayborne Carson's *In Struggle* document the internal struggles over gender relations within the traditional Civil Rights movement.
30. Liner notes, *Hypnotized: 20 Golden Classics* (Collectables-COL-CD-5452).
31. Quoted from the liner notes of *Hypnotized: 20 Golden Classics.*
32. Hill-Collins, *Black Feminist Thought,* 100.
33. Gilroy, *The Black Atlantic,* 200.
34. *The Best of Cannonball Adderley* (Capitol Jazz-CDP-7-95482-2).
35. Adderley, *Country Preacher* (Capitol Jazz-CDP-7243-8-30452-2-8).
36. Ibid.
37. Ibid.
38. Kelley, *Race Rebels,* 51.
39. George, *The Death of Rhythm and Blues,* 125–26.
40. "You've Got a Friend" was one of the many popular compositions included on King's brilliant recording *Tapestry.* Before the overwhelming success of her solo recordings, King was a songwriter of some distinction, including writing "crossover" vehicles for black artists like Maxine Brown and the Shirelles.
41. Similarly, Franklin asserted such influence when she gave her 1973 Grammy Award to Grammy nominee Esther Phillips, who Franklin felt better deserved the honor. Franklin's singular act acknowledged the influence of Phillips and other older and often tragic blues figures like Dinah Washington and Billie Holiday.
42. Kelley, *Race Rebels,* 42.

Chapter 3

* James, Joy. *Transcending the Talented Tenth: Black Leaders and American Intellectuals.* New York: Routledge, 1997.
1. Marable, *Race, Rebellion and Reform,* 123.
2. George, *The Death of Rhythm and Blues,* 138–39.

3. Marable, *Race, Rebellion and Reform,* 123–24.

4. Brain Cross, *It's Not About a Salary,* 8.

5. Knight and Dr. Dre, who were the administrative and creative pillars of the high-ly controversial Death Row recording company have been known to furnish Mother's Day dinners for Compton and Watts area mothers as well as donating turkey dinners for poor and working-class individuals in these neighborhoods.

6. Quoted from the liner notes of the *WattStax II* recording.

7. Fonce Mizell would later team with brother Larry and introduce the Motown production line technique to jazz trumpeter and innovator Donald Byrd. Black Byrd, the initial product of this collaboration, would go on to become the best-selling record ever for the Blue Note recording label.

8. George, *Where Did Our Love Go,* 185–86.

9. Ibid., 191–92.

10. Early, *One Nation Under a Groove,* 119.

11. Ibid., 117–18.

12. Ibid., 121.

13. George, *Blackface: Reflections on African-Americans and the Movies,* 60–61.

14. Liner notes, *Soulsation: 25th Anniversary Collection,* 34.

15. Ibid., 37–39.

16. George, *Where Did Our Love Go,* 185–86.

17. Ewen and Ewen, *Channels of Desire,* 223.

18. Brown, "The Language of Soul," *Rappin' and Stylin' Out,* 135.

19. Van Deburg, *New Day in Babylon,* 195.

20. Gilroy, *Black Atlantic,* 102.

21. Haymes, *Race, Culture, and the City,* 51.

22. Cross, *It's Not About a Salary,* 10.

Chapter 4

* (Manning Marable) Included in Current Bibliography.

1. Castells, *The Informational City.*

2. Goldberg, "'Polluting the Body Politic': Racist Discourse and Urban Location," *Racism, the City and the State,* ed. Cross and Keith.

3. Wilson, *The Truly Disadvantaged,* 39.

4. Brewer, "Theorizing Race, Class, and Gender," *Theorizing Black Feminisms* 19, 21.

5. Davis, *Women, Culture, Politics,* 201.

6. Madhubuti, "Conscientious Wanderer: Gil Scott-Heron," *So Far, So Good,* i.

7. Nikki Giovanni's *Truth is on the Way* (1970, COL-CD-6506) and *Like a Ripple on a Pond* (1972, COL-CD-6505), both recorded with the New York Community Choir under the direction of Benny Diggs, were reissued by the Collectibles label in 1993.

8. Conversation with Onase Allan Gumbs, 1993.

9. George, *Where Did Our Love Go,* 178–83.

10. Marable, *Race, Reform and Rebellion,* 38.

11. Playwright Samm-Art Williams's protagonist in *Home* immediately comes to mind here, as well as Richard Wright's Bigger Thomas.

12. I will examine this issue more thoroughly in the following chapter when I detail the emergence of hip-hop music in the postindustrial city.
13. Griffith, *"Who Set You Flowin'?"*, 97.
14. Ideas to this effect can be found on the cover art of the 1978 Funkadelic recording *One Nation Under a Groove.*
15. Clinton received writing credit for "I Bet You," a rather bizarre recording choice of The Jackson Five on their second release, *ABC.* The track that is representative of Clinton's work—he recorded the track himself on Funkadelic's *Funky Music* recording—is clearly out of place with Motown's desire for simplistic and danceable pop-ditties.
16. West, *Prophetic Fragments,* 182.
17. Gilroy, *The Black Atlantic,* 37.
18. I am alluding to Gibson's legal hassles, Hatcher's interracial marriage and the difficulties both Bradley and Jackson faced with the core constituents in their efforts to create a broader electoral base within their cities.
19. Harold Melvin and the Blue Notes, "Be For Real," *I Miss You* (PIR, 1974).
20. Ibid.
21. George, *The Death of Rhythm and Blues,* 155.
22. Gilroy, *The Black Atlantic,* 203
23. Lorde, *Sister Outsider,* 54.
24. Gates, *The Signifying Monkey: A Theory of African-American Literary Criticism,* 124.
25. George, *The Death of Rhythm and Blues,* 167.

Chapter 5

* (Tricia Rose) Included in Current Bibliography.
1. George discusses the birth of Quiet Storm radio in *The Death of Rhythm and Blues,* 131–35, 172–73.
2. George defines "retronuevo" as black music that embraces the past to "create passionate, fresh expressions and institutions." *The Death of Rhythm and Blues,* 186–88.
3. My commentary here is not of an effort to engage in debates about welfare reform, but to acknowledge the bureaucratic realities associated with many federal programs, particularly in their ineffectiveness in countering the general misery associated with black urban life.
4. Rose, *Black Noise: Rap Music and Black Culture in Contemporary America,* 30.
5. Mollenkopf, *Dual City,* 8.
6. Goldberg, "Polluting the Body Politic," *Racism, the City and the State,* 52.
7. Ibid., 51–52.
8. Wilson, *The Truly Disadvantaged,* 60.
9. Davis, *City of Quartz,* 250–53.
10. Lewis, *When Harlem was in Vogue,* 129–30.
11. Davis, *City of Quartz,* 311.
12. West, *Prophetic Thought in Postmodern Times,* 122.
13. Davis, *City of Quartz,* 304–305.
14. Jerry Mander addresses the relationship between American youth and television

in his text *Four Arguments for the Elimination of Television*.

15. Davis, *City of Quartz,* 306.
16. Dyson, *Race Rules,* 140–45.
17. Davis, *City of Quartz,* 293–300.
18. Rose, *Black Noise,* 11.
19. Ibid., 61.
20. Gilroy, "One Nation Under a Groove," *Small Acts,* 39–40.
21. The litigation between Chic and Sugar Hill records over the use of "Good Times" was just the first of many celebrated sampling cases, of which the 1991 legal battle between artists Biz Markie and singer/songwriter Gilbert O'Sullivan is the most notorious. Many artists have dealt with this problem by simply giving sampled artists songwriting credit, though given the history of pop music, these credits simply enhanced the financial coffers of corporate entities who controlled the publishing rights.
22. Marable, *Race, Reform and Rebellion,* 194–96.
23. Manning Marable offers a credible argument in his text *How Capitalism Underdeveloped Black America,* that the increased rates of black male incarceration is related to the use of prison inmates in the maintenance of municipal works and services. Marable believes that the use of prison inmates in such a way is representative of a modern form of enslavement.
24. Marable, *Race, Reform and Rebellion,* 192.
25. Tate, *Flyboy in the Buttermilk,* 125.
26. The works of black women like Angela Davis, Kathleen Cleaver, and Elaine Brown exemplify the type of necessary critique and reflection that needs to take place to more adequately consider the success and failures of the Civil Rights/Black Power era.
27. Tate, *Flyboy in the Buttermilk,* 126.
28. Ibid.
29. Boyd, *Am I Black Enough for You,* 39.
30. I am referring here to Joe Kleine's review of the film for *New Yorker* magazine in June 1989.
31. Rose, *Black Noise,* 128–30.
32. Ibid., 126.
33. Ibid., 130–35.
34. Despite a recording career that has been inconsistent at best and well-publicized financial problems, MC Hammer remains the best-selling hip-hop artist of all time.
35. During the summer of 1996 Combs renegotiated his deal with Arista/BMG, giving him ownership of his label's recording masters over a period of time. At the time of Combs's deal Reid and Edmonds were rumored to renegotiate along the same terms. Issues of autonomy and product ownership were at the core of Andre Harrell's severed relationship with Uptown/MCA, the label he founded, in the autumn of 1995. Harrell was subsequently chosen to lead Motown into the twenty-first century with considerably more autonomy and prestige than was offered at the boutique he founded in 1986, though his failure to produce new acts led to his forced resignation in August 1997.
36. Haymes, *Race Culture and the City,* 36–39.
37. Ibid., 37.

38. Rose, *Black Noise,* 104.
39. RKO owns both Hot 97 and KISS-FM in New York City. Hot 97, which is dedicated to a twenty-four-hour ghetto pop and hip-hop format, has also brought in popular artists, including former *Yo MTV Raps* hosts Dr. Dre and Ed Lover, to host segments of their programming. Ed and Dre, as they are affectionately known, are the station's morning drive-time hosts. WBLS-FM, the only-black owned station in the market, responded to these shifts only after RKO's experiment proved successful.
40. Notorious B.I.G., "Things Done Changed," *Ready to Die* (Arista/Bad Boy, 78612-73000-2).
41. Boyd, *Am I Black Enough for You?*, 43–50.
42. I am thinking here of works like Samm Art-Williams's *Home,* Cornel West's *Prophetic Fragments,* Farah Jasmine Grifffin's *Who Set You Flowin'?,* and Spike Lee's films *Crooklyn* and *Clockers,* which all consider the lack of communal vision in the aftermath of the migratory movement.
43. Arrested Development, "Tennessee," *3 Years, 5 Months and 2 Days in the Life of...* (Chrysalis 1992).
44. Ibid.
45. Michelle Ndegeocello, "Mary Magdelene," *Peace Beyond Passion* (Maverick/Reprise 1996).
46. The Crooklyn Dodgers, "Crooklyn," *Music From the Motion Picture Crooklyn* (MCA 1994).

Chapter 6

 * Kelley, Robin D.G. *Yo' Mama's Disfunktional: Fighting the Culture Wars in Urban America* Boston: Beacon Press, 1997
 1. Rose, *Black Noise,* 63
 3. Boyd, *Am I Black Enough for You,* 63.
 4. Common (Sense), "I Used to Love Her," *Resurrection* (Relativity 1994).
 5. Common (Sense), "Pop's Rap," *Resurrection* (Relativity 1994).
 6. Rose, *Black Noise,* 147.
 7. Donna Franklin's *Structural Inequality* is an excellent examination of the tensions faced by the contemporary black family.
 8. Gregory, "Race, Identity and Political Activism," *The Black Public Sphere,* 166.
 9. Gaines, *Uplifting the Race: Black Leadership, Politics, and Culture in the Twentieth Century,* 2.
10. Dyson, *Race Rules: Navigating the Color Line,* 135.
11. Many thanks to Dr. Eddie Jones of the University of Arkansas for giving greater insight into this issue.

REFERENCES

Adero, Malaika, ed. *Up South: Stories, Studies, and Letters of This Century's Black Migrations*. New York: The New Press, 1993.

Althusser, Louis. *Lenin and Philosophy, and Other Essays*. New York: Monthly Review Press, 1971.

Anderson, Jervis. *This was Harlem: A Cultural Portrait, 1900–1950*. New York: Farrar Straus Giroux, 1981.

Baraka, Amiri. *The Music: Reflections on Jazz and Blues*. New York: William Morrow & Co. 1987.

———. *Blues People: Negro Music in White America*. New York: William Morrow & Co., 1963.

Barlow, William and Jeanette Dates eds. *Split Image: African Americans in Mass Media* Washington: Howard University Press, 1990

Baudrillard, Jean. *Jean Baudrillard: Selected Writings*. Stanford: Stanford University Press, 1991.

Bell, Derrick. *Faces at the Bottom of the Well*. New York: Basic Books, 1992.

Bennett, Lerone. *Before the Mayflower: A History of Black America*. New York: Viking Pen, 1984.

Boyd, Todd. *Am I Black Enough for You?* South Bend: Indiana University Press, 1997.

Brandt, Nat. *Harlem at War: The Black Experience in WWII*. Syracuse NY: Syracuse University Press, 1996.

Brewer, Rose. "Theorizing Race, Class, and Gender," *Theorizing Black Feminisms: The Visionary Pragmatism of Black Women*. eds. Stanlie James and Abena Busia. New York: Routledge, 1993.

Brown, Elsa Barkley. "Negotiating and Transforming the Public Sphere: African-American Political Life in the Transition from Slavery to Freedom," The Black Public Sphere, ed. The Black Public Sphere Collective. Chicago: University of Chicago Press, 1995.

Capeci, Dominic. *The Harlem Riot of 1943*. Philadelphia: Temple University Press, 1977.

Carson, Clayborne. *In Struggle: SNCC and the Black Awakening of the 1960s*. Cambridge: Harvard University Press, 1995.

Cashmore, Ellis. *The Black Culture Industry*. London: Routledge, 1997.

Castells, Manuel. *The Informational City: Information Technology, Economic Restructuring, and the Urban-Regional Process*. Cambridge: Basil Blackwell, 1989.

Chambers, Iian. *Urban Rhythms: Pop Music and Popular Culture*. New York: St. Martin's Press, 1985.

Chevigney, Paul. *Gigs: Jazz and the Cabaret Laws in New York City.* New York: Routledge, 1991.

Churchill, Ward, and Jim Vander Wall. *Agents of Repression: The FBI's Secret Wars Against the Black Panther Party and the American Indian Movement.* Boston: South End Press, 1988.

————. *The Cointelpro Papers: Documents from the FBI's Secret Wars Against Domestic Dissent.* Boston: South End Press, 1990.

Cone, James. *The Spirituals and the Blues: An Interpretation.* New York: The Seabury Press, 1972.

Cooper, Ralph, and Steve Dougherty. *Amateur Night at the Apollo.* New York: HaperCollins, 1990.

Cross, Brian. *It's Not About A Salary: Rap, Race and Resistance in Los Angeles.* London: Verso, 1993.

Cross, Gary. *Time and Money: The Making of Consumer Culture.* New York: Routledge, 1993.

Cross, Malcolm, and Michael Keith, ed. *Racism, the City and the State.* New York: Routledge, 1993.

Crouch, Stanley. *Notes of a Hanging Judge: Essays and Reviews, 1979–1989.* New York: Oxford University Press, 1990.

Cruse, Harold. *The Crisis of the Negro Intellectual.* New York: William Morrow & Co., 1984.

Dates, Jannette, and William Barlow, eds. *Split Image: African-American in the Mass Media.* Washington, D.C.: Howard University Press, 1990.

Davis, Angela. *Women, Race and Class.* New York: Vintage Books, 1983.

————. *Women, Culture and Politics.* New York: Random House, 1989.

Davis, Mike. *City of Quartz: Excavating the Future in Los Angeles.* New York: Verso, 1990.

Davis, Ursala Broschke. *Paris Without Regret.* Iowa City: University of Iowa Press, 1986.

Dawson, Michael. *Behind the Mule: Race and Class in African-American Politics.* Princeton: Princeton University Press, 1994.

Dent, Gina, ed. *Black Popular Culture.* Seattle: Bay Press, 1992.

DuBois, W. E. B. *The Souls of Black Folk.* New York: Signet Classic, 1969.

Dyson, Michael Eric. *Reflecting Black: African-American Cultural Criticism.* Minnesota: University of Minnesota Press, 1993.

————. *Race Rules: Navigating the Color Line.* New York: Addison Wesley, 1996.

Early, Gerald. *One Nation Under a Groove: Motown and American Culture.* Hopewell, N J: The Ecco Press, 1995.

————. *The Culture of Bruising.* Hopewell, N J: The Ecco Press, 1994.

Eliot, T.S. *The Complete Poems and Plays, 1909-1950.* New York: Harcourt Brace, 1952.

Ellison, Ralph. *Shadow and Act.* New York: Random House, 1964.

Ewen, Stuart, and Elizabeth Ewen. *Channels of Desire: Mass Images and the Shaping of American Consciousness.* New York: McGraw-Hill, 1982.

Fiske, John. *Understanding Popular Culture.* Boston: UNWIN HYMAN, 1989.

Floyd, Samuel A., ed. *Black Music in the Harlem Renaissance: A Collection of Essays.*

New York: Greenwood Press, 1990.

Fox, Ted. *Showtime at the Apollo*. New York: Holt, Rinehart andWinston, 1983.

Franklin, Donna. *Structuring Inequality*. New York: Oxford, 1997.

Gabbard, Erin ed. *Jazz Among the Discourses*. Durham, NC: Duke University Press, 1995.

Gaines, Kevin. *Uplifting the Race: Black Leadership, Politics and Culture in the Twentieth Century*. Chapel Hill: University of North Carolina Press, 1996.

Garafalo, Reebee. "Crossing Over," Split Image: African Americans in Mass Media, ed. William Barlow and Jeanette Dates. Washington: Howard University Press, 1990.

Garrow, David J. *The FBI and Martin Luther King: From "Solo" to Memphis*. New York: W. W. Norton, 1981.

George, Nelson. *The Death of Rhythm and Blues*. New York: Pantheon, 1988.

———. *Where Did Our Love Go: The Rise and Fall of the Motown Sound*. New York: St. Martin's Press, 1985.

Giddings, Paula. *When and Where I Enter: The Impact of Black Women on Race and Sex in America*. New York: William Morrow & Co., 1984.

Gilroy, Paul. *Small Acts*. New York: Serpent's Tail, 1993.

———. The Black Atlantic. London: Oxford University Press, 1993

Goodwin, E. Marvin. *Black Migration in America From 1915 to 1960: An Uneasy Exodus*. Lewiston, NY: The Edwin Mellen Press.

Greenberg, Cheryl L. *"Or Does it Explode": Black Harlem in the Great Depression*. New York: Oxford University Press, 1991.

Gregory, Steven. "Race, Identity and Political Activism," The Black Public Sphere, ed. The Black Public Sphere Collective. Chicago: University of Chicago Press, 1995.

Griffin, Farah Jasmine. *"Who Set You Flowin'?": The African-American Migration Narrative*. New York: Oxford University Press, 1995.

Harding, Vincent. *Martin Luther King: The Inconvenient Hero*. Maryknoll, NY: Orbis Books, 1996.

Harper, Michael S., and Robert B. Steptoe, eds. *Chants of Saints: A Gathering of Afro-American Literature, Art and Scholarship*. Urbana: University of Illinois Press, 1979.

Harris, Michael W. *The Rise of Gospel Blues: The Music of Thomas Andrew Dorsey in the Urban Church*. New York: Oxford University Press, 1992.

Haymes, Stephen. *Race, Culture and the City: A Pedegogy for Black Urban Struggle*. Albany: State University of New York Press, 1995.

Hazzard-Gordon, Katrina. *Jookin': The Rise of Social Dance Formations in African-American Culture*. Philadelphia: Temple University Press, 1990.

Hebdige, Dick. *Subculture: The Meaning of Syle*. New York: Routledge, 1991.

Higginbotham, Evelyn Brooks. *Righteous Discontent: The Women's Movement in the Black Baptist Church, 1880–1920*. Cambridge: Harvard University Press, 1993.

Hill-Collins, Patricia. *Black Feminist Thought: Knowledge, Consciousness and the Politics of Empowerment*. New York: Routledge, 1991.

hooks, bell. *Black Looks: Race and Representation*. Boston: South End Press, 1992.

———. *Yearning: Race, Gender, and Cultural Politics*. Boston: South End Press, 1990.

Horne, Gerald. *Fire This Time: The Watts Uprising and the 1960s*. Charlottesville: University Press of Virginia, 1995.

Jacoby, Russell. *The Last Intellectuals: American Culture in the Age of Academe.* New York: Basic Books, Inc., 1987.

James, Ralph. *Northern Protest: Martin Luther King, Chicago and the Civil Rights Movement.* Cambridge: Harvard University Press, 1993.

James, Stanlie M., and Abena P. A. Busia, eds. *Theorizing Black Feminisms: The Visionary Pragmatism of Black Women.* New York: Routledge, 1993.

Jameson, Frederic. "Postmodernism and Consumer Society." *The Anti-Aesthetic: Essays in Postmodern Culture,* 111–25. Ed. Hall Foster. Port Townsend: Bay Press, 1983.

Johnson, James Weldon. *Black Manhattan.* New York: De Capo Press, 1991.

Johnson, James Weldon. *The Autobiography of an Ex-Coloured Man.* New York: Random House, 1989.

Jones, Jacqueline. *Labor of Love, Labor of Sorrow: Black Women, Work, and the Family from Slavery to the Present.* New York: Random House, 1985.

Kaplan, E. Ann. *Rocking Around the Clock: Music Television, Postmodernism, and Consumer Culture.* New York: Methuen, 1987.

Kelley, Robin D. G. *Race Rebels: Culture, Politics and the Black Working Class.* New York: Free Press, 1994.

Kirk-Duggan, Cheryl. "Confronting and Excorcising Evil through Song." *A Troubling in My Soul,* 150–71. ED. Emile M. Townes. Maryknoll: Orbis Press, 1993.

Lehman, Nicholas. *The Promised Land: The Great Black Migration and How it Changed America.* New York: A. A. Knopf, 1991.

Levine, Lawrence W. *Black Culture and Black Consciousness: Afro-American Folk Thought from Slavery to Freedom.* New York: Oxford University Press, 1978.

Lewis, David Levering. *When Harlem was in Vogue.* New York: Oxford University Press, 1989.

Liggett, Helen, and David C. Perry, ed. *Spaital Practices: Explorations in Social/Spaital Theory.* Thousand Oaks: Sage Publications, 1995.

Lipsitz, George. *Rainbow at Midnight: Labor and Culture in the 1940s.* Chicago: University of Illinois Press, 1994.

Mander, Jerry. *Four Arguments for the Elimination of Television.* New York: William Morrow and Co., 1978.

Marable, Manning. *How Capitalism Underdeveloped Black America.* Boston: South End Press, 1983.

———. *Race Reform and Rebellion: The Second Reconstruction in Black America, 1945–1992* Jackson: University Press of Mississippi, 1993.

———. *The Crisis of Color and Democracy: Essays on Race, Class, and Power.* Monroe, Maine: Common Courage Press, 1992.

Mollenkopf, John, and Manuel Castells, eds. *Dual City: Restructuring New York.* New York: Russell Sage Foundation, 1991.

Ottley, Roi. New World A-Coming: *Inside Black America Boston*: Houghton Mifflin, 1943

Peretti, Burton W. *The Creation of Jazz: Music, Race and Culture in Urban America.* Chicago: University of Illinois Press, 1992.

Pruter, Robert. *Chicago Soul.* Urbana and Chicago: University of Illinois Press, 1991.

Reed, Harry A. "The Black Tavern in the Making of a Jazz Musician: Bird, Mingus, and Stan Hope," *Perspectives of Black Popular Culture.* Bowling Green: Bowling Green State University Popular Press, 1990.

Ritz, David. *Divided Soul: The Life of Marvin Gaye.* New York: McGraw-Hill, 1985.

Rose, Tricia. *Black Noise: Rap Music and Black Culture in Contemporary America.* Hanover: Wesleyan University Press, 1994.

Rosenthal, David H. *Hard Bop: Jazz and Black Music 1955–1965.* New York: Oxford University Press, 1992.

Ross, Andrew, and Tricia Rose eds. *Microphone Fiends: Youth Music and Youth Culture.* New York: Routledge, 1994.

Rotenberg, Robert, and Gary McDonogh, ed. *The Cultural Meaning of Urban Space.* Westport, Conn.: Bergin and Garvey, 1993.

Scarry, Elaine. *The Body in Pain: The Making and Unmaking of the World.* New York: Oxford University Press, 1985.

Schuyler, George S. "The Negro Art Hokum," Voices from the Harlem Renaissance, ed. Nathan Irvin Huggins. New York: Oxford University Press, 1976.

Scott, James C. *Domination and the Arts of Resistance: Hidden Transcripts.* New Haven: Yale University Press, 1990.

Shaw, Arnold. *Black Popular Music in America.* New York: Schirmer Books, 1986.

Smith, Arthur, ed. *Language, Communication and Rhetoric in Black America.* New York: Harper and Row, 1972.

Smitherman, Geneva. *Talkin' and Testifyin': The Language of Black America.* Detroit: Wayne State University Press, 1977.

Tate, Greg. *Flyboy in the Buttermilk: Essays on Contemporary America.* New York: Simon & Schuster, 1992.

Thompson, Robert Farris. *Flash of the Spirit: African and Afro-American Art and Philosophy.* New York: Random House, 1983.

Thrift, Nigel, and Peter Williams, ed. *Class and Space: The Making of Urban Society.* New York: Routledge, 1987.

Toop, David. *Rap Attack 2: African Rap to Global Hip-Hop.* London: Serpent's Tail, 1991.

Trotter, Joe William, ed. *The Great Migration in Historical Perspective: New Dimensions of Race, Class, and Gender.* Bloomington: Indiana University Press, 1991.

Vincent, Rickey. *Funk: the Music, the People, and the Rhythm of the One.* New York: St. Martin's Griffin, 1996.

Wallace, Michelle. *Invisibility Blues: From Pop to Theory.* New York: Verso, 1990.

Wakefield, Dan. *New York in the 50s.* New York: Houghton Mifflin, 1992.

West, Cornel. *Keeping Faith: Philosophy and Race in America.* New York: Routledge, 1993.

———. *Prophetic Fragments.* Trenton: Africa World Press, 1988.

———. *Prophetic Reflections: Notes on Race and Power in America.* Monroe, Maine: Common Courage Press, 1993.

———. *Prophetic Thought in Postmodern Times.* Monroe, Maine: Common Courage Press, 1993.

Wilson, John S. *Jazz: The Transition Years, 1940–1960.* New York: Appleton-Century-Crofts, 1966.

Wilson, William Julius. *The Truly Disadvantaged: The Inner City, the Underclass, and Public Policy.* Chicago: University of Chicago Press, 1987.

Wolf, Daniel. *Your Send Me: The Life and Times of Sam Cooke.* New York: William Morrow & Co., 1995.